# LUCAS SAMARAS

LUCAS

# SAMARAS

KIM LEVIN

HARRY N. ABRAMS, INC., PUBLISHERS, NEW YORK

For there is nothing covered, that shall not be revealed;
neither hid, that shall not be known.

The Gospel According to St. Luke 12:2

Nai Y. Chang, Vice-President, Design and Production
John L. Hochmann, Executive Editor
Margaret L. Kaplan, Managing Editor
Barbara Lyons, Director, Photo Department, Rights and Reproductions
Kim Levin and Betty Binns, Book Design

Library of Congress Cataloging in Publication Data
Levin, Kim.
  Lucas Samaras.

  Bibliography: p.
  I. Samaras, Lucas, 1936-
N6537.S3L48        709'.2'4[B]        74-23630
ISBN 0-8109-0267-2
ISBN 0-8109-4747-1 lim. ed.

Library of Congress Catalogue Card Number: 74-23630
Published by Harry N. Abrams, Incorporated, New York, 1975
All rights reserved. No part of the contents of this book may be
reproduced without the written permission of the publishers
Printed and bound in Japan

# CONTENTS

# ACKNOWLEDGMENTS:

I wish to thank

Thomas B. Hess and Henry and Martha Edelheit, who read the manuscript and made a number of helpful suggestions

Paul Anbinder and Sam Hunter for their editorial contributions

The Pace Gallery for help in compiling photographic material, and the Dwan Gallery, which also provided some photographs

Richard Bellamy, Lilly Brody, the Edelheits, Norman Fruchter, Gloria Graves, Arnold Glimcher, Allan Kaprow, Tom Kremes, Barbara Long, Claes Oldenburg, Carol Samaras, George Segal, Costa Tsipis, and Robert Whitman for allowing me to interview them

And, most of all, Samaras himself for his cooperation and unstinting generosity in giving me access to his time, his memories, his manuscripts, notes, documents, cups of tea . . .

K.L.

# LIST OF PLATES

1. Passport photograph. 1947

2. *Untitled.* Before 1958

*3, *4. *Untitled.* 1958

5. The Rutgers Rifle Team (Samaras with beard). 1956

6. *Target Sheet.* 1956

7. Samaras with his father

8. Samaras with his mother and aunt

9. Samaras in Claes Oldenburg Happening: *Store Days.* 1962

10. Samaras in Claes Oldenburg Happening: *Fotodeath.* 1961

11. Samaras in Claes Oldenburg Happening: *Store Days.* 1962

12. *Untitled.* 1959

13. *Untitled.* c. 1954

14. *Drawing.* 1959–60

15. *Drawing.* 1960–61

16. *Drawing.* 1961

17. *Drawing.* 1961

18. *Untitled.* 1963

*19. *Paper Bag #2* (containing *Book #2*). 1962

20. *Dinner #4 Box #4.* 1963

21. *Drawing.* 1962

22. Kastoria, Greece

23. Samaras family, Lucas on mother's shoulders. c. 1937–38

24. Samaras in Claes Oldenburg and Robert Breer Film: *Pat's Birthday.* 1962

25–27. Installation of exhibition at Dwan Gallery, Los Angeles. 1964–65

*28, *29. Two drawings of *Bedroom.* 1962

30. *Box #25.* 1964

31. Perspective drawing for interior of *Room #2.* 1966.

32. *Drawing* (1930s ombre). 1961

33. *Drawing.* 1964

*34. Byzantine icon Samaras bought in Greece in 1967

35. *Drawing.* 1967

36. Sketch for boxes. 1966

37. *Transformation: Boxes.* 1966–67

38. *Transformation: Plates.* Completed 1968

39. *Untitled.* 1965

40. *Lucas Samaras.* Autopolaroid. 1970–71

41. Film strip from the movie *Self.* 1969

42. Film strip from the movie *Self.* 1969

43. *Lucas Samaras.* Autopolaroid. 1970–71

44. *St. Simeon Stylites.* Byzantine icon Samaras bought in Greece in 1967

45. Samaras's parents and relatives at a carnival in Kastoria. 1934

46. *Stiff Box #12.* 1971

47. *Stiff Box #7.* 1971

48. *Chicken Wire Box #41.* 1972

49. *Untitled* (self-portrait). 1958–59

Greece is my prehistory, my preliterate past, my unconsciousness, my fantasy. America is my history, my consciousness, my adult life my reality.

Samaras, "Autobiographic Preserves"[1]

scraps

Lucas Samaras came to America in 1948 at the age of eleven and a half from Kastoria, the Macedonian town of his wartime childhood.

One of the earliest things he chooses to keep is a blank and faded sheet of blue-lined paper, the kind children use for schoolwork. On the top line is signed his name and the date, nothing else. Just a blank page of hair-thin blue lines signed by a thirteen-year-old schoolboy, but in retrospect it contains the future. "Making a signature was a way of becoming an artist,"[2] says Samaras.

For him everything is first what it is and nothing else. And everything else. Each of his substances—pins, jewels, wool, mirror—is purely visual, nothing but itself, and yet each contains within itself memories and associations and erotic impulses, unraveling in a skein of substitutions, supremely ordered, deviously haphazard, deliberately elusive—like the blank piece of paper. Things follow by resemblance, by their likenesses to other things, revealing chance meaning. Containing contradictions and reversals. His work accumulates bits of its own past, it steals from his life, and it creates forms that predict the future, referring backwards and forwards in a voracious dialogue with his own work, other artists' work, art history, and his childhood. It swallows and digests everything that resembles itself.

Jars of beads, sequins, springs, lenses, and epoxy fingers are lined up in his studio like jars of dazzling pigments. They are his paints. Instead of turpentine Samaras uses glue, and the substances, finally, are all interchangeable skins that express the multiple alternates and reflections of a single object: himself.

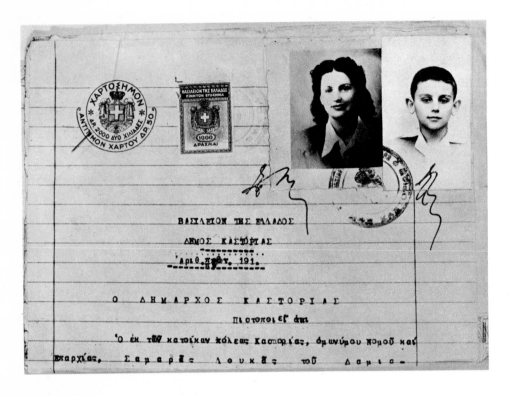

1. Passport photograph. 1947

To the young Samaras America was West New York, New Jersey, with the New York skyline visible across the Hudson River like a mirage of the future. Placed in the third grade because he did not speak English, his foreignness was compounded, but by the time he completed high school he had almost caught up to his age group. He entered Rutgers University in 1955 on an art scholarship won on the basis of a group of semi-Cubist crucifixion drawings.

According to Allan Kaprow, who was then teaching at Rutgers and was in charge of awarding the scholarship: "Along with about twenty applicants who drew misguided equivalents of movie stars there came this packet of sophisticated curious stuff from Lucas—pencil, tinted watercolors, collages. They were somewhere between Futurism and Feiningeresque Cubism."

"I interpreted Cubism as crucifixion art," says Samaras. "Crucify, cross, criss-crossing, Cubism. There's a breaking involved; it's a slightly violent artistic mode."[3]

"Lucas was arrogant, silent, egotistical, self-contained, very intelligent, intensely interested in becoming an artist," recalls George Segal, who was teaching an informal drawing group at Rutgers. "He would sit at my table with his jacket thrown over his shoulders like a cape, and his arms crossed, very silent. For years he refused to eat in my house. He would grandly accept one clear glass of water."

Robert Whitman, who was a fellow student, remarks: "I think he thought that eating food was very personal. I was really impressed by his facility to make the things he wanted to make. He had a fantastic technical ability at painting and also a pretty good critical eye. He was very good at verbalizing criticism. I accepted a lot of what he said because he was so good at it. Only later did I discover he was fallible like the rest of us."

Norman Fruchter, who was his freshman roommate, recalls: "His hair was longer than most people's, he dressed in a kind of patchwork that was totally unlike the kinds of styles you find on a campus. When he was painting I have a vague memory that he wore a kind of

butcher coat. One of the things he had done in high school was a crucifixion. In any religious sense it was not at all unstraight. I was astounded at that. I assumed skepticism or atheism from everybody. What I remember most was somebody I couldn't place at all. He'd already developed a lot of reserve which was a shield. He'd cultivated a kind of imperiousness. Lucas had a more definable set of selves—not false selves but public selves—than anybody I knew. People's sense of him was he was both an actor and an enigma."

"Some friends took me to meet him because we were both Greek," recalls another fellow student, Costa Tsipis, who was studying science, "and there was Lucas, who immediately showed me two works: one had gained him his scholarship. It was a crucifixion. The other was a woman with open legs seen from a low angle. I was struck by his concept of what a woman's genitalia are like—they were cavernous."

"He was a pain in the ass in those days," says Barbara Long, a writer who was attending Douglass, the women's college. "Everybody had to come to him. He lived in a boarding house, 82 Somerset Street. It was next to a convent. The nuns later bought it and destroyed it because it was immoral—it's now a parking lot. It was a refuge for bright outcast students. Lucas was the mysterious one. He lived on the top floor and everybody had to climb five or six flights to get to him. He was always working—that was the unfair advantage he had over us. I posed for him once, in 1958. The painting was a sentimental nude, pink and silver. I was out of my clothes a minute and a half and then he said, 'You can go now.' He probably did want me out of the room. I was afraid he would criticize my body, he was sort of an authority figure—everyone was afraid of him, he was judging us on life styles. He was very scary to me."[4]

From the beginning the future revealed itself not only in his life style but in his use of materials. Even though his subject matter was traditional—figures and flowers, his paintings were split in substance—half gouache and half pastel, or silver paint and Day-Glo. He used what were in those days unconventional materials, and

2. *Untitled.* Before 1958. Tinfoil and smoke, 6¼ × 6″. Collection the artist

3, 4. *Untitled*. 1958. Two pastels, each 18 × 12″. Collection the artist

he made unconventional combinations of them. Using the smoke from a candle instead of a pencil and scratching into it with a pin, he made a drawing of flowers on a piece of tinfoil—a student gesture that unknowingly paralleled the humor and disdain of Duchamp's landscape[5] made with talcum powder and chocolate on blotting paper.

He used glass, painting flowers on small glass panels joined accordion-folded like a Chinese screen. He made a double triptych of painted glass that unfolded, opening from both sides. On it he used gold underpaint, silver paint, delicate shadowy textures, and toilet paper. This folding glass piece is prophetic in more ways than in its odd use of substances: its three-dimensional constructed form has resemblances to books and boxes[6]—it folds and unfolds, opens and closes—and, when open, it resembles a miniature stage or room. It challenges the past. The desire to make great art is part of its content. "It was my attempt to bring altarpieces into the twentieth century," an idea that was made possible, he says, by having seen the polyptych paintings of Jan Müller at the Hansa Gallery.

The artists at Rutgers in the late 1950s were involved in the Hansa, a cooperative run by Richard Bellamy and Ivan Karp, through Allan Kaprow and George Segal, who were members. Kaprow was creating his Environments there; Segal was just beginning to use plaster. The milieu was romantic bohemian nostalgia (Kerouac and the Beat poets and Provincetown summers), and the Hansa artists were working, in the shadow of Abstract Expressionism, with the idea of the private myth—with the nostalgia of idyllic nature, monsters, allegorical figures and archetypal symbols, and the nostalgia of rusty metal. Though Jan Müller was the spiritual leader of the group, Stankiewicz's junk sculpture[7] had gained public acclaim, and the way to the future was being shown more in the use of discarded materials than in Surrealist-derived mythic content. Outside of the Hansa group, Picasso's monkey and Cornell's boxes had appeared, and Rauschenberg was making Combines. Samaras at Rutgers, as he became aware of these possibilities, began to use every-day cast-off materials. From the start his materials, like Rauschenberg's, were highly personal, retaining an autobiographical nostalgia.

"I did a painting that was my undershirt. I had the undershirt stretched on the stretcher, half the stretcher showed. I put paint and ink and sparkles on it. I also did a painting that was my bedsheet. I took the bedsheet and I put it on the wall and I made squiggles on it with ink, little squiggles—it was like Pollock but it wasn't, it was more like sperm actually."

His college friend Tsipis recalls: "In 1958 I went to Greece. Coming back I missed the plane. It fell and everybody was killed. Lucas read about it. He said it was a pity I was not dead, what he really wanted was my corpse. I was impressed that he thought of my body as an artistic experience. It had something to do with pins or nails, I think; he had an idea to nail a body to a wall and paint it. I thought it was one up on Rauschenberg's *Bed*. At that time, 1958, he was painting flowers. He was painting feverishly. The school gave him money to buy canvas. His room was full of cans, boxes, empty soda bottles to put flowers in, pieces of scrap wood and metal, all kinds of junk. He painted kneeling on the floor. He painted himself in front of the mirror, squatting, looking in the mirror, naked and painting."

Swinging from the light bulb in the center of his college room was a small hanging man of plasticine that Samaras had made in high school and covered with liquid solder or Sculpmetal. He used it to turn the light on and off: it also became a target for darts.

In his freshman year at Rutgers Samaras joined the rifle team. He was a good shot. He has saved pages of target sheets punctured by bullet holes, his best scores as a sharpshooter. Ten tiny black-and-white targets on a page the size of a piece of typewriter paper—ten small neat bullet holes shot from a distance of fifty feet.

As a child in Greece, "more than anything else, penetration was my favorite occupation," he wrote in his "Autobiographic Preserves." "To cleave the twigs and leaves from a long skinny branch, transform it into

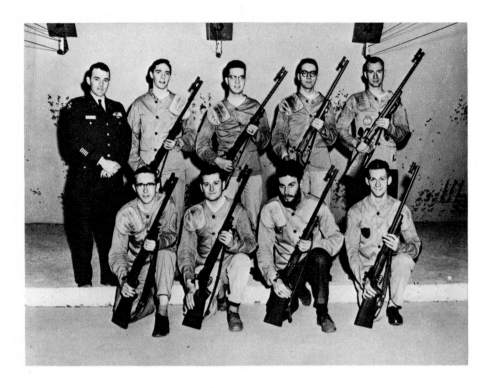

5. The Rutgers Rifle Team (Samaras with beard). 1956

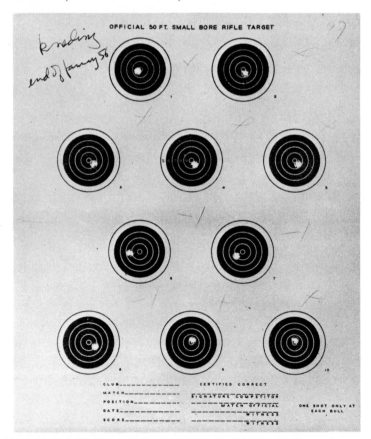

6. *Target Sheet.* 1956

a spear and never to stop thrusting it into the air, earth, or objects . . . it was physical, direct, elegant . . . what were my thrusts against the ground, against a tree, against walls, against the water? Of course I wanted some response, some shriek, some sigh. And also some reassurance that these things were inanimate things."

Bullets, thrusts, and darts turn into evenly spaced blue dots covering a face in an early pastel, or into tacks sticking out from mirror surfaces, pins sticking into photographs of Samaras's face, or into x-rays of his skull. Targets become vortexes, spectra, whirlpools, halos, faces: the target is himself.

He had grown up in the midst of World War II and the Greek civil war in a household of female relatives. "I had forgotten I miss the centuries-old houses, the dusty, rubbled atmosphere of war; the bombings, the hidings, my aunt's slightly ripped belly, the fear of separation, the playing in bomb pits, the sound of executions, armored vehicles, the strange pride in being visited by a catastrophe,"[8] wrote Samaras after returning to visit Greece—by appropriate coincidence—on the eve of the 1967 revolution.

The source of Samaras's bullet-hole imagery is multiple: it was his childhood, and it was, he claims, the target trademark of the Looney Tunes cartoons he used to see in the Laffmovie house on Forty-second Street. It was also, in terms of art history, Jasper Johns's targets, which surfaced early in 1958. Like Rauschenberg's *Bed*, they were inescapably corrosive to Abstract Expressionism. They proclaimed the end of illusionistic space and a new code of realism. But Samaras absorbed them as images: frontal, concentric, and radiating. They showed him that "the expansion and contraction of a dot was possible." His vases of flowers had always been like targets—the flowers were the bullet holes, floating dots of color.[9] Targets became elements of iconography as well as things to shoot at.

If the problem during the late 1950s, when Samaras was at Rutgers, was a reaction to Abstract Expressionism—where to go after Pollock, or how to put the figure back into painting without doing a De

Kooning—it was, according to Samaras, also a reaction against Albers. "Why couldn't he make a square in the exact center and why was his paint so clean and flat?"

Samaras played with the Albers problem in the heavily impasted mud-color paintings he did during his last year at Rutgers. Solid, drab, and dark, they are nothing but paint itself as a repugnant viscous substance—the color of overworked student paintings—laid on in patterns of repeated thick brushstrokes. Labyrinths of paint narrow in concentric rectangles like a corridor, split away from the center like parting curtains, or tightly zero inward in stripes or squares to a tiny central diamond or square that might be a bright unexpected color. Targets of another sort. Commenting on Albers and on Abstract Expressionism, and oddly paralleling the work of Frank Stella, who had just graduated from Princeton. They were called *Icons Minus the Deity*, a title Samaras has since rejected but which seems mildly significant in relation to his glass "altarpiece" with toilet paper.

If crucifixion drawings marked his entrance into Rutgers, profanity underlined his exit. As Kaprow tells the story, "Lucas was of course a good student in everything and was given a chance to do an honors project. He did a kind of autobiographical manuscript, photos of his work illuminated by poems which he lettered himself on handmade paper. On the honors day at a seminar of all the honors students Lucas read some of his poems. They had a few terrible words like 'piss' in them, which in those days could have brought the wrath of God down, but they didn't cause much of a ripple. Then the honors work was displayed in the executive office for a kind of party. The dean, casually looking, saw Lucas's elegant manuscript and took offense. The president was called in and said we acquired university money for embarrassing purposes, offending the taxpayers and the church. There was talk of firing me on the spot and not letting Lucas graduate."

The poems, made of mostly meaningless syllables and words, were a kind of abstract babytalking wasteland of concrete Dada. One is an endless single line splitting the page in half with a repeated "tsiktsiktsik,"

7. Samaras with his father

8. Samaras with his mother and aunt

like the sound made by a disapproving adult to a child. Another one, composed wholly of recognizable words, is a page containing a large and centered square made out of the word "fuck" neatly printed over and over hundreds of times, with a "you" at the end.

Because of the incident Kaprow was forced to leave Rutgers. "I don't think Lucas contributed to it. I encouraged him to do his work, that's all," says Kaprow. Says Samaras: "It was the best thing that could have happened to him."

## NOTES

1 Unpublished manuscript, 1968–70.

2 Unless otherwise indicated, quotations are from interviews by the author with Lucas Samaras during February, 1970, and conversations during the summer of 1970.

3 Samaras, unpublished notes, April, 1964.

4 Quotations are from interviews by the author with Allan Kaprow, George Segal, Robert Whitman, Norman Fruchter, Costa Tsipis, and Barbara Long during 1970.

5 Moonlight on the Bay at Basswood (Robert Lebel, Marcel Duchamp, cat. no. 198).

6 See Box #40 for a recurrence of the shape of the folding glass piece.

7 Samaras feels that the work of Jean Follet was equally important. She made reliefs of rusted metal scraps, keeping within a rectangular format. It is possible to make some distinction between the Hansa group and the artists at Rutgers who, inspired by the desolate New Jersey industrial landscape, were using industrial raw materials such as plaster and plastic, and everyday materials, as well as junk. Among the Rutgers artists were Robert Watts and George Brecht, and later Roy Lichtenstein.

8 Samaras, "A Reconstituted Diary: Greece 1967," Artforum (October, 1968), pp. 54–57.

9 One of Samaras's earliest paintings done at Rutgers, in 1956–57, turned Abstract Expressionist brushwork into a dense tangled texture of scribbled webbing with a dark round target-like center that is vaguely a face.

To put it simply, I make things to seduce myself.
Samaras, unpublished notes, April, 1963

We must become preoccupied with and even dazzled by the space
and objects of our everyday life, either our bodies, clothes,
rooms or, if need be, the vastness of Forty-Second Street.
Not satisfied with the *suggestion* through paint of our other
senses, we shall utilize the specific substances of sight,
sound, movement, people, odors, touch. Objects of every sort
are materials for the new art: paint, chairs, food, electric
and neon lights, smoke, water, old socks, a dog, movies, a
thousand other thing .[1]
Allan Kaprow, "The Legacy of Jackson
Pollock," *Art News*, October, 1958

After graduating from Rutgers in 1959, Samaras re-
turned to live with his parents and younger sister in
West New York, while he studied early medieval and
Impressionist art history with Meyer Schapiro at
Columbia.[2] His *Icons Minus the Deity* were shown in
November at the Reuben Gallery along with the pastels
and oils of flowers and figures from Rutgers. Rather
than show the folding glass piece or the undershirt,
Samaras chose to enter the art world in terms of a
painting tradition.

Shortly before Samaras showed his paintings, Kap-
row extended the concept of his Environments into the
theater as Happenings. Samaras acted in Kaprow's first
Happening at the Reuben Gallery in the fall of 1959, and
was a regular participant in subsequent Happenings,
Whitman's and Oldenburg's as well as Kaprow's.[3] If art
could make use of discarded materials, it could also be
discarded. Impermanence was inherent in these crude
and lyrical theater pieces done by artists and related to
Abstract Expressionism—its sense of performance and
risk—as well as to junk sculpture, to collage, to the
classic film comedies. Performance became the execu-
tion of simple repetitive actions, words were used as
pure sound, plot was replaced by juxtaposition. Per-
formers and objects were interchangeable, and the
spectator was made an element in the work.

" 'Happenings' refers to the attitude toward the ma-

**premonitions**

9

10

11

terial rather than the method. It's the voyeurism of phenomena," explains Oldenburg. "Lucas was the perfect performer actually for these things. Whatever he did he did very slowly, obsessively, calculatedly. How did I use him? How did he use himself? He developed a certain attitude and a certain set of approaches that I could work around. I knew there were certain things I could do with him. I could set him onto obsessional activity. Like buttering bread. In one of my Happenings he butters hundreds of slices of bread. It was a methodical approach to an absurd activity. I would supply him with the props but after a while I knew what props to give him. If I had given him something he didn't want he wouldn't take it. When I started doing these performances I wasn't too clear about what I wanted them to be. Lucas sort of defined them for me."[4]

He had acted at Rutgers. Norman Fruchter recalls: "The last two years he talked a lot about acting and making movies. He liked horror films, Bela Lugosi. He did a lot of theater. The theater company was into a mixture of classics and lush modern stuff—Giraudoux, Anouilh, Ionesco, Beckett. I think they did *The Chairs* and *The Lesson*; I remember Lucas as the Professor. He could get away with the kind of theatricality that was needed; he could also do comedy. What he carried was the air of distance he had anyway plus an ease for the kind of gestures—he could satirize gesture meaningfully. There's an Anouilh play in which there's a double, two brothers. Lucas played both characters. Both he and the audience got an immense amount of glee out of it."

Samaras views his acting in the Happenings, and also his posing for several of Segal's plaster figures, as a kind of offering—letting his live body be used as a medium by other artists. He never did a Happening of his own, though his notes and sketches contain brief ideas for them. The stories that he began writing—"Shitman," "Killman," "Dickman"—took the place of Happenings for him. They also anticipated his art—its qualities, themes, even specific images.

The stories are about elementary body functions. Each proceeds from a single word, preferably a forbid-

9. Samaras in
   Claes Oldenburg Happening:
   *Store Days.* 1962

10. Samaras in
    Claes Oldenburg Happening:
    *Fotodeath.* 1961

11. Samaras in
    Claes Oldenburg Happening:
    *Store Days.* 1962

den one, but they go beyond the "fuck" poem, they go beyond the word to the idea and its personifications and to the dreamlike fantasies, taboos, and narrative possibilities that emerge out of the word, surrounding it with irrational terrors and transformations.

The stories read like a contemporary comic-book version of Dante's *Inferno*, or a profane Lives of the Saints, recounting the miracles and martyrdoms that his heroes perform and undergo while apocalyptically pursuing their oral-anal-genital odysseys of eating, excreting, and copulating. As in the Happenings, basic actions emit an excess of irrational violence and eroticism, becoming both threatening and comic. There is the same involvement with displacing ordinary things, objects, scraps, bodies, and setting them into a new structure with a dreamlike suspension of logic. But Samaras carried the astonishing fantasy life of his improbable characters to extremes not possible in an actual Happening. He did not have to compromise with the limitations of physical reality. The Happenings attacked the spectator, bombarding him with images and sounds, threatening him, splattering him with paint, pushing him, forcing him to be wary. Samaras's stories did the same, but the bombardment was verbal and absolute.

In his small bedroom at home during the fall of 1959, besides writing the first of his stories, Samaras was making little figures of plaster and twisted rags,[5] like the ghosts of Tanagra figurines. The figures are doll-size, and like rag dolls they are floppy, sprawling, full of gesture, movement, humor. Crude. Rough. Expressive. And sometimes comically erotic in their exploration of the abstract possibilities of two human forms combined. Double figures are stuck together like Siamese twins, sharing backs, legs, fronts, or heads, mirroring each other and becoming extensions of each other, pliable as dough—hinting at mirror imagery in advance of his use of actual mirror, hinting at edibility before his food pieces. Sometimes the cloth pattern shows through the milk-white plaster.

These little figures are like the characters in his stories, and one was actually an illustration of a bizarre erotic episode in his first story, "Pythia," in which Pythia "climbs to the top of the dumbfounded threeleggedman opens her bottom mouth real wide revealing her pink flesh parts inside and plops right onto the head of the threeleggedman."[6] Another was a phallic hot dog painted Day-Glo red and clutched between two rag and plaster hands. Included in a group show at the Reuben Gallery in January, 1960, the small plaster figures sprawled around a low platform in the middle of the gallery; one climbing figure was suspended above the platform.[7]

During the late spring and summer of 1960 Samaras made his first boxes. Small, crude, wooden, they are stuffed with plastered rags or crepe paper pinched into the rough image of a face, sometimes with stray feathers from an old pillow emerging like eyelashes and teeth. "I was using things that were partly ruined or about to be thrown away. I think I was interested in the idea that when something became useless I could rescue it and give it a dignity it never had," he says; his impulse was close to that of Schwitters.

The form of the box was also a way of three-dimensionalizing a rectangle. The thick paint of the mud Icons became the thicker plaster as strips of rag replaced brushstrokes. Among Samaras's pastels from Rutgers are faces that fill the page to become rectangles, faces that are geometric shapes. And among his mementos of the past is a tiny pencil sketch that he did in high school: it is of a warped box.

He turned a cube's front into a plaster face, wrapped its sides with string, or bandaged them with cloth strips. He propped boxes open with spooky plaster faces; he balanced one on its hinges, booklike, and gagged it with plastered cloth. Unable to open or to close, they are fixed yet potentially explosive containers.

Except for one. The only one that can actually open and close is the box in which he used mirror for the first time. Open and standing on its side, one half is filled with plastered rags roughly formed into the barely discernible image of a face. The other half is a mirror dotted with tacks glued on and pointing out. Look in-

side and the mirror reflects your face, gives back your image; it is an alternate to the plaster face, with the added threat of the tacks. The tacks make it clear that the face is a target, and warn that the image is dangerous and protected—the mirror cannot be approached. And when the plain dark wood box is closed, the mirror secretly reflects and aims its tacks at the plaster face, the substitute.

At Rutgers Samaras had used a small portable mirror for painting himself. In 1960, when he made the first mirror box, taking the actual mirror and putting it into the work of art was not yet quite acceptable.[8] Even less acceptable was the idea of having the boxes made by a carpenter, as some of them were.

"What sort of pact did I make with mirrors? What picture did I see when somebody yelled my name? I must have seen my face."[9] An early Samaras box is a package and a face, hiding and revealing its contents, often small enough to be held in the hand like a mirror, reflecting himself. It might also be an image of his father, who went away to America when Samaras was three years old and did not return to Greece until he was ten. "Yes, I think I am still waiting for him to come in the form of a letter, a package, a party, an explosion, an icon, a natural event. When I make art I am making a father," he writes in his "Autobiographic Preserves."

And it is a ghostly image. "I grew up with the Chapel of Saint George across the street, with the waxy icons, boxes with bones, smell of incense and old people, darkness and heavy oppressive eternity,"[10] he has written. Samaras's cousin Tom Kremes says: "In our home town there were seventy-two churches. Ten thousand people and seventy-two churches. It was the custom to dig up the dead after three years, and their bones were put in wood boxes painted black and stacked against the walls of the church."[11] He and Samaras used to play hide-and-seek among the reliquaries in the churches in Kastoria, peeking into the frightening boxes of bones. They also played with bullets. "Bullets were everywhere. We threw them in bonfires and watched them explode," he says.

Other plaster pieces, not encased in boxes, appeared

12. *Untitled.* 1959. Pastel, 12 × 9″. Private collection, New Jersey

13. *Untitled.* c. 1954. Pencil, 3 × 4½″. Collection the artist

during the summer of 1960, while Samaras was using the closed Reuben Gallery as a studio. Much larger than the plaster figurines, they are even more like ghosts or mummies, shrouded, bandaged, white. A large sausage shape, phallic like the hot dog, had a face at one end.[12] A rough half-figure with an extended arm has an extra head instead of a hand, held up like a mirror to its face and doubling the image.

Suggestions of mirror imagery recur throughout 1960. Not only are faces mirrored in boxes and in hands, but in his pastels double faces merge, kiss, share a nose, eat each other's ears, or reflect as opposites. Single faces have double mouths or noses, or mouths for eyes, or they are covered with dots and circles. Other pastels are pages of blending color covered with nothing but dots.

At the same time Samaras was making paintings out of irregular ragged pieces of cardboard fitted roughly together like jigsaw puzzles with spaces between the pieces. They fragment the image, break up the rectangle, and let the wall come through. He applied the paint thickly, not in the channeling brushstrokes of the earlier Icons, but as separate raised dots of bright color, stippled with the brush so that the chunks of paint were jewel-like encrustations or sharp tacklike peaks. They were his last oil paintings.

During this pre-Pop period of the Reuben Gallery's existence Samaras was part of a close-knit community of artists that included, among others, Whitman, Kaprow, and Oldenburg,[13] working together downtown, undermining the Abstract Expressionist establishment. De Kooning still reigned, but their allegiance was with Johns and Rauschenberg.

The Reuben group, rejecting the traditional limits of painting within a flat rectangular canvas, were making art out of anything and everything—found, made, bought—objects, garbage, or cheap disposable materials. Rejecting the inviolability of art, their work absorbed the city environment and extended into it. Their art, like their Happenings, was messy and expressionistic, retaining the human imagery of the Hansa group but shedding the nostalgia. There was an exchange between their work that was the give and take of shared thoughts and unspoken common assumptions. If one mentions influence at all, what is significant is the influence of Kaprow's ideas on everyone; Kaprow, who had studied with Hans Hofmann, Meyer Schapiro, and John Cage, was the pivot.

Samaras interpreted the attempt to break out of the rectangle in terms of a physical threat of danger: an assault on the rectangle (the jigsaw-puzzle paintings look as if torn into pieces) and an assault by the rectangle into real space. He interpreted it in terms of a sharp element evenly repeated, multiplying into a spiky surface texture. Peaks of paint, stiff plastered feathers, sharp tacks. His centered square of "fucks" turns into a square of large nails sticking out from a white surface, or as a more menacing alternate, rows of razor blades. Or into centered rag faces within rococo frames that he made of plastered feathers. Like the rest of the Reuben group he used common materials and real objects, but instead of dissolving distinctions between art and life, the odd use Samaras made of these materials acted as armor and weapon in a war against ordinary reality.

The tacks, nails, and razor blades led to his use of other small metallic items of hardware by 1961. Instead of spaced attacks they began to accumulate into surface encrustations that are total coverings. Samaras covered the central square of one of his edible-looking feather frames with an accumulation of nails, screws, nuts, pins, flashlight bulbs, razor blades, and bullets instead of a face. Shown in the Museum of Modern Art's *Assemblage* exhibition, this Byzantine icon was his entrée, as enfant terrible, into the art establishment.

## NOTES

**1** Kaprow's remarks about the new art had antecedents in Italian Futurism, in Cubism, and in Dada. Boccioni in 1912 had written: "The sculptor can use twenty different materials or more in a single work, if the plastic emotion requires it. Here is a little list of that choice of materials: glass, wood, cardboard, cement, concrete, hair, leather, cloth, mirrors, electric lights, etc." Apollinaire

in *The Cubist Painters* in 1913 had stated: "You may paint with whatever material you please, with pipes, postage stamps, postcards or playing cards, candelabra, pieces of oilcloth, collars, painted paper, newspapers." And Kurt Schwitters, who had been using discarded materials since 1919, later wrote: "I could not, in fact, see the reason why old tickets, driftwood, cloakroom tabs, wires and parts of wheels, buttons, and old rubbish found in attics and refuse dumps should not be as suitable a material for painting as the paints made in factories."

2 He had received a Woodrow Wilson Fellowship.

3 Kaprow, Segal, Whitman, and Samaras had all contributed illustrations to the Rutgers literary magazine. The first script for a Happening, "18 Happenings in 6 Parts," had appeared in the magazine in the spring of 1959; the cover of that issue was by Samaras, who was its art editor.

4 Interview by the author with Claes Oldenburg, 1970. Rather than simply buttering bread in the Happening mentioned by Oldenburg, Samaras added strangeness by spreading jam around the crusts like icing on a cake.

5 Samaras says that the impetus to use plaster probably came from Kaprow, who was then making plaster figures, as much as from Segal, who had been using plaster since 1958.

6 Samaras, *Book* (Pace, New York, 1968). Eight of his stories are collected in this volume. Samaras's aunt (the mother of Tom Kremes) collected postcards of oddities. Among them was one of a three-legged man and another of Siamese twins.

7 After the show Samaras destroyed the Pythia piece and threw the Day-Glo hot dog away. It was retrieved by Jim Dine, but its subsequent fate is unknown.

8 Included in the second version of the *New Media—New Forms* show at the Martha Jackson Gallery in the fall of 1960, his mirror box—and the show—attracted John Canaday's disparaging comments in the *New York Times*. In Oldenburg's *Fotodeath*, performed in February, 1961, Samaras entered with a long mirror and, lying down on the floor with it, made love to his own mirror image, like one of his double plaster figures. "I supplied him with a mirror because I saw him looking in a mirror," recalls Oldenburg. In 1961 Samaras made a second version of the mirror box, elaborating on the idea, resulting in a medieval torture chamber rather than a confrontation with the face. Again one side is filled with plaster, but there is no face; the plaster is smooth and concave, as a result, Samaras says, of seeing Edward Higgins's sculpture. The other side, instead of being a single flat mirror surface, is completely lined with mirror dotted with tacks. Pointing down from the top, up from the bottom, and in from the sides as well as the back, the tacks present a more complete threat, a richer texture, a more elusive image as they multiply further by reflection.

9 Samaras, "Autobiographic Preserves," 1968–70, unpublished manuscript.

10 *Ibid.*

11 Interview by the author with Tom Kremes, whose family also came to America and lived in the same apartment building in West New York.

12 It no longer exists. Snapshots taken at the time show Samaras holding it like an infant, and also straddling it.

13 Others in the Reuben group, which was formed in 1959 after Hansa closed, were Jim Dine, Red Grooms, George Brecht, Rosalyn Drexler, and Martha Edelheit. George Segal, Robert Breer, and Al Hansen were also part of the community.

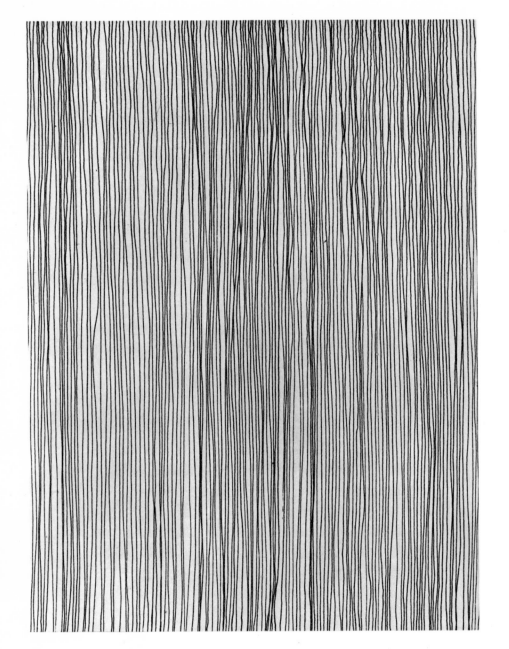

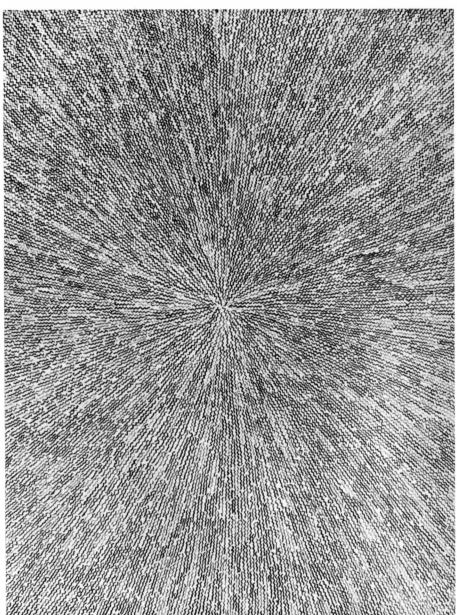

14. *Drawing*. 1959–60. Ink, 11 × 8½″. Collection the artist

15. *Drawing*. 1960–61. Ink, 11 × 8½″. Collection the artist

The increasingly exacting nature of totemic prohibitions in North Australia provides a sort of "culinary" equivalent of the restraints on marriage imposed by a system with eight exogamous sub-sections. Thus some peoples forbid a man, conditionally or absolutely, to eat not only his own totem but also those of his father, his mother, his father's father (or mother's father).

Claude Lévi-Strauss, *The Savage Mind*

Dazzling Killman would place a fat naked dead woman on a cup chair, sit on her and have his dinner with glass spoons and glass forks and glass knives and he would have broiled brains, hair salads, finger stew, people juice, stuffed breasts ferrara, spaghetti and eyeballs, etcetera.

Samaras, "Killman"

Instead of the usual wine at the opening of his show at the Green Gallery in December, 1961, there was a table piled with real food, fruits and nuts, and the spectators ate as they looked at dishes of inedible food and twisted silverware, goblets full of screws and nails covered with intricate drippings, plaster frames of lacy icing, boxes stuffed with meringue faces and bristling mirrors, fine ink lines on thin paper. Delicate, sharp, menacing —pointed things repeated with intricate, infinite loving care and lulling repetition. The procedure of logic applied to the dream, resting on absurdity. Everything looked somehow mute, masked, covered, filled: the feeling of something within carefully hidden. The precision of the sharpshooter permeated the work.

Forks and spoons and food became evil, human, passionate. A tall goblet was filled with pins, glass tubes, tacks, nails, and other hardware, and topped with a long sharp pin. Goblets were broken, mended, reglued, and covered with traceries of liquid aluminum: Samaras gave one a steel-wool shadow, another a spiraling string top. One contained his mother's false teeth; with a twisted fork and a saucer of blackened cotton it became known as *Small Breakfast*. Half a soup bowl, broken, was filled with cotton painted with red nail polish to look like rotting meat and topped with

breakfasts and threats

wedges of broken glass. A plate with epoxied-cotton scrambled eggs turned into a Gorgon face with doll's eyes startlingly embedded in the eggs and a soup-spoon tongue.

The climax of these dreamlike, repelling, and dangerously inedible food pieces was a broken plate splitting open, attacked by twisted forks, spoons, and knives that seem to have burst up and pried it apart. "It was a sort of pie that was breaking apart, and it was plates and spoons, the materials, the containers, becoming the contained, and it had the quality of breaking apart, or opening, like the nursery rhyme about the pie that was served to the king, with blackbirds inside. But this was a little bit more violent," explained Samaras to Alan Solomon in a 1966 interview in *Artforum*.

These food pieces were violent, threatening; they were also fragile, vulnerable, easily destroyed. Destruction was built into them: evidence of past destruction, possibilities of future destruction. The plate filled with forks became art by being broken up and restructured: Samaras was making a Cubist idea literal. And he was three-dimensionalizing painting by making sculpture out of still-life materials. And reacting to Jasper Johns's paintbrush-filled coffee can cast in bronze (shown early in 1961 and as inescapable as the targets) by retaining the original materials. Destructible, and also change-able: the fork pie, when taken to Richard Bellamy at Green, was movable, and could be rearranged. Later it was fixed permanently.[1]

If the food pieces convey forbidden suggestions of Oedipal cannibalism and the irony of the sick jokes popular in the 1950s, two tiny boxes that he made at the same time had an even more immediate shock effect. In them Samaras used cotton to simulate fingers instead of food. Each box contains one realistically flesh-colored cotton finger with a real fingernail—his own. He cut off the long nails of his pinky fingers, cultivated as a remnant of his Greekness.[2] One cotton finger is bent like an elbow, the other is straight and is coupled with a hypodermic needle which can either pierce it or rest next to it. Apart from their contained horrors, these boxes, painted silver, predict the future in their use of materials: one finger lies on a bed of tiny dark feathers, the other on tiny jewels. A third small box was filled with hair—his mother's—and glue.

In the midst of these alluring and repelling images, hanging mutely on the walls of the Green Gallery were some rectangular liquid aluminum wall pieces, each with a spoon, a fork, a razor blade, or a long pin set in its center. Less spectacular, less shocking, more conventional because they hung like paintings, they were generally overlooked except by the people who barely missed being impaled on one of them.

Liquid aluminum is a toothpaste-like substance. Squeezed directly from the tube to cover the surface, the thin wriggles of liquid aluminum replace the Abstract Expressionist brushstroke of the mud Icons; Samaras exploits the gesture inherent in the substance, squeezing out wavy, spiraling, curving stripes whose repeating ropy lines are the most direct and simple form that liquid aluminum can take.

The repeated stripings of liquid aluminum parallel the images in Samaras's pastels of the same time, for in 1961 the ubiquitous faces in his pastels turn into patterns, concealed within and merged with vortexes, targets, and stripes, often submerged entirely as abstract experimentation takes precedence. The central dots, splotches, and X's of the pastels are transformed into the real objects—spoon, pin, fork—at the center of the liquid aluminum pieces. And the real objects themselves are transformed by being bent, twisted, deformed.[3]

Instead of "some reassurance that these things were inanimate things," Samaras evokes from them uneasy suspicions of an animate image in an organic substance. The spoon or the fork becomes a living thing, a body, a face, a hand. It has the mysterious frontality and subtlety of an icon. Trapped like Laocoön in a tangle of gray matter, it is engulfed by the stringy spiderweb of circling lines. Passive or aggressive, it drowns or surfaces, or struggles against a morass of dripped Pollock-like swirls, striking out at Abstract Expressionism with a certain humor. Samaras takes it out of its

identity as a crude kitchen utensil and turns it into an object of fantasy and of fear—the spiky, curling prongs can wound.

One of the wall pieces is curved, deforming the rectangle by warping it out from the wall. Another disorients the rectangle by setting it diagonally, with vertical lines of liquid aluminum that emphasize the deliberate shift. A razor blade cuts its center, and Samaras recalls, as he sits playing with a pencil that has a sharp pin stuck into its eraser, that he saw a cartoon in the late 1950s that made a strong impression on him: it depicted a boy sliding down a banister that ended in a razor blade. Cruelty is at the core of comedy; humor in its simplest form is based on fear and shock and is close to horror.

The liquid aluminum striping of one of the wall pieces is effaced by a covering of Sculpmetal, dabbed on in a rough impasto surface that again is the most direct way of applying that particular substance. The striping shows at the edges, however, remaining as a border or frame and as a memory of something underneath. At the center a long, straight, unbent safety pin sticks out at eye level.[4] Both pin and razor blade are almost invisible at first, unveiling themselves in two moves: first you see the object by its shadow, and then you are confronted by the fact of its sharpness and the shock of its threat.

Not only do these pieces confront their own centers and the spectator's space; like the Happenings, they also attack his traditional invulnerability, making him the target. The function of the spectator is to look, but the pin threatens to blind him, just as the food, if eaten, would pierce or choke him. The anticipation of hurt is part of the imagery; one is made aware of one's eyes, or mouth, or hands because their basic functions are threatened. Using objects like silverware, normally handled, and images of food, normally swallowed, Samaras thwarts instinctive responses. Shock depends on the reversal of expectations.

Samaras also took the rectangle off the wall and set it flat on the floor, a move so ahead of its time in 1961 that no one seems to have noticed it in the show at the Green Gallery. The floor piece is a large square made of

sixteen smaller squares of the dabbed Sculpmetal surface. It is a rough gray impasto rug. Its peaking texture is not unlike the plastered feathers, and its fitted squares recall the jigsaw-puzzle paintings. Vulnerable to being stepped on, it lies flat on the floor except for a slight, almost imperceptible rise toward the center, a slow, curved mound gently threatening to erupt.[5] It is curious as an art historical footnote to the origins of Minimal art. No one has mentioned it as a predecessor, though Donald Judd reviewed the show in *Arts*, favorably concluding: "Samaras' work is messy and improbable, as well as exceptional, and should present a general threat to much current cleanly dullness."

The gray of the liquid aluminum and Sculpmetal pieces relates to Samaras's earlier fascination with silver paint, but though it is metallic, like the hardware and cutlery he was using, it is nonreflective, passively metallic, neutral, with its origins in industry. It is a dark dead gray. Like the earlier mud-colored Icons it effaces color and light, and this mute lack of visibility is what makes one lean closer to look.

The idea of effacing, of wiping out or covering over—in the blind neutrality of the gray, and also in the silverware swallowed up by liquid aluminum or the liquid aluminum covered by Sculpmetal—plays throughout Samaras's work.[6] There is a constant competition between concealing and revealing, between hiding and showing, covering and exposing, opening and closing, folding and unfolding, filling and emptying. In his early work the impulse to conceal usually wins out: effacing is the most extreme form of concealment. Effacing and defacing: the desire to erase, to damage, to deform is always lurking. His work makes use of faults and flaws and denials, just as his stories revolve around imperfections of the psyche.

Samaras himself strikes people as being elusive, aloof, inaccessible. "In the area of verbal vituperation he was extremely agile. Nobody could approach Lucas and say 'Hello, how are you?' His response would be 'Why?' Verbally he's always rejecting things, it's part of his style,"[7] says Martha Edelheit, a painter friend from

16. *Drawing.* 1961. Ink, 11 × 8½″. Collection the artist

17. *Drawing.* 1961. Ink, 11 × 8½″. Collection the artist

Reuben Gallery days, attempting to pin down what George Segal has described as "a streak of meanness running straight through him."[8]

An ink drawing of 1961 consists of the word "love" scribbled repeatedly over a page of writing. There is a certain amount of frustration at the unreadability and the doubling—an impossible desire to know what message is underneath. The scribbled-over writing, like the twisted forks, the cracked goblets, the broken plates, or the straightened safety pin, is something other than meanness. The partial destruction of the objects is somehow necessary to the making of art, a literal extension of the "risks" inherent in the Abstract Expressionist painting process.

The risk of physical destruction and the threat of psychic danger permeate Samaras's work, inspiring a kind of tragicomic fear, terror, and pity. He had early thought about the deliberate destruction of his work: a planned announcement of an exhibition at the Reuben Gallery in 1960 includes an invitation to a burning of the work afterward, "partly honoring Monet."[9] But he rarely played with the idea of total annihilation, except in the realm of theater, where destruction is a natural element. In many of his roles in the Happenings he personified the violence of an irrational force, and in Oldenburg's *Fotodeath* in February 1961, just before he started breaking plates and deforming cutlery, he demolished a chair, smashing it to bits in an instant. But his next deliberate annihilation of an object as an artistic act probably did not occur until 1969, when he methodically destroyed one of his own boxes in another theatrical situation, the film *Self*.[10]

In his art he always rescues the things he damages. Breaking is not actually destroying a thing if visible memories of its image remain, if information about its original state can be retrieved. Breaking is more a way of preserving an object in fantasy by a violent transformation from reality. Samaras's perils and rescues are done with love, to take things out of their original state, to make them art: sacrifices are necessary.[11]

His work insists on the psychological connection between destruction and creation, between love and hate. If art is love sublimated, it is equally hostility rechanneled. Making art, love, or war are all processes of destroying boundaries and scouting forbidden areas. The ambivalent love message of the scribbled ink drawing is echoed in the announcement for his 1961 show: a square of almost unreadable tiny print on silver paper that repeated "I love you" as small as possible. "Like pinpricks," says Samaras. A year later he was making drawings by puncturing the paper with pinholes. Each pinprick was a gesture of love and hurt, like the little pinches that an aunt in Greece would give him to show her love.

"Lucas loves" announces one of his word drawings of 1962, the round snakelike spaghetti lettering of rainbow-color ink washes made by using a piece of cotton as the drawing tool. Others spell out "Lucas is dead," testing a forbidden thought, the impossible idea of contemplating one's own annihilation. One of these word drawings, crumpled as if for the wastebasket, was partly uncrumpled and epoxied, becoming the evidence of its own narrow escape.

## NOTES

1 In 1961 food was subject matter for other artists, too, among them Oldenburg and Daniel Spoerri. A traditional element of still life, food could also be seen as an equivalent for luscious paint or as the material of basic bodily processes, besides being a perishable substance, a disposable object, or a leftover; it thus was appropriate to the new ideas about art.

2 He let the long nail grow back; he has retained his foreignness.

3 Samaras's use of cutlery was not new: Dada abounds with spoons and forks; Segal had attached a real spoon to a painting of a cup in 1958; Rauschenberg's *Bride's Folly* of 1959 has a real fork in the center on a long brushstroke, and a year later another of his

paintings had a real spoon in a real glass. Arman used cutlery in 1961 in a work that was in the *Assemblage* show. But Samaras says these were not his sources—his source was a painting of a dinner by Soutine. Samaras's use of cutlery, even in the relatively conventional and abstract liquid aluminum pieces, had an illogical expressionism that differed from the literalism of his contemporaries' cutlery and from the absurdity of Dada.

4 With no warning of danger, unlike the elaborate precautions taken at Walter De Maria's 1969 show of spikes at Dwan.

5 Or the squares can be rearranged so that the slight rise occurs at the corners.

6 There are drawings that are nothing but blank white pages with thin ink borders. There are pastels of faces with the eyes scratched out or a thin blue line instead of a mouth, and earlier ones in which part of a face or a target was wiped over with a muddy wedge or band.

7 Interview by the author with Martha Edelheit, 1970.

8 That streak of meanness could be equated with the quality of "vindictive craftiness" that was highly prized by the Byzantines (Gervase Mathew, *Byzantine Aesthetics*, The Viking Press, New York, 1963, p. 68).

9 Disposability could be interpreted in terms of destruction. Just as an underlying idea of reduction led to the interest in basic repetitive actions such as eating, and to the use of basic formal repetitions such as striping, the idea of impermanence logically culminated in destruction—itself a reductive process. Ideas of violence and destruction were prevalent about 1960–61, particularly in Happenings but in other art as well, including Tinguely's self-destroying machine and Arman's sliced objects. It was perhaps partly a carry-over from the trauma of Hiroshima on the culture of the 1950s as well as an outgrowth of Abstract Expressionist theory. More immediately, it was a reaction to the cool theater of John Cage, Merce Cunningham, and Paul Taylor.

10 The destruction of much of Samaras's early work was partly accidental, partly a matter of weeding out, and partly Samaras's vengeance for being unrecognized.

11 As Claude Lévi-Strauss points out in *The Savage Mind*: "Every sacrifice implies a solidarity of nature between officiant, god, and the thing sacrificed, whether this is an animal, a plant, or an object which is treated as though it were alive."

He lived in a huge magnetized pin-covered building. Any living thing passing flying crawling near the structure would be zook pinned to the walls. Birds, kites, cats, people, helicopters, embellished the skyscraper.

Samaras, "Killman"

Samaras used to make dinner arrangements using an open *Art News* magazine as the place mat, setting his goblets, forks, and plates on reproductions of Pollock, Still, or Rothko. These early combinations of book and dinner were not permanent. They precede his use of real books. Their irreverence is tempered by the threat of art history: it is like the cannibal eating his enemies—just one ritual bite—not because he is hungry but because he wishes to absorb their power, to take into himself their energies, to exorcise their spirits.

The impermanence of these dinner arrangements and of the movable fork pie is extended in 1962 to a changeability of material. The real kitchen objects which were the material of his work in 1961 were being transformed into fragile crushable tinfoil. One piece was a tinfoil impression of a plate with two tinfoil forks and, to underline the difference between being soft and looking soft, one real twisted fork. The soft and crisply faceted reflective tinfoil surface gave a crumpled look to the objects. Samaras was re-creating the food pieces in an alternate substance, one that was both soft and metallic, like liquid aluminum or silver paint, and shinier than the real objects. He also was making tinfoil impressions of his hand: walking or holding its own curling arm, it substituted for other parts of the body. His use of tinfoil goes back earlier than the Rutgers tinfoil and smoke drawing. Samaras's cousin recalls that in Greece the children used to collect the silver foil from soldiers' cigarette wrappers, shaping it around the thumb and pinching it into little goblets.

The changeability works another way. Things made are later reused, reappearing as parts of other works, in different contexts. In 1962 Samaras was experimenting

pins and pastels

18. *Untitled.* 1963. Tinfoil and spray paint, 11½ × 7 × ½".
Collection Walter Gutman, New York

with putting the earlier food pieces into containers: inside glass domes like the dried brown flower arrangements and stuffed birds that were Victorian parlor motifs. Or inside paper bags. He was covering things, making them untouchable when not invisible.[1]

A large shopping bag, *Paper Bag # 3*, is stacked full with Samaras's early paintings from Rutgers, along with a sheet of scratched mirror.[2] Again there is the frustration of information withheld, of the secret in the package—of not quite being able to see the paintings inside.

The scrambled-egg-face plate of 1961 was used temporarily as part of a place setting on a tablecloth-box perched on the shoulders of a headless manikin's bust. "Like any beginning Surrealist I got hooked on the idea of a manikin," he remarks. He encrusted the sawed-off head of the manikin with cotton, pins, and jewels. The jewels came indirectly from Joseph Cornell: a box with sand and jewels was given to Samaras by Gloria Graves, a disciple of Cornell. According to her: "I gave him an egg with a baby inside, and a box, but he never opened it. He wore flowered shirts with a pinstripe suit and sneakers, and liked to keep cookies in his pocket for people to find."[3] About Cornell Samaras has written: "When I first saw his work I didn't like it but I absorbed it."[4] Like Cornell, Samaras used chunks of mirror and glass like hunks of ice; he put them on glass-covered boxes or inverted domes that contained real goblets and pastel sunset scenes of double mountains that were like breasts or buttocks. Most of these attempts at assimilating Surrealism have been destroyed.

When Pop art was publicized in the spring of 1962, Samaras was unpalatable. He shared similar artistic origins and upbringing, similar premises and attitudes, and the same impulse to extend the implications of Abstract Expressionism into the world, to make real things. But he diverged. Where Oldenburg, Dine, Warhol, and Segal made objects literal, Samaras made substances literal. He shared subject matter and materials—food, hardware, household objects, tools—but for him these were not public consumer objects but private, consumed, consuming material for

"My books have what they contain on the outside," he wrote in 1966 in a letter to Martin Friedman, director of the Walker Art Center, explaining that the sculpturization of the books took place after he decided to give up studying art history.[6] He left Columbia in 1962. "In another sense I was burying their content knowledge, covering it up and substituting a textural vocabulary. They also relate to Byzantine silver Bible covers that have saints and designs. The fact that they are difficult to touch because of the pins reminds me of the fact that certain objects in a Greek church must not be touched by people other than priests."

A taste for the fact that nature is made out of particles, or that art can be made of hammered silver, bits of mosaic, or impressionist flecks of color, is reflected not only in Samaras's pin coverings but in his pastels during 1962. These pastels are built up out of tiny wriggly lines, short touches of different colors occupying the same areas, making a lush vibrating surface not unlike that of the pin coverings. He discovered that by rubbing these with a finger, by playing with the substance, he could make figures look three-dimensional or get effects resembling foliage, water, or reflections. He stresses that the technique was simple: the substance suggested the image. And so his pastels depict a more realistic figure in a more romantic fairy-tale environment—exquisite and enchanted, with intrusions of bizarre fantasy and tinges of nightmare horror. The colors are dense, tapestried, jewel-like.

During these early post-college years there is very little color in his constructed work. With the brief exception of the jigsaw-puzzle paintings, only his pastels have concentrated color.

In 1959–60 his constructions were predominantly white, dipped in plaster. The bits of color that seep in—through the plaster or in the wood—are almost always colors that occur naturally or accidentally in the substances he is using. The black painted wood of some of the boxes only emphasizes the brightness of the white by contrast.

In 1961 the tonality shifts from white to gray: the dull, metallic, light-swallowing gray of liquid aluminum, cutlery, hardware. Again the bits of color that occur are usually inherent in the object—the blue patterning of a plate, the pink gums of the false teeth. He does color cotton to make it meat color, egg color, flesh color, but this coloring serves only as a substitute for the actual thing. When you look at the small finger boxes, their colors are the last thing you notice.

During 1962 the dull metallic gray and the natural color of paper bags and other objects—a blue dart, a nail-polish bottle with traces of red—shifts to the shiny metallic silver of tinfoil and culminates in the glittering silver pins that catch and reflect points of light.

Samaras had always been fascinated with light, with substances that transmit, catch, or reflect light—glass, silver paint, mirror, pins. But the literalness in his use of materials—totally belied by the way he transforms and anthropomorphizes objects into fantasy images—results in an unwillingness to violate the substance's natural properties at the same time that he alters its functions and forms with impunity. And so color does not become an element in his three-dimensional work until early 1963, when he discovers a new substance with inherent color: wool knitting yarn.

From 1959 through 1962 all the color is in his pastels. What excited him about pastel was the pure brightness, the light contained in the color. He particularly liked a glowing electric blue and red together. As a medium, pastel is nothing but dust; it is fast, fragile, and it involves the fingers directly rubbing it. "Like making a soufflé, you have to do it quickly," says Samaras. This was part of its appeal to him, and he liked the idea of working quickly also because "you left no evidence of being an artist, no wet paint; you could fold it up and hide it away." Individually wrapped in wax paper, some of the pastels were kept in a wooden box and shown by Richard Bellamy at the Green Gallery; opening and unfolding were involved in the process of showing them.

Like his stories, the pastels function as a storehouse of ideas. Forms, textures, images—abstract and figurative—contain the germs of future involvements.

They also function as a treasury of color effects. In his constructions color was an almost accidental event, but in the pastels color itself was the material. Blended, mixed, rubbed together to create illusory iridescences and transparencies merging imperceptibly into shimmering veils of elusive color like Thomas Wilfred's *Lumia*, color became space and surface. Or it became imitations of the surfaces of other artists—Renoir, Monet, Pollock, De Kooning—as continuous textures on the page, nothing more than the surface qualities of their color mixtures. Assimilating the past—Vuillard, Bonnard, Matisse, Redon, Van Gogh, Hofmann—they never pretend to be copies. They are already half digested, further evidences of Samaras playing with the past and cannibalizing it.

Color became dots, and it became lines in the patterns of multicolor stripes that are color equivalents to his liquid aluminum stripings. Layered plaids and grids of thin lines interweave like threads in space, or twisting stringy lines are intertwined with each other. All along there are stringlike color images, wiry scratchy lines, braided double lines, fat snaky bands. Along with the rounded rainbow lettering of his ink word drawings, they are all efforts at making the line three-dimensional.

When he discovers the multicolor wool yarn for his constructions, he has found a ready-made pliable three-dimensional line that contains the rich, glowing intensity of color, the regularity and irregularity, the softness and chalkiness of pastels. He stopped making pastels at the same time that he started using the wool yarn.

## NOTES

1 The lineage of his work is complex. For example, *Dinner #0*: a cotton food face from 1961 was used inside a glass dome in March, 1962, along with a cup of cotton coffee with a cloth shadow, also from 1961, a goblet covered by a paper bag with a glass shadow, and an embracing fork and spoon. In August the same cotton food face reappeared inside the first of the small epoxied paper bags. In September the glass dome was covered with tacks, but it did not assume its final form until July, 1963: the coffee cup remains but the bag-covered goblet has been replaced by a stocking-covered one, and other goblets with histories of their own have been added.

2 A silvered painting in the bag had been painted over a nineteenth-century landscape, again covering up the art of the past. The scratched mirror was something Samaras was experi-menting with in 1962 but dropped when he saw H. C. Westermann's mirror-and-glass constructions.

3 Letter from Gloria Graves to the author about Samaras, July 23, 1970.

4 Samaras, "Cornell Size," *Arts* (May, 1967).

5 The box contains a button from his boy scout days, smashed crockery that, he says, had been a pottery replica of a Greek shoe, pheasant feathers brought by an uncle who hunted, and an enigmatic toothless metal comb.

6 In studying early medieval art history, Samaras had been doing research on Byzantine silver dishes, which may relate to his tinfoil dishes. He had also taken courses in Minoan and Mycenaean pottery and in Islamic art, and was thus familiar with Persian miniatures as well as medieval illuminated manuscripts.

First came birds, covered with green sauce, served in red
clay dishes embellished with black designs; then all species of
shell-fish caught on the Punic coast, followed by broths of
barley, wheat and beans; and snails dressed with cumin, on
plates of yellow amber. Later the tables were covered with
every variety of meats: roasted antelopes, with their horns—
peacocks in their plumage—whole sheep cooked in sweet wine—
legs of camels and buffaloes—hedgehogs, with garum sauce—
fried grasshoppers, and preserved dormice. . . . Oblong flames
trembled over the brazen cuirasses; all manner of scintillations
flashed from the dishes encrusted with precious gems. Bowls
bordered with convex mirrors multiplied the reflected images,
enlarging every object so strangely.

Flaubert, *Salammbô*

I'm trying to shift the minor arts into the major arts.

Samaras, self-interview, December, 1963

The appearance of colored wool yarn in his boxes and
Dinners of 1963 is preceded by the use of uncolored
string, which was an early if minor material in
Samaras's work: string wrapped a plaster-filled cube
in 1960, and it filled a goblet with a spiral topping in
1961. At the end of 1962, tangles of string occurred
unobtrusively in some of the books and in the first
pin-covered box, while a cascade of tangling rope
spewed forth from *Box #3*.

But by April of 1963 *Box #6*, also pin-covered, is
crammed full with a tangled mass of red and green wool
knitting yarn and only a few straggles of string. An
almost complete substitution has taken place.

When the wool yarn first appeared, it was used like
string: in one Dinner it stuffed the inside of a goblet, in
another it wrapped a transparent plastic box. By May
the yarn's original identification with string as a wrap-
ping or a tangled filling had become transformed:
glued to the outsides of boxes in rows of stripes, it made
a complete color surface of soft three-dimensional
lines, dispossessing the pins. "I have recently begun
using colored wool string," wrote Samaras on May 24,
1963. "I sometimes let my umbrella scratch along the
sidewalk when I walk. I love string, I love the line, I love
making incisions."

boxes and dinners

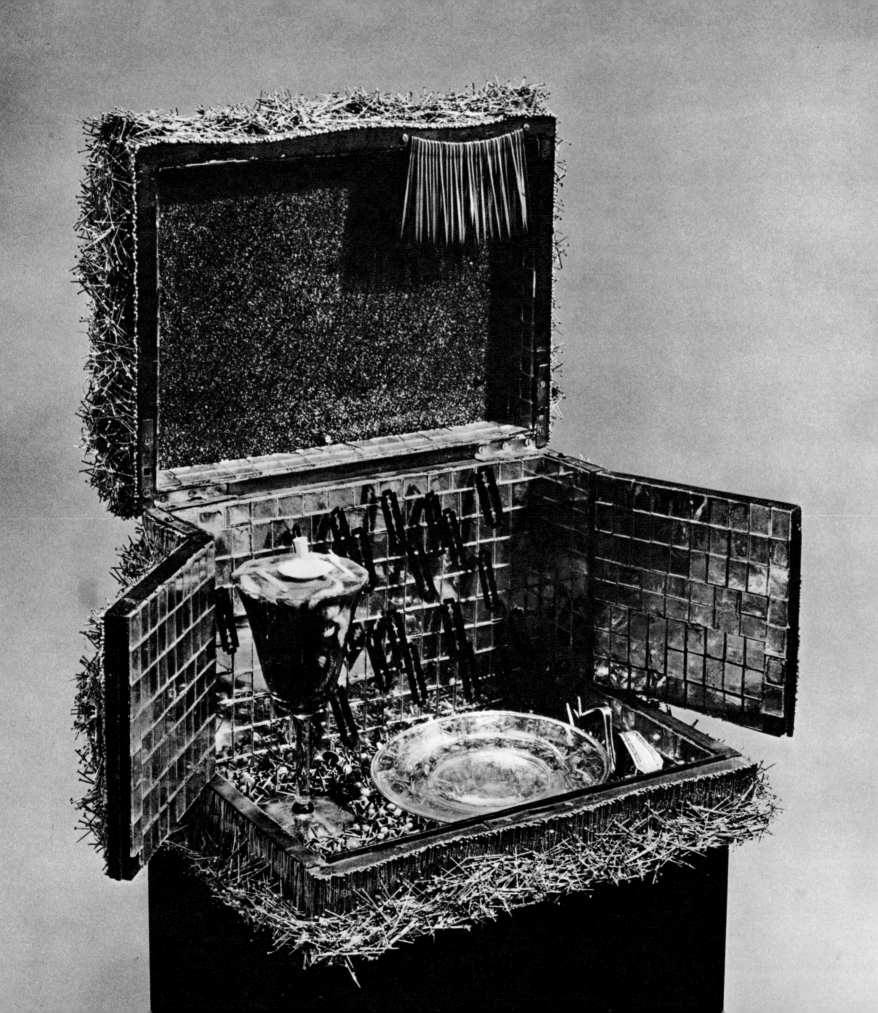

The yarn stripes begin to curve, they follow an edge or a contour, they turn into whirlpools and targets. They replace the stripes of color in his pastels and the repeating line patterning in his inks, and they resemble the stringy stripings of liquid aluminum,[1] with color added.

By July the pins are back, covering the yarn on *Box #11*, stuck into it like darts, dotted evenly and closely over it to make a new rich double texture combining sharpness and softness, glittering silver and lush color, yarn lines and pin dots. The surface of yarn and pins also appears on rectangular wall pieces with the circling yarn making double or quadruple targets of glowing spectrum color and continuing around onto the sides to become its own framing.[2]

The pins, which now point inward, piercing the work of art, nevertheless function in the same way as the tacks on the mirror, in a subtle reversal. The face appears again in a new form, unmistakably referring to himself: besides sticking pins into yarn targets, Samaras begins using a photograph of his own face.[3]

Inside *Box #8* the photograph of his face is repeated four times and stuck with pins that threaten the face as the tacks threatened the mirror image. Straight pieces of wire hang from the pins, an intricate starlike cat's cradle is stretched across them, and a wriggly braid of colored yarn is caught by them, covering the faces as if materializing the artist's role in creation.

An untitled self-portrait box is totally covered on the outside with the repeated photograph of Samaras's face, bristling with an all-over covering of pins like *Box #11*, elaborating on the alternate image. The face, instead of the yarn target, is covered with pins, and, in a curious inversion, the yarn is inside the box.

"I mean do pins mean anything to you?" Samaras asked himself in a self-interview in December, 1963. "Let me find out. (1) When I use them with the flat paintings they create a net pattern which breaks up the flat picture and creates a stranger illusion. (2) Pins are marks, lines, and dots. (3) They are relatives of nails. My father spent some time as a shoemaker. I was raised up by a very religious family. The nailing on the cross. As a child I often played with pins at my aunt's [cousin's]

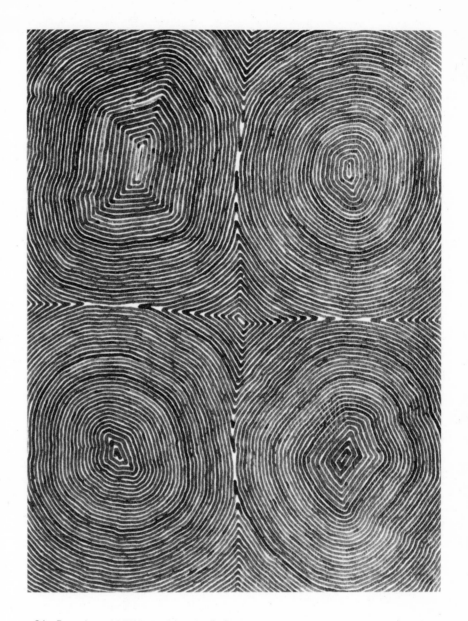

21. *Drawing.* 1962. Ink, 11 × 8½″. Collection the artist

◀ 20. *Dinner #4 Box #4.* 1963. Mixed mediums, 10½ × 14 × 10½″ (closed). Collection Mr. and Mrs. Morton G. Neumann, Chicago

45

dress shop. Nailing pieces of cloth. My father spent many years in the fur business stretching and nailing furs. The pin is to an extent a part of the family. One of my earliest and strongest memories deals with seeing an Indian fakir sitting on a bed of nails in a *World Book Encyclopedia*."

Along with the discovery of yarn and the appearance of color in 1963, the boxes and the Dinners on traylike bases that he made that year have a greater intricacy and elaboration of surfaces. The boxes are mostly found or bought Victorian boxes with curving fronts, swiveling drawers, drop shelves, tilted tops. Less is hidden and more is revealed as the boxes begin to demand to be touched, to be opened and closed.

What is revealed appears at first glance to be surface decoration in a spirit of absurdity, but it is really an obsessive, intensely private, almost hallucinatory covering of things with repetitions and accumulations of many tiny objects and details. Like the pastels of 1962, every surface is covered with texture, richness, pattern, color. Inside the boxes a wide variety of objects become alternates for the pin-covered and yarn-covered exterior surfaces: nests of ball bearings, pebbles, marbles, brass springs, Duco cement caps, small glass lenses, tiny oval mirrors and square mirror panes become linings. Before the pin-covered books, the Reuben group squalor and morbidity were factors in his art; after them, whatever substances Samaras uses become exquisite, fantastic, macabre, magically transformed and preserved. Hard-edge cleanliness was entering the art world.

In 1962 Samaras had imagined a box totally covered on the outside with stuffed birds, but he could not find enough birds actually to make it. A stuffed bird is among the objects that crammed the first pin-covered box at the end of 1962, and *Box #3* is a nest of pins sheltering a bird. In 1963 *Box #8* opens to reveal, along with the photographs and pins, a stiffly formal stuffed bird standing on icy glass lenses. "Dream, passing by a pond with birds like pigeons on the water and then the water froze and the pigeons froze elegantly also," Samaras had recorded on January 26, 1963.

But the connection of the bird with the glittering box may be traced back to 1959, to Samaras's story "Pythia," in which one of the characters is a three-legged peacock: ". . . well the bird came upon a diamond box the lid open. It was infinitely small like a speck of dirt which isn't. As a matter of fact she almost overlooked it was like the dust that went into her ntiple eyes. Well she stood before it dazzled and a longing overcame her she wanted to get into the diamond box. So she prayed for forty nights and then lusted for another infinity and then she took her double she was carrying and stuffed her into the box."

The use of the small elegant bird could be a comment on Rauschenberg's awkward stuffed eagle and chicken, a reference to Cornell or to Miró's *Objet Poétique* with a parrot that he had seen in the *Assemblage* show, or an elaboration on his own early use of feathers. The bird is also an image that evokes for Samaras childhood memories of swallows building hard-mud nests under the balconies, of bright-colored birds in cages on the porches, of storks nesting in the chimneys of old houses in Kastoria, and more menacing memories of myths about harpies and abductions by eagles. Everything has multiple contradictory meanings and associations. The bird had the capacity to make a house, it could go away and come back; and so, like boxes, birds became a kind of symbol of his father in America. They were also a symbol of himself and the helplessness of childhood. "I hated the idea of a bird being in a cage. I was in a cage."

"A box is a mouth certainly," Samaras noted on May 25, 1963, while making the boxes and Dinners. In the same entry he wrote: "Having been brought up as a Christian, the Last Supper is of some importance, symbolic cannibalism of the most beautiful creature in existence."

Samaras's Dinners substitute a whole range of elegant inedible alternates for his cotton foods of 1961. Between the 1961 food pieces, which in their messiness and kitchen-like informality can be thought of as

"breakfasts," and the elegance and formality of the 1963 Dinners, Samaras, who had been studying acting with Stella Adler, had acted in Oldenburg's Ray Gun Theater Happenings in the spring of 1962, and many of his actions had involved food or eating.[4]

But the precious objects that are the Dinners have little to do with Happenings. Besides their oral imagery and hints of the Last Supper, they have suggestions of the bedroom and dressing table. Candy jars or cosmetic jars replace plates; like Mars and Venus, a fork and spoon are caught embracing in a needle trap. Goblets give birth to miniature goblets or contain epoxy tilted like liquid magically come alive and defying gravity. The danger becomes less that of direct assault and more a danger of seduction, as visual enticement, bizarre and elegant formality, and rarefied extravagance enter Samaras's work. As an alternate to the cannibalistic dinners of Killman, he also wrote in 1963 the story of Flowerman, who never ate. "The scratching forks, clanking plates, the tsing of the glasses chewed food laughter noise words . . . were his food."

Another early memory is like a visual echo of the boxes and Dinners. In the house of relatives in Kastoria (with whom he lived briefly when his own house was occupied by soldiers) was a room that Samaras loved. It had hand-painted landscape scenes on all four walls, each within a wide painted border filled with patterning. The ceiling, too, was completely painted with elaborate designs. It was a room used for entertaining and for dining on festive occasions.

## NOTES

**1** Some drawings that he did in 1963 are wet-looking dribbles and spirals of raised three-dimensional lines of liquid solder on black paper or translucent liquid epoxy on white paper.

**2** Samaras's double target shifts strangely, from one side where the target is a spinning spiral whirlpool to the other, where it is a glowing, expanding white-hot ball—his repetitions always involve alternates. It also resembles a pair of eyeglasses.

**3** In *Dinner #5* an oval mirror substitutes for a face; in *Dinner #8* the photograph of Samaras's face peeks from under a crystal cube, chopped with Cubistic distortion. The lid of *Box #10* lifts to reveal two oval half-faces: the yarn striping around them makes one a peephole, the other a target.

**4** He sliced up a telephone book like a ham, with the fierce, expressionless concentration of Buster Keaton, totally involved in a dialogue between his body and the objects. He set a small round table with silverware, multiplying the place settings until the table was tightly ringed with spoons, forks, and knives, and then tipped everything onto the floor. And he was the waiter in a slow-motion dinner scene in which all the participants had masked their faces in tinfoil. This use of tinfoil by Oldenburg may have derived from Samaras's use of tinfoil impressions of his hands and face. Or vice versa. The imagery of this dinner scene also relates to Segal's sculpture of the dinner table. Such comments on each other's work were common at this time.

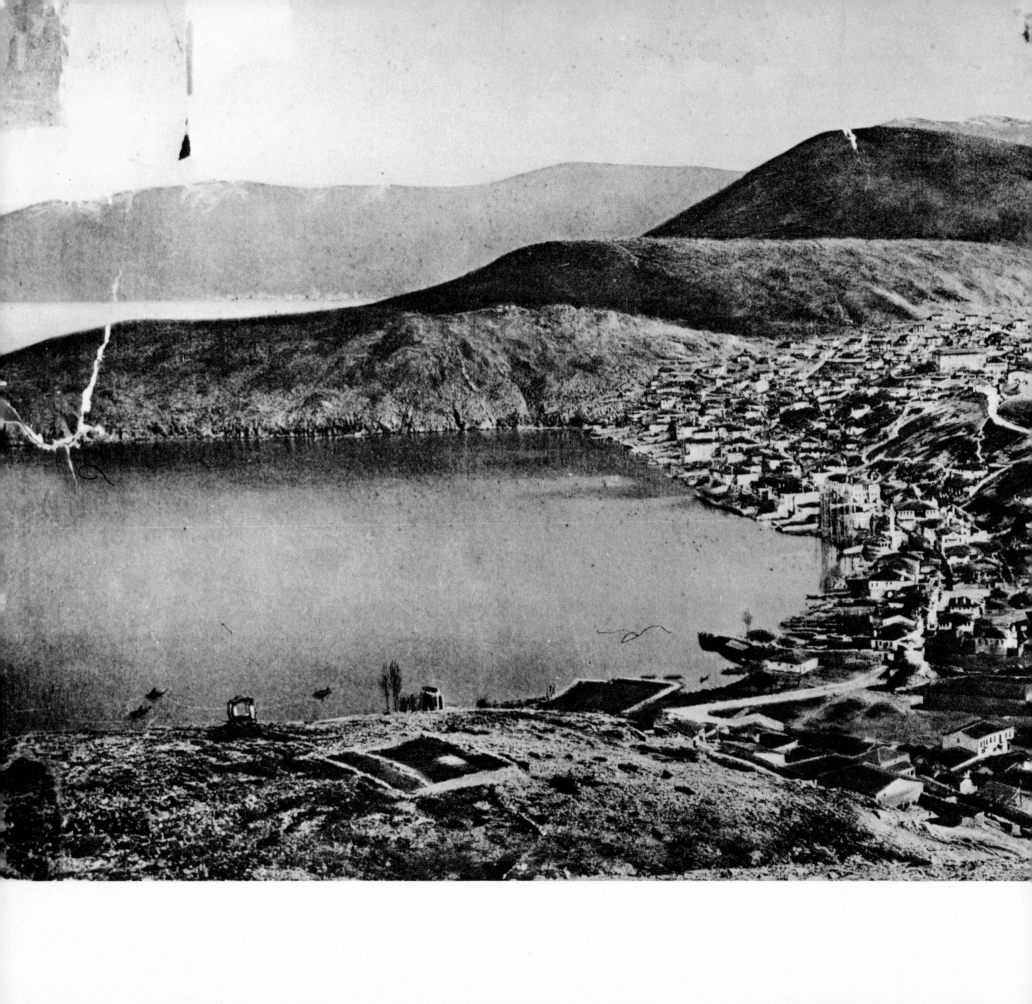

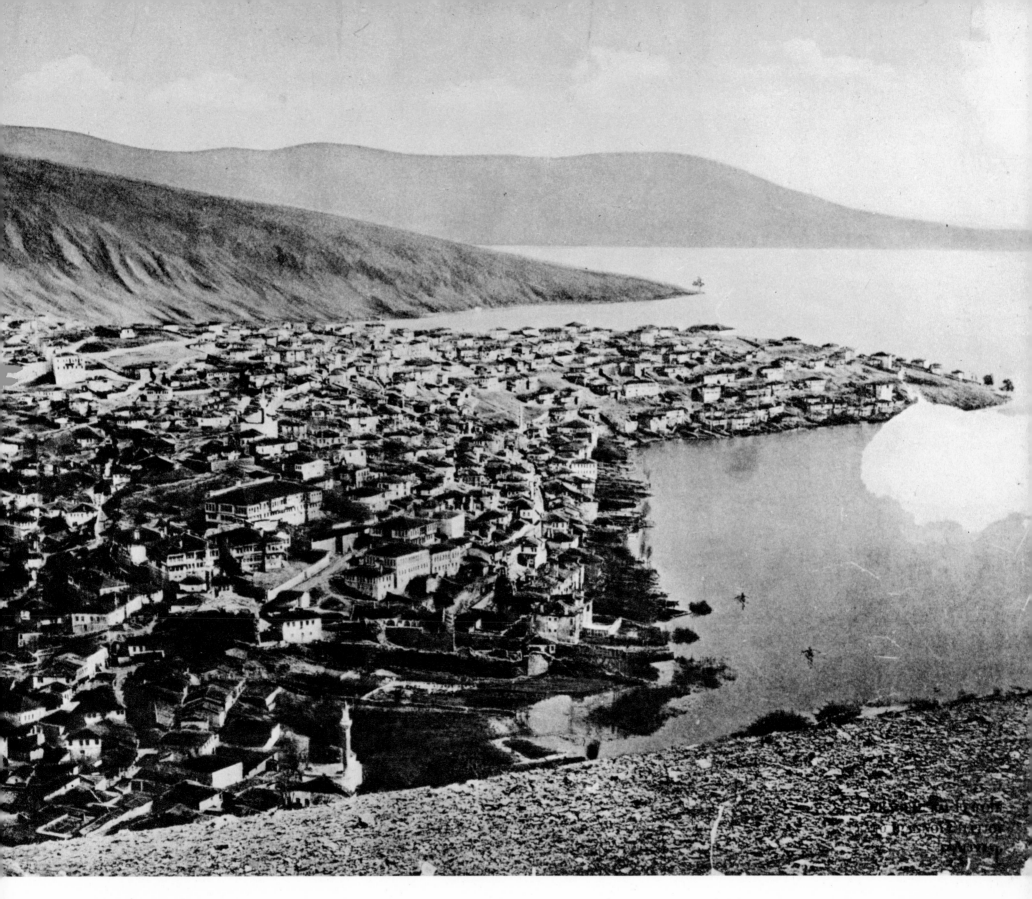

22. Kastoria, Greece

23. Samaras family,
Lucas on mother's shoulders.
c. 1937–38

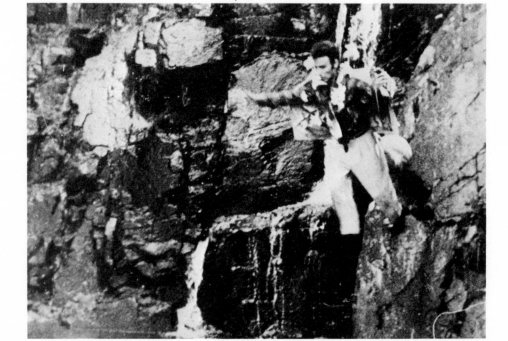

24. Samaras in Claes Oldenburg
and Robert Breer Film:
*Pat's Birthday.* 1962

The town was built on the lowest of three hills
surrounded on three sides by a fertile deep lake that managed
to gobble up at least one person every year. Two of my
distant cousins fell through the winter ice and drowned.
What was frightening and undismissable about the drowning,
besides the suffocation, was the description of their bodies
being bloated with seaweeds and little fish and water.

Samaras, "Autobiographic Preserves"

The passion for transparencies is one of the most
spectacular features of our time.

Moholy-Nagy, *Vision in Motion*

In 1964 Samaras used himself in different ways in his boxes, exposing not his face but photographs of his home town, Kastoria, the tinfoil casts of his hands and feet that he had been making since 1962 (now lined with plaster and sprayed with color), and his name—the word he identifies with his face. "I'd never had the experience before of knowing anyone who was so totally autotelic, self-engendered," says Richard Bellamy. "That kind of narcissism that being so extreme and so conscious becomes something else. He's turned all of what might be termed neuroticisms in his behavior to such conscious perfection that it's something quite other than bizarreness. He has made a consistent fabric of his personality; it's quite seamless." Samaras made a series of five watery-looking boxes in 1964, each containing one letter of his name, $L$, $U$, $C$, $A$, and $S$, another way of making a signature.[1]

The scale of these boxes is larger; they are made rather than bought, with curved or triangular backs and plain exteriors. They are very much like miniature stages or rooms. They have glass fronts like aquariums and shiny mirroring Mylar linings that create an underwater imagery of distorting disorienting reflections, turning a flat jewel-covered floor into a stretching hilly sea-bottom terrain, merging real things indistinguishably with their reflections, creating illusory expanses of watery space with Surrealist overtones. The objects that suffer this sea change—eyeballs, ears, plastic let-

ters, fingers, and limp drowned forks—are suspended from wire, string, or coiled cord as if from fishhooks. The parts of the body and the letters of Samaras's name become the bait.

In box C the reflecting Mylar that doubles the objects deceptively changes their color so that a transparent glass full of shards becomes blue and a pinkish tinfoil foot turns orange, while the back corner of the triangular box dissolves as blue and yellow Mylar reflect each other, merging into green. The C lies on a bed of pins like the Indian fakir Samaras remembers from the childhood encyclopedia, as if proclaiming the artist's role as sacred magician, defying the laws of nature with illusions that trick the eye—but the box is turned into a cage by a regular grid of doubled red and blue wool yarn stretched across its glass front.

In the C box the Mylar duplicates the objects. In the S box, which has no reflecting Mylar, the real things that are suspended duplicate and echo themselves—things are paired, multiple, or opposite. An epoxy icicle and a cluster of plastic fishes allude to water in the S Box, which is bisected diagonally from front to back by a blocked staircase with steps covered in transparent green and orange plastic. The association of the staircase with water occurred in Samaras's unpublished "Addenda to Dickman," written in 1962. "Dickman waited a long time. He took a handful of water from the lake and drank it. When he took the water he noticed concrete steps under the water leading downward, disappearing in depth." This image later appears more explicitly in a sketch for a sculpture for Central Park.

The LUCAS boxes look as if they are filled with water; epoxy raindrops or tears drip down the front of one. Box # 22 actually contained a glass of water in which a whirlpool effect was created by a magnetic stirrer that Samaras found while searching for a liquid with an oil-slick surface in a chemistry laboratory.[2] Seen from its one glass side, the box contains just a glass of whirling water on a pedestal and a hanging plastic knife, backed by disorienting red and green reflecting Mylar. But seen from another side through a series of small receding hinged doors that open one after another, like Tutankhamen's coffer, the spiraling whirlpool is disclosed like an Orphic secret, like an initiatory revelation, suddenly almost obscene. The vortex images of his pastels are made actual in a spinning phallic shape of water, with connotations of a flushing toilet.

The color that had appeared in Samaras's constructions with the wool yarn is transformed in 1964 into transparent immaterial color with his discovery of plastic: bendable mirroring Mylar and transparent colored plastic. Color becomes something elusive, shifting, fluid and luminous, the effect he was seeking in his Rutgers paintings on glass and in his pastels: it becomes literally a transparent veil of light.

In the LUCAS boxes the letters of his name are made of the transparent colored plastic. In May he began making small transparent plastic cubes and other simple shapes with each side a different color. He made them throughout the summer, using the Green Gallery as a studio. The shapes are like linear outlines—turning the three-dimensional line of the yarn into a four-sided cubic line of plastic.

The cubes split, separating into interlocking parts like Chinese box puzzles. They can be rearranged, moved, taken apart, always revealing unexpected shapes and colors as shape is confounded by color. They are meant to be held in the hand, picked up: part of their magic is their weightlessness, their immateriality, their fragility. Their edges are hardly visible; with a slight shift in position there is an immediate shift in their colors and in the diaphanous color shadows that they throw.

Playing with the internal structurings of the cube, the shapes that can combine to make a cube, Samaras splits them apart in systems of blocks and diagonals; corners, steps, tiers, pyramids result as cubes are quartered, sliced, or bisected in different ways. Some have black or silver parts, combining transparency with reflectiveness. Some do not split apart but have internal twisting intestinal tunnels instead. A skeleton of a cube

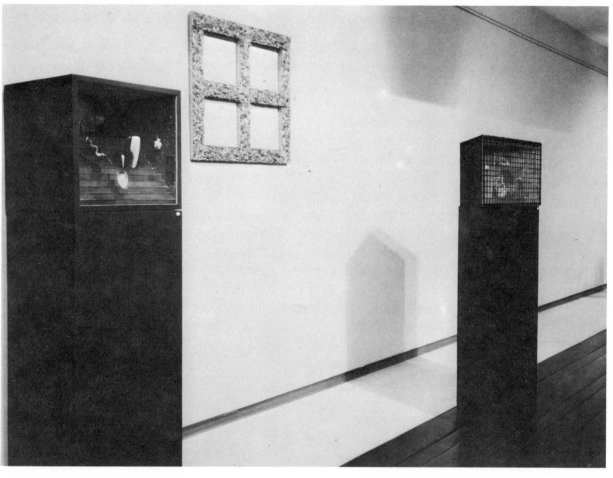

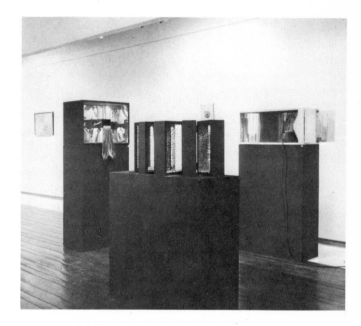

25–27. Installation of exhibition at Dwan Gallery,
Los Angeles. 1964–65

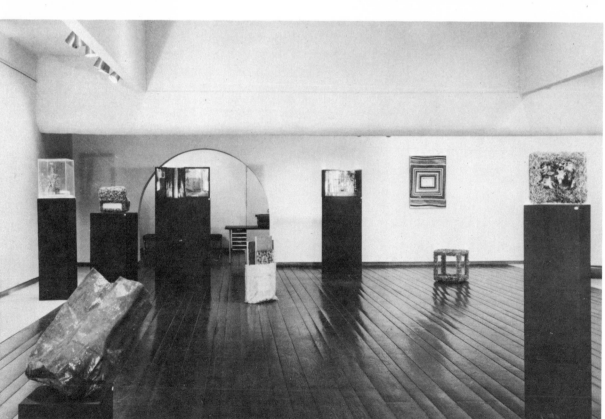

leads to partial cube skeletons as he plays with eliminating different edges until nothing is left but a single corner.

His interest in the structure of the rectangle, which he had restated at the beginning of 1964 in some pin-and-yarn frames that were skeletons of squares bisected by a diagonal or quartered by a cross, becomes spatialized and three-dimensionalized into an interest in the cube, and in taking the cube apart. The plastic cubes raise the problem of the floor piece again: they seem to have some relation to Minimal art, which was just about to emerge, and to Op art. Samaras seems to sense the questions and quickly to exhaust a range of possible answers—in three months, with a fragile material, on a small scale he anticipates the next step. Like an amateur explorer on an unofficial expedition, he brings back scraps of evidence for his own use, not official documents. He thinks of them as "sculptural drawings."

For the amateur explorer the discovery of forms is never quite an end in itself; recollection and anticipation play a part, extraneous subjective elements enter, formal logic is never enough. "I'm always playing with L's and S's," Samaras remarked while showing me the plastic shapes, lifting a corner from a cube to leave an L shape that splits into smaller L's. He finds references to himself everywhere, even in his own purely formal speculations. In an interview in 1968 he said to Paul Cummings: "I see this place in history called Samarra and it has the same name as I have. So somehow that relates it to me. It is as if it is mine. And there is this spiral tower and I have been for a long time using this form, this spiral form. And again there's another connection with the past—it's as if it is mine; the tower is my tower."

## NOTES

1 A 1960 pastel filled the page with the letters *ME*; some of the colored-ink word drawings of 1962 spelled out only *LUCAS*, and *LUCAS* was written in rainbow colors across a large drawing of a mountain in 1963. Also in 1963, the letter *L* lay in a drawer in *Box #10*.

2 The search for an oil-slick liquid recalls a description in "Killman" of the setting for Killman's dinners, written the previous year: "On the second floor was the dining room. The room was full of water up to the waist. There was a glass table just a bit over the water. Whenever there were ripples some water did manage to go over the table. On top of the water was a mixture of oilgasoline that constantly changed spectrum colors." In 1969, in the film *Self*, a tabletop of iridescent Mylar in Samaras's kitchen substituted for an oil slick.

room

Up to 1964 Samaras was still living in the small apartment in West New York with his parents and sister. It had a cramped, overstuffed, dense quality, a taste for floral linoleum, patterned wallpaper, Turkish carpets, that was the equivalent of luxury among immigrant families. As Martha Edelheit has said: "There was a strong feeling of familiar strangeness."

His sister, Carol, who was a child at the time, remembers his tiny, cluttered room as a mysterious place with a fascination about it; the door was always closed or half closed. She used to sneak into the room with young cousins when Samaras was not there, and says it had the effect of a "holy place, sort of scary, full of surprises, and full of things you weren't supposed to touch —knives, needles, beads, hair." It had a nice smell of glue, paint on the sheets, and if you moved anything, there would always be something else behind it or under it, she says, recalling that the cousins never touched anything because they were too scared. She also remembers how her brother cajoled her into giving him her doll's eyes for the scrambled-egg plate.[1]

In June his parents and sister moved back to Greece, and Samaras moved across the Hudson River to an apartment in New York City. As his bedroom in West New York was disassembled he moved its contents into the Green Gallery, where he re-created it inside a room that had been built within the gallery space; it was a process similar to the breaking up and reassembling of the plate with cutlery.

The room at the Green Gallery had the same propor-

28, 29. Two drawings of *Bedroom*. 1962. Ink, each 11 × 8½″. Collection the artist

tions, the same yellow ocher walls, the same orientation of the furniture, and the same feeling as his room at home, but it was not a reproduction; it was a re-creation, a transformation accomplished with "no transformation or violation of the objects."[2] "Basically it was the same room," says Bob Whitman. "He did what any good archaeologist would do when he's re-creating the tomb of some Egyptian king—he fixed it up."

"Room. It is a bedroom, a workroom, a storeroom. It has a door. It is real in that it has real things and you can walk in, poke around, sit down and make love. It is presented as art. Things don't have to be glued down. Relationships are not fixed but fluid. It is not a ready-made although it has ready-made clothes and books. It is not a reproduction of another room that once existed for me. The other room was the sketch, the germ, the idea. This room is the reality, the presentation, the art," wrote Samaras in his notes on October 16, the week it was dismantled at the gallery.

The artist's room, re-created as a work of art, is cluttered with past work, unfinished work, and raw ingredients—pins, glue, hair, paper bags, shopping bags, and plastic bags full of yarn the way *Paper Bag #3* had been filled with paintings. The whole room is like an amplification of the idea of *Paper Bag #3* or of the pinless book: it is a container of everything up to that point. Of his art and his life. The past sticks to it, visibly and invisibly. Stacks of books, photographs, letters, darts stuck into the wall, clothes, a bed. A long piece of string hangs from the light bulb like a central axis splitting the space. An early self-portrait presides at the head of the bed. The radio is on.

The Room is a self-portrait, an autobiography, a history containing everything but his body. In the 1966 interview by Alan Solomon, Samaras said: "And I guess I wanted to do the most personal thing that any artist could do, which is, do a room that would have all the things that the artist lives with, you know, clothes, underwear, artworks in progress. I had books that I had read, or that I was reading. I had my writing, or my autobiographical notes. It was as complete a picture of me without my physical presence as there could possibly be."

Samaras, exposing his room, turned the spectator into an accomplice, a Peeping Tom spying on him in his absence. The radio aroused expectations of his imminent return. For Samaras the Room was realistic; for the spectator its contents were bizarre and private, things that should not be exposed. Though the spectator had been invited to spy, the menace of his own surreptitious forbidden curiosity replaced physical menace; the assault became interiorized.

The Room was a total enveloping environment with the spectator inside, derived from Pollock space made literal by way of Kaprow. If Kaprow's Environments—and Schwitters's *Merzbau*—made the Room possible, the period rooms at the Metropolitan Museum were for Samaras already-existing evidence of a complete sculptural and architectural environment which could become a work of art in a single style. "These rooms gave me permission to be able to do a complete environment you enter into with no externals, no gallery walls."

The Room also derives from Van Gogh's bedroom and Matisse's red room, and from Brancusi's studio that had recently been installed in the Musée d'Art Moderne in Paris.[3] Samaras was making a monument for himself in the same spirit that he had announced, "Lucas is dead," paying homage to himself in advance, acknowledging pretensions and desires for immortality—parodying Great Art and proclaiming that he was an artist.

The Room was an answer to other rooms that had come out of Kaprow's Environments—to Oldenburg's neo-modern *Bedroom Ensemble* shown at Janis earlier that year, and to Segal's use of isolated furniture in his dining room without walls. If Oldenburg turned Pollock into a fabric pattern, Samaras referred to him with tangled yarn and hair.[4] It summed up the ending of the scavenger era in the art world when treasure could be found in thrift shops, in the gutter, and in the garbage.

## NOTES

**1** Interview by the author with Carol Samaras, 1970.

**2** Jill Johnston, "Reviews and Previews," *Art News* (September, 1964), p.10.

**3** Alan Solomon, "Conversation with Lucas Samaras," *Artforum* (October, 1966), pp. 39—44.

**4** Samaras had hoped to cover the gallery floor with jewels for the exhibition, but this plan was deemed impractical. Shown in September, 1964, along with the boxes and plastic shapes and cubes, the Room—which from the outside was just another gallery wall—caused titillation, shock, and misunderstanding. Its statement was not taken quite seriously. It was called a Ready-made or compared with Kienholz. But it was not an *objet trouvé*, the connection with Duchamp was tenuous; it had more to do with his *Box in a Valise* done, as Richard Hamilton has written, "with the objective of producing a portable museum, a life's work in a valise," than with Ready-mades. The connection with Kienholz was irrelevant, and Samaras says he had not seen Roxy's in 1963. Russell Baker, the *New York Times* humorist, had not seen the Room but thought it an outrageous joke and wrote an article about it. Samaras says, half seriously: "The Room was made—aggressively—for Sidney Janis (who had gathered and shown the Pop artists as 'The New Realists') to show him what realism really was, but he didn't come to see it."

On one wall was a million-stuck-on-flies box which upon
opening revealed jeweled parts of a man, a mirror inside,
mirror outside box, and an x-ray machine.

<div align="right">Samaras, "Killman"</div>

A strange thing indeed, the existence in man of this mental
activity which substitutes one thing for another—from an
urge not so much to get at the first as to get rid of the
second. The metaphor disposes of an object by having it
masquerade as something else. Such a procedure would make
no sense if we did not discern beneath it an instinctive
avoidance of certain realities.
   In his search for the origin of the metaphor a
psychologist recently discovered to his surprise that one
of its roots lies in the spirit of the taboo.

<div align="right">José Ortega y Gasset, <em>The Dehumanization of Art</em></div>

Samaras had made two more Dinners in 1964, but with
the increasing openness of his space they look more
like landscapes than dinners—strange, sparse,
spatial: a long horizontal wire balancing on a goblet
cuts a solid line through the air, or a plastic tree
presides over a bucolic coupling of two combs
on a lamb's-wool-bedded plate.

   The combs, like all the objects Samaras uses, be-
come human and erotic. Doubled, they are like people;
they are also like teeth and mouths. And they carry
memories of Duchamp's Ready-made comb, of
Magritte's comb and Rosenquist's. Of the toothless
metal comb in Samaras's own pinless book and a field
of biting combs in a previous Dinner.[1] But most of all
the combs carry the memory and anticipation of hair.

   Samaras started using hair again in 1964: a waterfall
of artificial hair cascaded from a square tunnel in the
center of the *A* box and hanks of hair were perhaps the
most startling objects in his Room, hinting at transves-
tism because he had not yet established their role as art
substance. At the end of the year two boxes were cov-
ered on the outside with long hanging tresses.[2] In
Greek, the same word is used for both hair and wool. If a
box can be a head or contain a face, why should it not
have hair?

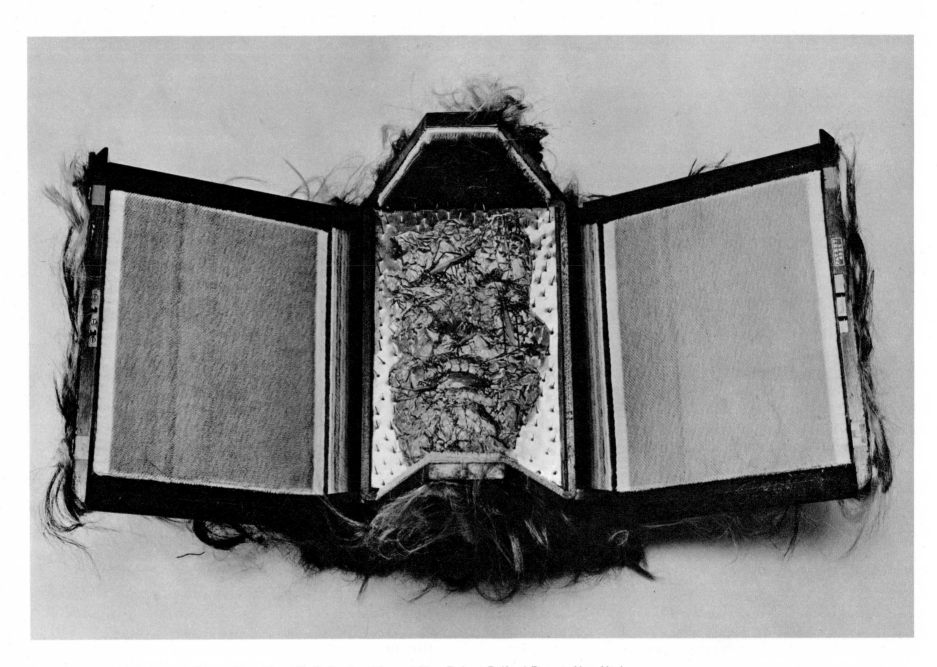

30. *Box #25*. 1964. Mixed mediums, 12 × 14 × 12″. Collection Mr. and Mrs. Robert Delford Brown, New York

"And his hair began to grow and flow and it grew flew ten times his size many times his size and hair grew from his back and from the back of the buttocks and thighs and legs and he had a long hair shadow," Samaras had written in 1962 in his "Addenda to Dickman."

Boxes made in 1965 have linings of hair or are covered with tangled masses of hair. Like a sinister carnivorous nest, a box of variegated hair devours a plaster foot and a fish whose tail sticks out of the almost-shut box. Another, covered in black hair, opens only enough to spit out the bones of the foot along with an ominous red pepper. As if in a continuing dialogue, the front half of the fish protrudes from a box covered with black pins instead of hair. Just as the earlier pins were "silver grass" or "steel hair," the hair is an equivalent to pins and to grass, the earth's hair— "and they lied down on the pine needles forest hair."[3]

In the continual shifting pattern of referrals and reversals within his work, other substances and images that had been peripheral earlier became prominent in 1965. Besides hair surfaces, Samaras began using colored glass jewels as total surface coverings. He had not forgotten the impossible carpet of jewels. The jewels, sharply faceted, fragile and sparkling, turn color into transient light; like the transparent plastic cubes, they reflect light as shifting planes of changing color. Just as Samaras had found a three-dimensional line in the wool yarn, the jewels—solid dots of transparent color—were a three-dimensional ready-made dot. His use of jewels is directly connected to the jewels and mosaic surfaces of Byzantine art, but more than that, it is a solid tactile translation of the dots of Impressionist painting. If hair and pins are opposite but interchangeable alternates, so are yarn and jewels.

A "Jew Jeweled boy" appears in his 1965 story "More Dickman," and Samaras says he associates the words not only because of their similarity but also because both were associated with treasure, and with mysterious forbidden things from his childhood in Kastoria. The Jews could not light fires on Saturdays, and they vanished during the war; a Jew who owned the hardware store gave him mirrors to play with. "Around my family mirror had connotations of devilry and vanity."[4]

He also mentions his childhood view of the lake, seen from the window of his house: the glittering water looked to him as if it were made of jewels. Echoes of his memory and of the 1964 boxes emerge in 1965, when he encrusts an open-mouthed tinfoil head with jewels and glass shells, or makes a watery Dinner of coral, fingers, and the string-filled goblet from 1961 with the spiraling top (which now seems to refer to the whirlpool in the water glass), on a base of jewels and pins.

In 1964 Samaras made some wormlike tinfoil knots covered with pins; in 1965 knots are covered with jewels, becoming the overtly phallic "jeweled parts of a man" of Killman's wall. He ensconces a jeweled ball and ring in a hair-lined box or hangs hair inside a jeweled box with a pinnacle-shaped lid. A long box, floating gingerly on springs and covered with jewels and tiny mirrors, does not open; black panels slide out of its sides instead. Its front is covered with a tinfoil impression of Samaras's face, crumpled like a mountain range and sprayed scaly red and blue; it is like a new version of the early plaster sausage that ended in a face.

The work of 1965 has a greater eccentricity of substances (hair, jewels, bones, black pins), shapes (curved horns, rings, pinnacles), and objects. There are walking shoes and curling tennis rackets. There is the well-known pair of tilting chairs,[5] one of yarn, the other of pins, one leaning forward, the other shrinking back, embodying characteristic polarities. Substances, shapes, and objects have direct bodily associations, are male or female, are sexual. His use of organic substances comes close to primitive art—like the ritual objects and weapons encrusted with bones, feathers, shells, hair in the Museum of Natural History, Samaras's favorite museum.[6]

Gone is the miniature scale of earlier boxes and their contents. Size is something actual, sometimes awkward, sometimes precarious as the work undergoes a process of enlargement. While Samaras lived in New Jersey, the small size of his work was not just a rejection

of Abstract Expressionist scale, it was a practical necessity. With the move to New York he had more room to work in, and less problem transporting the work.

Pinpoints become enlarged into single curved pinnacle shapes[7] that can form the seat of a chair, a jeweled lid, or a white plaster shape inside a box, sliding neatly into a pointed hole as the box is closed. These curving pinnacles are not only enlarged points; they are also the positive solid counterparts to the space between the parting curtains—a shape that had appeared early in Samaras's work and had reappeared abstractly or upside down as the space between breasts, buttocks, mountains.

Samaras returned to pastels in 1965, doing a series with V-shaped points on subtly blending luminous fields of color. "Do you know what this is?" he asks slyly, drawing an upside-down V. "It's the Greek letter L." Everything eventually refers back to his name, his face, his body, as he relates the world to his own image. Another series of pastels is of fingers that are like phalluses and also like bodies with fingernail faces. Huge, single erect fingers fill the page on grounds of spectrum stripes, or male and female fingers cavort in landscapes.

And the tinfoil impressions of parts of his body that he had been making since 1962 became enlarged in 1965 to gigantic size: he made five monumental tinfoil fingers the size of legs. Although they were meant to be cast, he decided not to make them permanent after he saw a reproduction of César's big thumb, and they remain only as background in some double nude photographs of Samaras, standing upright together on the floor behind him while he covers his genitals with a cluster of hands.

His body was conspicuously absent from the Room. During 1965 it is constantly present, but with his usual reversals it is no longer just tinfoil skin or photographed face. The photograph of his face when it does appear is sliced up on the handles of a carving set or is a negative with pins sticking through: he turns past images inside out before slipping out of them to reveal new images underneath. Besides exploring parts of the body as erotic shapes and using hair as an erotic—and repulsive—substance, Samaras peels away layers of the body's surface, strips it of its skin, and penetrates to its internal tissues and its bones. For besides the "jeweled parts of a man," the x-ray machine on Killman's wall becomes actualized in 1965 as Samaras seeks the medical definitions of the body.

"How can I call myself I? It's we we we we. What do I want? To communicate with my cells my sperms my spleen my bones my nerves? That would be nice and it would be enough to keep me occupied for all my lifetime," he wrote on December 26, 1964.

First he bought a baby's heart embedded in a plastic cube, a wax spore model with plant spores that become translucent and full of colored dots when lit from behind, a fish skeleton in a glass case, and a large medical anatomy chart. Then, in the spring of 1965, he bought medical atlases and anatomy books and began cutting and pasting from them, dividing pages in ways familiar from his pastels, and dotting them with starry patterns of pins.[8] It was at this time that he used the skeleton of a foot in a hair box.

At the end of the year he was given x-rays of hands, intestines, spines, and feet by a friend from Rutgers who had become a doctor, and he had x-rays made of his own skull, front and side view.[9] In his "Autobiographic Preserves" he says: "I had an x-ray of my skull taken to see the bone structure and I felt faint even though I couldn't see my soul. I said I did it to see how the skeleton would look after my death and by this devious glimpse of death to diffuse its horror."

The pin drawings that he did in the spring led to similar but more spatial ones at the beginning of 1966, using his own x-ray. Pinning it like a *memento mori* to photographs of nebulae—smoky veils dotted with white stars—he fused the apt chance resemblance of two scientific images—the x-ray and the telescopic photograph—and the trite poetic resemblance between pins and stars into a quixotic double metaphor. Though hidden structures are revealed, an x-ray can no

more pierce the inner regions of the mind than a telescope can pierce heaven. Both remain essentially poetic mysteries.

In the summer of 1966 Samaras transformed the x-rays into drawings in which the skeletal motif is a basis for design. These drawings of skulls or bones are dark, sometimes with parts in color on dark patterning, sometimes with rainbow ink bands. Sometimes the image is doubled—a black silhouetted skull has a patchy color shadow—or the skull is absorbed into the geometric design and is almost invisible, merged with grids, convoluted wriggles, or vortexes of radiating lines.

In these skull drawings the line is an incision: Samaras made depressed pale lines with a hard pencil and then covered the surface with graphite, a subterfuge that left the original indented lines as whitish negatives and gave the drawing the look of an etching.

Besides portraits of himself as a skeleton, he was making large pencil drawings of imaginary boxes, using the same technique in which the line is white, negative, invisible, and the penciling—the visible medium—becomes the surface, the background, the space in a technical reversal.

The imaginary boxes have lids that do not fit because of discrepancies in size or shape, or they recede infinitely to vanishing points. They look as if they have been warped by space.[10] The radiating vortexes of white lines on the black graphite surface now create endless perspectival recession, becoming the transmitters of glowing light and infinite space, and there is a revelation of the impossible object as a self-luminous floating vision, providing false clues about space. The vanishing point—the dot from which the lines radiate—is both on the surface and at infinite depth. Samaras is using the elementary-school principle of the converging railroad tracks[11] multiplied beyond all logical conclusions.

This transformation of flat surface into infinite space is like the equating of pins and stars, vertebrae and galaxies. Microcosm and macrocosm converge by resemblance. Psychology and astronomy interest Samaras equally. *Scientific American* is likely to be on his kitchen table, and he frequently discusses psychological ideas with his friend Henry Edelheit, a psychoanalyst.

## NOTES

**1** *Dinner # 9*, which has been destroyed.

**2** *Box # 25*, which contains an epoxy face (jewel-like and jelly-like) covered with grasshoppers, and *Box # 26*, a curved tunnel-like box that contained pornographic photographs and has been dismantled. During his high-school years Samaras had worked for his father in the summers cutting fur skins, mostly Persian lamb, into strips and sewing them together. He remembers the heat, the nails, the hairs, the smell.

**3** Samaras, "Addenda to Dickman," unpublished manuscript, 1962. In "More Dickman" (*Book*, Pace, 1968), the nuns in a convent give Dickman a man-eating "book whose covers were of hair and dew." Written in 1965, the carnivorous book refers to the hair boxes and recalls the earlier pin-covered books and the rooming house at Rutgers, bought and demolished by the convent next door as a threat to morality.

**4** Samaras, statement written in 1968, published in "Letters from 31 Artists to the Albright-Knox Art Gallery," ed. by Ethel Moore. (*Gallery Notes*, 1970, vol. XXXI, no.2, and vol. XXXII, no.2.)

**5** Samaras wonders if the tilting chairs had something to do with a memory of the view from his window in West New York. As seen in a snapshot, it was of a house that leaned away from the next house, its tilt made even more apparent by the fact that its brick entrance porch did not tilt.

**6** It is possible also to see some relation between Samaras's boxes that begin to become landscapes such as those of 1964 with glass fronts, and the great vitrines in the Museum of Natural History that contain stuffed birds and plaster beasts among plastic foliage. This collection of forms of life, preserved behind glass as a record and arranged like art, with the ultimate fakery of illusionistic landscape painting as backdrop, also recalls Samaras's early attempts

to combine real goblets and pastel landscapes and his later *Transformations*. His interest in skeletal forms during 1965 may also relate to the skeletons in the museum (which he remembers visiting after he moved to New York in 1964).

**7** The first pinnacle-shaped box, done in 1964, was yarn-covered and opened to reveal a torn petal-like hole, as if the pointed lid had somehow ripped through it, exposing its Day-Glo red undersides like a wound.

**8** Artists' use of medical illustrations, like many of Samaras's materials, has Surrealist antecedents in Max Ernst's collages and in Cocteau's illustrations for *Opium.*

**9** The x-rays of his skull were taken by Christos Pyrros, a surgeon cousin. The other x-rays were given to him by Maria DeCordoba.

**10** These perspectival spatial distortions in Samaras's work can be compared with what Lucy Lippard has called the "perverse perspectives" in the shaped canvases and structural art that replaced Op art.

**11** Railroad tracks are important to him, both as two parallel lines continuing endlessly and as lines converging to a point in surreal perspective. He lived near the tracks at Rutgers; a relative was killed on a train when Samaras was a child. The pinched shape of a railroad tie appears in some of his sketches. In Ray Saroff's 1963 Pop film *The Real Thing*, Samaras played a role in the subway and walked on the tracks. "The idea of leaving, departure, is very meaningful to me," he says.

There is a concept which corrupts and upsets all others.
I refer not to Evil, whose limited realm is that of ethics;
I refer to the infinite. I once longed to compile its mobile
history.

Jorge Luis Borges, *Labyrinths*

. . . but were they walls? To anyone who had never seen
such a place before, this was a very peculiar room indeed. . . .
It would have been hard to resist the temptation to walk
forward, hands outstretched, to discover the physical limits
of this extraordinary place.

Arthur C. Clarke, *The City and the Stars*

The Mirrored Room of 1966, cubic and totally covered
inside and out with square mirror panels, was an ab-
stract sequel to the real Room of 1964. The Room had
contained everything but his body; the Mirrored Room
was designed as a container for his body, as a space
to be populated by his image, which would multiply
infinitely. Or by the image of whoever entered it.

"I suppose people paint with their bodies when they
enter the room; you know, they inspect themselves,
'paint' themselves; they scribble. Then they go away
and the scribble goes away too so that they don't leave
their marks. Kind of an instant erasure,"[1] said Samaras
in October, 1966, while the Mirrored Room was being
built.

The effect was less narcissistic than the idea
—endless receding space stole the show from the
human figure, which diminished on all sides to infinity.
The body became the object—the pin, the jewel, the
star—caught and repeated endlessly shrinking into in-
finity in the floor, ceiling, walls, in each mirror panel of
the room.[2] The spectator is the multiplied object of
fascination, fascinated with himself and horrified as he
sees himself a mile down through endless boxlike
spaces, vanishing into invisibility.

Between the Room and the Mirrored Room the idea
of enlargement had turned into the illusion of infinite
space. A drawing visualizing how the Mirrored Room
would look resembles the perspectival drawings of

31.  Perspective drawing for interior of *Room #2*. 1966. Pencil, 14 × 16¾". Collection the artist

imaginary boxes. Its vanishing point at the center is a pinhole.

Between 1964 and 1966 Minimalism emerged and art embraced technology.[3] Samaras's Room full of actuality, messiness, and autobiography turned into the Mirrored Room, pure, clean, artificial, and inscrutable. The environment became the synthetic man-made environment, made to specifications from a scale drawing.

In 1964, while the real Room was being assembled, Samaras had sketched versions of an abstract room as an alternate to it. It was to contain the barest elements of furniture, a single chair and a table, to identify it as a room. One sketch had a transparent hollow table and chair filled with water and live fish. The pair of tilted chairs that Samaras made in 1965 were precursors of the abstract room, which became a possibility when the Green Gallery closed in the summer of 1965 and Samaras joined the Pace Gallery. "He was pretty astonished at our willingness to build it," recalls Arnold Glimcher,[4] director of the gallery. "We were astonished too," adds Fred Mueller, co-director. The Mirrored Room contained the mirrored skeletons of a chair and table: topless, bottomless, unusable, they were sculptural outlines, abstract frameworks like the earlier cube skeletons.

The idea of the completely mirror-covered room occurred in 1963 in Samaras's story of Killman. Killman's bathroom "was a cube room that was completely mirrored. Even the floor and ceiling. When he wanted to shit he shit on the mirror floor."

But it is hinted at earlier. "Samaras begin to have an affection for your body. Live in a house with mirrors. Man cannot live without people or his reflection. Samaras begin to love Samaras. He is the only one who will be continuously thinking for your good," he exhorted himself May 10, 1961, in a strangely self-conscious and revealing statement of aims for becoming self-sufficient—a year after he had made his first mirror box.

And on December 31, 1961, he wrote down an idea for a Happening with one mirror wall and a diagonal band of transparent body-shaped chairs.[5]

In an unpublished part of "Still Dickman," written February 1, 1962, "he went to a square room and the walls were covered with tiny square mirrors and there was a male face in each mirror and of different ages and sizes and kinds."

A year later, still before "Killman" was written, he noted the idea of a room in which everything is covered with one-foot-square mirrors for a Happening to be called Mirroroom, with himself inside the room and murder taking place in it.

Mirror was associated with death, not only in the idea of the Happening with murder, but during his childhood. "Just as scary was the custom of covering all the mirrors of the house as long as the corpse was in it."[6] As a child, "mirror was one of the 'elements' like fire or water that one had to somehow unravel. Like the wonder of complicated organisms beneath a person's skin or the slow understanding about the structure of the sky," he wrote in a 1968 statement for the Albright-Knox Art Gallery.[7]

In the same statement Samaras also recalled "its use in magic shows. Also the use of a 'liquid' mirror by Cocteau in *Blood of a Poet*, the distorting deforming mirrors outside the old Laffmovie house on 42nd street and countless movies with partly mirrored mazes." Mirror had theatrical origins, but other artists had used it, among them Kaprow, Cornell, Rauschenberg. In 1965 Kusama made a polygonal mirror structure and Robert Morris showed mirrored cubes (invisible from certain angles) at the Green Gallery.[8] Samaras felt it had never been used totally, as something to be entered into. By coincidence, among some notes made by Duchamp between 1910 and 1920 and published in *Art in America* in 1966 is this one: "Have a room entirely made of mirrors which one can move—and photograph mirror effects."

The accumulation of the past is always visible in Samaras's work. If he is not taking inventory of his discoveries, his forms and substances, with hybrid restatements in which they become units of another thing, he is transcending and annotating his own visions. The absolute simplicity and logic of the Mirrored

32. *Drawing* (1930s ombre). 1961. Ink, 11 × 8½″. Collection the artist

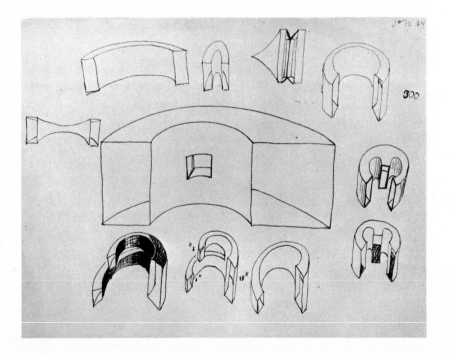

33. *Drawing*. 1964. Ink, 8½ × 11″. Collection the artist

Room is the outcome of a process not unlike the ancient Greek development of the Doric order: continual variations of the same elements, reworking the relations of parts. The underlying concern is with abstract order. Samaras's first use of mirror as a surface is as early as his use of the box as a form. Beginning in 1960 with a single flat mirror surface (more satisfactory than glass and silver paint), his use and reuse of mirror in boxes as an ever more total covering grew to a complete interior lining, dotted with tacks or made of distorting Mylar. And even the "mirror inside, mirror outside box" on Killman's wall had become actual in 1965: an untitled box with a square hole through its center was totally surfaced with mirror, outside as well as inside. From there to the Mirrored Room all that is required is a gigantic leap in scale (made possible by the real Room and by the expanding size of his work during 1965), or a recollection of Killman's bathroom.

After the Mirrored Room was built, sketches for mazelike structures and corridors began to grow out of doodled zigzags and meanders as Samaras played with different ways of manipulating and boxing in space as alternates to the Mirrored Room.

A corridor designed at the end of 1966 and built of mirror in California in 1967 turns back on itself in three parts, accordioning to fold itself neatly into the shape of a room as well as the shape of an *S*. But with a twist: the ceiling slopes lower and lower until the person in the corridor bumps his head, and it continues sloping; the person is forced to fold himself up to fit into the space and must crouch to get out through the low door. The actual space diminishes while the mirror surfaces fake vast space with exaggerated perspective.

A sketch for a long ladder coming to a point, with built-in perspective making it look infinite, plays with illusion in the same way. This ladder to the sky was a counterpart to the stairway into the water, and both were sideline comments on New York City's invitation to several artists to make sculptures for Central Park and other sites around the city.

Another mirrored corridor that Samaras designed at

the same time, and that was built in Philadelphia in 1969–70, is a straight, seemingly endless tunnel that provokes irrational dream responses alternating between vulnerability and invincibility. When you look sideways, there is an endless row of yourself marching in step; another person in front or in back multiplies into another rank of marchers. Samaras said to Paul Cummings in a 1968 interview: "On television sometimes I see the German Nuremberg Rally; it absolutely thrills me to see, you know, ten thousand people stand up at attention all at once like that."[9] But when you look down there is the disorienting precarious feeling of seeing yourself endlessly receding, a feeling of vertigo, a dropping in the pit of your stomach as from a dream of falling. "Killman's house. The corridor. It was bent like a train track by a forest fire. The floor was a clear through glass and below was a bottomless canyon," reads a note for "Killman" written June 27, 1963.

In another note a few days earlier, "Killman's closets were 20′30′ shafts. Killman liked to open the door and listen," recalling Samaras's description to me of the Kastoria water control house that had hollow water-filled concrete shafts in which he could hear haunting subterranean echoes. In 1967 he designed a mirrored staircase like a vertical corridor or shaft.

Another mirrored structure designed in 1967 was built at the 1968 Documenta in Kassel, Germany. An elaboration on the original Mirrored Room, it adds the menace of the tacks in the mirrored boxes. It is cubic but is armed like a fortress with large mirrored points to keep you away and a low door to keep you out. If you do enter, crouching, in spite of these warnings, you hit your head on a large point right above the door as you straighten up, while the interior aims more large mirrored points at you from every side, breaking up the space and faceting it like a perplexing jewel. "It's the most threatening thing he's ever made, and the most dangerous. Everyone bumped their heads," describes Arnold Glimcher. "You didn't know where the points really were in the slick wet dark light, you were totally inhibited, your perceptual faculties were completely confused. It was terrifying." In Byzantine warfare, mirrors were used to blind assailants or set fire to enemy ships. In Samaras's work, mirror is always dangerous. "When I used it to direct a beam of sunlight into a passing girl's eyes it became a weapon of shock,"[10] Samaras recalls from his childhood.

About the Kassel room he remarks: "For years people had been talking about the danger in my work. With this room you actually did damage yourself 90 percent of the time. It was pretty lethal. Like sending a torture machine to the land of torture. It wasn't even a Trojan horse; it's an entirely different use of a gift. For them to see and go into and hurt themselves. But I don't think they saw my vengeance. Actually the fact is they selected that room themselves; they had a choice."

## NOTES

**1** Alan Solomon, "Conversation with Lucas Samaras," *Artforum* (October, 1966), pp. 39–44.

**2** The interior—dark, dotted with pinpoints and lines of reflected light—is not simply a cubic space. In addition to its illusionistic deceptions and psychological effects, the Mirrored Room could be interpreted as a visualization of a four-dimensional cube—a theoretical geometric shape known as a tesseract or hypercube. The fourth dimension of this hypercube (of which a cube is a cross section) is a hypothetical fourth spatial dimension, different from Einstein's time though not necessarily contradicting it.

**3** The change in taste in the art world between 1964 and 1966 saw the ready-made replaced by the custom-made, and painterly messiness replaced by sleek craftsmanship and smooth shiny materials (not only in the emergence of Op and Minimal but in a change within Pop art—Oldenburg's vinyl, Lichtenstein's enamel-on-steel paintings, Warhol's rejection of handmade painting). This taste for clean art was reflected in the aesthetic of the Pace Gallery, which, in contrast to the roughness of the Green Gallery, favored a gleaming and immaculate exhibition space and encouraged untouchability.

**4** Interview by the author with Arnold Glimcher, 1968–70.

**5** The ceiling was to be glass with fish swimming above, an idea which is echoed in the 1964 sketch of the fish in the water-filled transparent furniture. The 1961 idea of the Happening bears some resemblance to the setting of the E. E. Cummings play *Him* (with which Samaras was familiar).

**6** Samaras, "Autobiographic Preserves," 1968–70.

**7** "Letters from 31 Artists to the Albright-Knox Art Gallery," *op. cit*.

**8** Among the small plastic cubes that Samaras made in 1964 were some of reflecting silver Mylar.

**9** From the unpublished transcript of a 1968 interview by Paul Cummings with Samaras in the Archives of American Art.

**10** "Letters from 31 Artists to the Albright-Knox Art Gallery," *op. cit*.

The general recurrences of things are very obvious in our ordinary experience. Days recur, lunar phases recur, the seasons of the year recur, rotating bodies recur to their old positions, beats of the heart recur, breathing recurs. On every side, we are met by recurrence. Apart from recurrence, knowledge would be impossible; for nothing could be referred to our past experience.

A. N. Whitehead, *Science and the Modern World*

The boxes that Samaras covered and filled while the Mirrored Room was being made are the culmination of past boxes, further refinements of his patient perfectionist attention to accumulations of minute detail. Methodical, fiendish, acquisitive, they are collections of anything tiny, shiny, sharp—bright glittering attractive nests. In a way they pick up where he left off in 1963.

And they contain souvenirs of his intervening work. Clinical evidence of the body is present in the boxes. Objects of scientific measurement appear as gratuitous evidences of his imminent mastery over space: compass, globe, tape measure, protractor. And in their presence old objects recur amplified with new associations: pebbles and jewels become microcosms of the earth; shells, sea horses, and coral refer to the sea, birds to the sky; and yarn patternings can turn into a fiery sunset.

But the prime characteristic of the objects Samaras uses is still their sexuality. Like all dream symbols, they are permeated with erotic associations. Similarities and transformations of shape are like nonverbal puns playing on chance resemblances. Man is the measure—like the ancient Greeks, he sees everything in terms of the body. No object is ever neuter, though it may be both male and female at once: round things and pointed things are often interchangeable. "Samaras is well aware of the multiple meanings implicit in any object and his brilliance has been to make an inventory of objects, ranging from junk to jewelry, that are persistently erotic. His objects give him back to himself like mirrors," wrote Laurence Alloway in 1966.

The tape measure Samaras puts into a box can be seen as a witty comment on Duchamp's *Stoppages* and

more boxes

on Johns's and Morris's wooden rulers and Samaras's own preferences—he chooses a unit of length that is sharp, metallic, and flexible. Compressed into a round shape, coiled into a spring, it can be pulled out, unwinding like a scroll in a long ribbon-like line, and can snap back suddenly, razor-sharp as a lizard's darting tongue. It embodies both line and dot. The bird-covered box that he envisioned in 1962 materialized in 1966, its top tightly packed with a bevy of stuffed birds of all colors and shapes. In it a tape measure is a ribbon-like tongue that makes an unexpected clicking sound when the box is opened. Or coiled in a box full of round objects (with a lid pierced by tiny holes and painted pinheads), a tape measure presides paired with a watch-face—one measuring time, the other space.

His imagery is as Platonic as it is Freudian. In a box known as the Hermaphrodite Box, transformations of some ideal point—in the form of a cone, a finger, a pencil point, the curling point of a seahorse—are lined up in a row of compartments, hinting at phalluses. The theme of pointedness carries to the nails and screws that line the lid; a hypodermic needle and a tray of finger cots like miniature condoms reinforce the clinical sexual metaphor. And, finally, in a drawer there is another pointed object, a paintbrush—a clue that one must brush aside a covering of jewels (face down they too are conical, pointed) to find a buried image. What is disclosed is not a phallic image but the absence of it: a medical photograph of a hermaphrodite, revealing the missing phallus with the shock of the unexpected razor blade.

Glue, viscous and invisible, is the most constant substance in Samaras's work. But he also invites displacement; shedding skins, he invites the spectator's participation. Preservation has replaced impermanence, but the changeability remains. There is more compartmenting, layering, opening, and unfolding in these boxes than in those of 1963, and there are hidden surprises that are revealed only if the spectator shifts the contents. It is necessary to touch. The accumulations of objects are not fixed but loose, movable and shiftable. And spillable: vulnerability is still an element. And

menace is still its complement. The menace of a jeweled box armed like a battleship with pencils and pierced by knives is more like a reminder than a threat, but, like the bones in the boxes in Kastoria, the images buried in these boxes are shocking ones, disquieting medical oddities from his books on anatomy, skin diseases, and hermaphroditism. The unveiling of the unexpected image is the threat now. Samaras never pulls quite the same rabbit out of his hat.

This is not to imply that the effect is intentional. "If I thought about things like that I wouldn't be an artist," Samaras remarks when confronted by an observation about his own iconography. Art is what exists, as Duchamp said, in the gap between "the unexpressed but intended and the unintentionally expressed."[1] The contents of the boxes were assembled by what Samaras calls a process of "protracted daydreaming." "Lucas is incredibly intellectual and his art is completely intuitive," says Arnold Glimcher. "It's totally separate visually from its psychological implications."

Simple cubic shapes when closed, many of the boxes are covered on the outside with straight striped yarn in even surfaces that give them a formal classical simplicity. But they are not simple. If there is not a bird on the lid stalking a metal grasshopper on a pin-covered pencil or pecking at painted pinheads, the lid itself splits, peeling back like parting curtains or the corner of a Kodak ad, curling to reveal a mossy underside of miniature jewels the size of pinpoints. Alternates to the bright-colored yarn appear—monochrome gray yarn or pale pink and blue yarn—on boxes split down the center by an abrupt change of color or substance.

The recurring polarities in Samaras's work extend to the processes of creating: he alternates between making use of existing forms and inventing imaginary ones—between the bought boxes of 1963 and the carpenter-built boxes of 1964, between the Room and the Mirrored Room. Boxes that he had built in 1966 are surfaced with swirling yarn patterning, and their insides are blocked, solid and white like his earliest boxes. Filled with stiff white accordion pleating, *Box # 45*,

ornate and severe, combines the classical logic of a fluted Greek column with the elaborate irrationality of peasant embroidery.

If these boxes are not solid they are completely hollow, shot through with holes like Swiss cheese as the curvilinear whorls of yarn turn into spaces in boxes that are cut out, pierced, and penetrable. The centers of the patterning become the voids as Samaras makes skeletons of the decoration instead of the structure, dissolving a cube with amorphic spaces (the biomorphic shapes of the Surrealists) that eat away its shape, leaving only the yarn-covered outlining of its patterning.

These boxes with holes are a distant reversal of the disconnected jigsaw-puzzle paintings: both make entrances for the surrounding space. As points were enlarged to pinnacles, holes became enlarged from pinpricks to gaping spaces. A goblet is a hole, a paper bag is a hole, a box is a hole; the hole that had previously been a filled container is now multiplied into a flat surface element that is a conveyor of space.

The box itself as a container had undergone multiplication early in Samaras's work, splitting into multiple hinged segments that fanned open. Like the hole, the accordion form shifts during 1966 from being a container and becomes the filling and surfacing. Only the simplest boxes with accordion pleating, such as *Box #45*, were actually made, but the idea can be traced from rough sketches to finely executed pencil drawings in a progressive elaboration from a simple jack-in-the-box to fantastic boxes whose sides fan out in intricate pleats like accordion-folded paper party decorations.

The idea of accordion pleating had fascinated Samaras long before he made the small folding glass panels at Rutgers. Fastidiously folding a sheet of paper, he quickly demonstrates that the Greek way of making paper airplanes is different from the American way, resulting in an intricately folded heavy nose that makes the paper glider swoop more unexpectedly. Accordion folded paper is like steps: both are the three-dimensional form of a zigzag line folding back on itself. And is it only coincidence that while the Greek *L* is a point, the Greek *S* is a zigzag?

Accordion pleats are the imagery in the pencil drawings of boxes; on other drawings accordioning pencil strokes become the medium. Using the simplest rapid zigzagging stroke—a line folding back on itself repeatedly—Samaras explores pencil as a medium by using it in the simplest way, like a reflex scratching action.

Materials and tools are reversible. Like the Pop artists, Samaras had turned tools into art objects with knives, scissors, pencils sticking out of boxes. And he turned the substances of his art into tools, making ink drawings with a piece of cotton or cardboard or a glass tube, or pricking holes with a pin. The pencil which had been a weapon and a phallic image can also revert back to its original status as a tool for making lines. But he does not leave it there. In a double reversal he also begins to use it as subject matter: a drawing that has pencil and ink as its medium has pencils and pens as its subject. Delicate mazes of convoluted doodling[2] fill in the spaces between the bent and doubled sketchy pens and pencils in this drawing. Samaras multiplies a doodled line, the kind of playful unthinking tracing and retracing of outlines and edges that anyone's hand might make while the mind was otherwise occupied; he repeats a chance scrawl until it becomes a pattern, until it creates a meaning for itself.

Words undergo the same transformations. In his sketches there is often a list of words that may be only a shopping list or may be doodled words that emerge from each other by chance similarities of sound. "I am last lust lost least." "Maze amaze mazono" (English can be paired with Greek—*mazono* means "I collect"). "Cosmos osmosis cosmetic"—meaning nothing but encompassing Samaras's sliding scale from macrocosm to microcosm, from the universe to pins and baubles, from the sublime to the superficial. Every word is relevant as well as meaningless; the repetition of sounds leads to chance links of meaning the way the repetition of curving lines leads to chance patternings that can resemble fingerprints, teardrops, targets, or interchangeable male and female shapes. Form in art is found in the balancing, repeating, or paralleling of simi-

lar and opposite elements. Samaras multiplies formal repetitions to a point where they become transformed into an expressionistic content.

Like his pins, jewels, or yarn, his mazes of obsessive patterning are coverings, skins, surface excitations that appeal to primitive tactile instincts, to a childlike delight in things that sparkle and tease (hide-and-seek, peek-a-boo, now-you-see-it-now-you-don't), bypassing adult veneers.[3] In spite of enveloping autobiographical allusions, it is a content that is mute. And it is a decoy, seducing the eye while penetrating the unconscious to the buried eroticism and amazements of childhood.

## NOTES

**1** Marcel Duchamp, "The Creative Act," 1957 (in Robert Lebel, *Marcel Duchamp*).

**2** This doodled patterning is a miniaturization of the repeating ink lines of the word drawings of 1962, or the yarn surfacing. It appears also during 1966 in some of the skull drawings, like a visualization of tortuous brain structures, and it forms the background in detailed drawings of the boxes with holes, creating a bewilderment of surfaces.

**3** All of this may be more threatening to men than to women, who have been used to ornamenting and camouflaging themselves as sexual objects.

I get a stifling suffocating feeling sometimes that I am
not living in three-dimensional space with plenty of room but
in one which is smack flat two-dimensional with illusive,
fake extension and no behind.

Samaras, "An Exploratory Dissection of
Seeing," *Artforum*, December, 1967

In the summer of 1967 Samaras visited Greece.[1] While
he was there he bought an icon of a saint killing a
dragon. Its painted image is cut out against a jewel-like
enameled patterned surface. On his return to New York
he moved to a different apartment, and designed curly
cut-out painted wood furniture for the large high-
ceilinged living room. The wood-coffered ceiling, the
patterned parquet floor, the chandelier dripping bits of
glass and light became preexisting extensions of his
surfaces, annexed by resemblance, like the icon.

He also designed *Book* as a repository for the stories
he had written, reinventing bookmaking as an art, reas-
serting craftsmanship in a time of technology. A rever-
sal of the pin-covered books, it is an extravagantly dec-
orative cut-out cardboard volume, thick like a child's
book or a Bible, full of secret recesses and hidden
layers under a camouflage of dots and stripes. But its
innocent alluring surface is a barrier to close scrutiny,
as is the tiny forbidding print: its threats are internal,
contained within the well-hidden stories.

*Book*,[2] like all his work, contains elaborate visual
cross-references to its own past. Its pierced and
penetrable form refers to his furniture; both refer to the
earlier boxes with holes. The stories themselves are a
collection, dating from 1959 to 1967, dissecting the
different species of human fantasies in a ferocious uni-
verse permeated by bizarre erotic impulses. Apart from
their relation to Happenings, the stories are autobiog-
raphies of states of mind; they are also pure fictions,
clever satires, literary explorations of relatively un-
known territory. Just as the intricate repetitions of
Samaras's curvilinear forms have more in common with
Islamic, medieval, or Oriental art than with Art Brut, the

subtractions

34. Byzantine icon Samaras bought in Greece in 1967

psychological content of the stories is device more than symptom, treatise more than case study, a shrewd artistic use of clinical psychology.

*Book* is, like Samaras's furniture, a real practical object. Unlike the pin-covered books, it can be read. But just as his early "breakfasts" looked deceptively real, these real objects have the unreal look of fairy-tale fabrications from some Transylvanian Disneyland.

Samaras's mirrored structures presented an ultimate perspectival space; that space, however, was always an illusion, whether on the flat plane of a mirror or in a penciled patterning of perspective lines. The actuality is a flat two-dimensional surface, like the surfaces of his furniture and the pages of *Book*. By the end of 1967 absolute flatness replaced the illusion of space in his work, and the only space was actual space—the environment filtering through the holes.

During December, 1967, shortly after writing about a "smack flat two-dimensional" space, Samaras began making flat white cut drawings that are nothing but blank paper and holes[3] made with the aid of templates. He had begun using drafting aids—French curves and templates for geometric shapes—to make background patterning in some of the large drawings of skulls and imaginary boxes in 1966, and with them a new precision entered his work. He also liked the colored plastic drafting aids as shapes in themselves: shapes that are transparent and full of holes like the holes in his cut-out boxes.

In the cut drawings, lacy lattices of intersecting circles, squares, crescents, French curves, and grids are made using these templates. Profiles of Samaras's head and hands and the heads of his friends appear, mixing, doubling, and interlocking, camouflaged in the intricate lattice patterns. Profiles are ribbon-like outlines, solid paper, or cut-out space, or they are visible only by the slight shift of a nonexistent edge where two patterns meet. Again there is the invisibility of the now-you-see-it-now-you-don't image as the profiles—the human element—are used as abstract design shapes.

Samaras's profile is drawn by a paper hand or cut by paper scissors, or framed by other profiles like hair. Exposing techniques, tools become subjects in cutouts of hands holding scissors, templates, ruler, or hole puncher. In one, Samaras's hand balances a sharp tool on the end of a finger, watched by his own profile and two others: the tool has become a virtuoso balancing act, like the symbol of the craftsmanship in this cut drawing, which is, appropriately, the last one of 1967. At the beginning of 1968, profiles of other people begin to become portraiture with identifying stenciled letters or words, or symbolic objects suspended within the outlines of the head. Tools turn into background patterns as cut-out razor blades or scissors multiply around a profile.

The patterns for these profiles were made from projected shadows, indirectly recalling Duchamp's use of shadows as well as Colonial Silhouettes. The shadow, a transparent flat silhouette image dependent on light, enters Samaras's work as a useful medium, a drawing aid, as before it had been a witty substance—steel wool, cloth, or broken glass. A figure in an early drawing had a three-dimensional shadow; a shoe in a later one had a trench for a shadow. "Shadow play. Having a paper skeleton covered with wax to resemble a person and then taking the figure toward a lit candle until it started to melt. Re-enacting the burning of Athanasius Diakos behind a white sheet" is something Samaras remembers in his "Autobiographic Preserves."

The painter Lilly Brody recalls: "When he did my profile, I was so embarrassed and happy together when he put my face down, I said to myself I don't need to do anything ever again—I am done. He had a light on and he made my profile and I can't tell you the happiness when he did that and then I started to think but you also use a gimmick. I thought he has such an ability that he draws someone like that; I imagined his drawing power was immaculate. I imagined that all those profiles are done with his skill. I was a little bit disappointed but then later when he showed me some drawings one looked like a landscape and Lucas said to me—that's you—and the mountain in the landscape was my pro-file. The horizon was my profile and I didn't see it. I was so flabbergasted. When I saw the mountain—I mean that is his genius—what he does with it. No matter what he uses as a tool. I said to myself later everything is allowed. If I can only take you for a walk in my world that's what I call an artist."[4]

Like dressmakers' paper patterns for sleeves and bodices, the cut profile patterns of Samaras and his friends are tacked to the wall of his studio. When he visited the shop of his dressmaker cousin as a child, he not only played with pins and magnets, he cut paper. He may have used pinking shears with their zigzagging edge. He also recalls that in school in Greece they used to cut paper strips and weave with them.

The cut drawings are like paper doilies, bendable, flopping, fragile: they need to be seen loose, to be picked up, but they are easily torn. Adding nothing to the substance, to the bare paper surface, Samaras makes the most common material precious by a process of subtraction, by cutting into it and making it less: his incisions are the obverse of the three-dimensional line.

Just as he liked the quickness of pastels, he liked the mindless repetitive cutting process of the paper cutouts. "You do all the inventing before you start; then you become the craftsman of your own work," he says, adding that he also liked the mindless repetition of working on an assembly line at the American Can Company one summer while he was at college.[5]

The cut drawings were preceded during 1967 by some pencil drawings of hands and feet that he made just before going to Greece. Some have patterns of penciled zigzags and lines, some are shaded and solid against dark scribbled grounds, and others are bare white silhouettes. One was cut out. After exploring the possibilities of pencil, Samaras turned to the bare paper.

The cut drawings were preceded also by the last of the few boxes Samaras made in 1967. These are of cotton and pins: one contains a cluster of glass balls, another a bird. Like opposites to the hair boxes, they are snow nests or "cloud sculpture."[6] Pristine, cold and

35. *Drawing.* 1967.
Pencil, 14½ × 11½″.
Collection the artist

white, they are evidences of a desire for whiteness and transparency, a desire for something purer: in a way they mark the end of the boxes.

The flatness that prevailed at the end of 1967 with the cut drawings continued into 1968.[7] Samaras's work of 1968 is concerned with flat surfaces: his materials are cardboard or wood, painted. He returned to painting with acrylics of spoons, knives, or pencils, or silhouette hands holding burning matches, "realistic" like posters or ads, on schematic flat grounds of dots. They have their origins in images in *Book*.

When he began making boxes again in 1968 they had little resemblance to previous boxes, except perhaps those with holes. They are large, abstract, and streamlined unboxlike shapes of painted wood. Instead of containing accumulations of the past, they are futuristic and empty. And they are shallow: like reliefs, the front view tells all.[8] These boxes in disguise are protected and camouflaged by thorns, horns, tentacles, tendrils, or jagged zigzags, with suggestions of Art Deco, Art Nouveau, or electrified cartoon cats. They grow out of the cut drawings: in the first sketches for them the lattice patterns are seen as their supporting or surrounding elements.

On these boxes, painted dots or stripes replace jewels and yarn. A line has extension, a rectangle has surface, a cube has volume. What is a dot? A bull's-eye, a pimple, a puncture, a place to start? It is the location of a sensation. Like Impressionist flecks of color, each dot is a sensation, a particle. It is also, as Samaras uses it, a cross section of a line.[9] Unlike the Impressionists, and unlike Lichtenstein's mechanical Ben-Day dots, Samaras's hand-painted dots are touches of paint that mean nothing other than the mark made when the brush touches the surface—though they may have originated in bullet holes, pinheads, or jewels. Or chunks of mosaic. By repetition, by accumulation, by insistence, the dots become a tactile surface, an emphatic flat plane. By variation and irregularity they emphasize the hand-paintedness. Pointillism? Samaras had liked the idea of Seurat, hearing about him from Kaprow, more than he liked Seurat's design. The dots are purely decorative, but besides that they may have as much to do with the historical process of reduction to the simplest component of form that has been going on throughout this century: the concern with making a line or a dot is a further subtraction from a post-Cubist interest in the square.

## NOTES

**1** For his account of the trip, see Lucas Samaras, "A Reconstituted Diary: Greece 1967," *op. cit.*, pp. 54–57.

**2** For a fuller account of *Book* see my article, "Samaras Bound," *Art News* (February, 1969), p. 35.

**3** Between December 11, 1967, and February 29, 1968, he made over sixty of these cut drawings.

**4** Interview by the author with Lilly Brody, 1970.

**5** His job was to spear tin cans with a pronged stick, lifting them off the conveyor belt and dropping them into bags or cartons, which bears some gratuitous resemblance to his earlier imagery.

**6** In a note for "Killman" written August 6, 1963, Samaras mentions "last night's moon floating past the cloud sculptures and pin stars."

**7** The cut drawings lead to two groups of cutouts which he did in 1968–69, "Views of Women" and "Private 1970." They are layered over each other like pages, to be lifted off one by one. Their thin latticing is striped with colored felt pen and recalls the yarn outlining of the boxes with holes.

**8** Along with these boxes, Samaras made a two-dimensional box suspended in a frame like a guillotine—flat, cut out, and painted in perspective to give a convincing yet unbelievable illusion of depth. Suspension had occurred earlier in his work. He thinks of suspension in terms of swinging, balancing between sides like a pendulum, and recalls a childhood game that involved balancing a nail in the hole of a skeleton key stuffed with scrapings from a match head and suspended on a string; swung against a wall, the nail compressed the scrapings and caused an explosive sound.

**9** Just as a line is a cross section of a square, and a square the cross section of a cube.

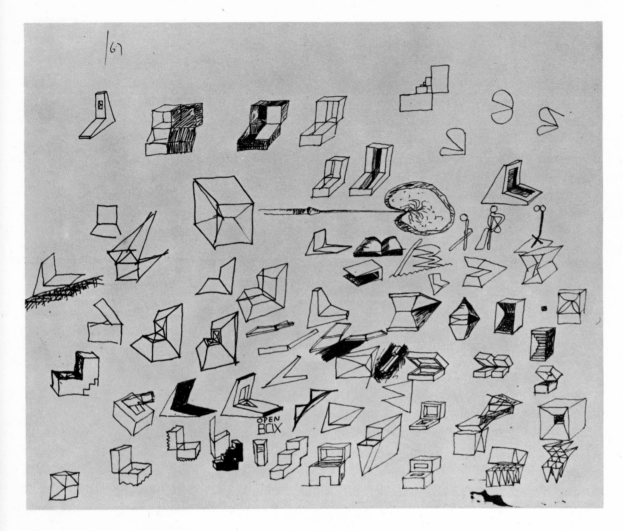

36. Sketch for boxes. 1966. Ink, 14 × 16¾″. Collection the artist

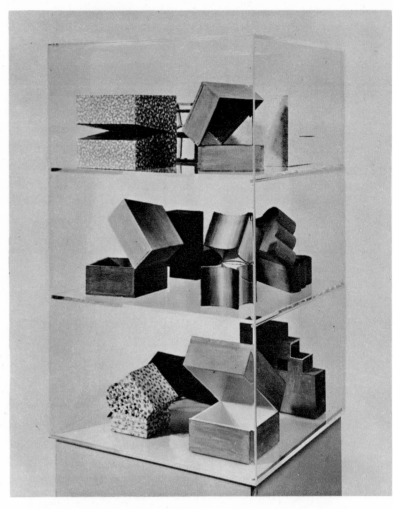

37. *Transformation: Boxes.* 1966–67. Painted board and Plexiglas, 26¾ × 12¾ × 12¾″. Albright-Knox Art Gallery, Buffalo. Gift of Seymour H. Knox

Just when he seems to have abandoned sensuous
substances for the painted flatness of paper, card-
board, and wood, Samaras's *Transformations* emerge.
As if cataloguing his substances, taking inventory of
them, he makes collections of knives, scissors, and
flowers, reinterpreting these objects out of all the
substances[1] he has used in the past like commentaries
on his own work.

What had been an implied idea in his boxes and
rooms turns into a statement that is less like the serial
imagery of Matisse's heads of Jeannette or Monet's
haystacks than like an Abstract Expressionist's varia-
tions on an image: each is not another step in a pro-
gression but a summary and a unit of a totality. Each is
both complete and partial. The *Transformations* are
perhaps most like Oldenburg's inventories, but Olden-
burg stays closer to the object, cataloguing the possi-
ble positions that it may assume or equating one object
with another, and where Oldenburg's imagery is a
transference of genital characteristics to objects,
Samaras's is a sublimation of nonlocalized erotic sen-
sations. If Oldenburg's fantasy is about things, about
phallic machinery, Samaras's is about desires, about
states of ecstasy. The erotic content is in his materials,
his surfaces—in their ability to dazzle and seduce.

While Oldenburg uses contemporary materials that
have undifferentiated extension, Samaras's surfaces
are invented. They have a particle nature. They are also
total fields—made of separate, intact, recognizable par-
ticles that accumulate and adhere. Fields of pins, of
jewels, of yarn, of dots. Even the mirror structures are
made of small panels rather than whole walls. Skin is
not smooth—it is an intricate pattern of pores.

The collection of knives, like chloroformed butter-
flies, is pressed behind glass in a spoke arrangement,
as if to catalogue the different species of knife: pin-

transformations

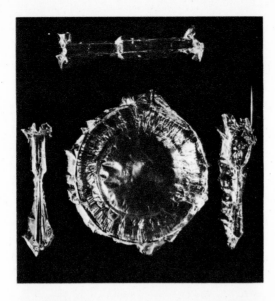

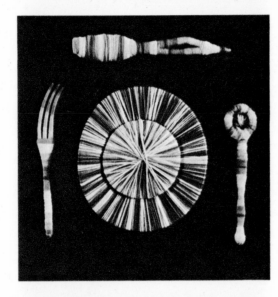

38. *Transformation: Plates.*
Completed 1968.
Polyester resin, yarn, and plaster,
each 17 × 17 × 3⅞″.
Collection Valerian Stux-Rybar,
New York

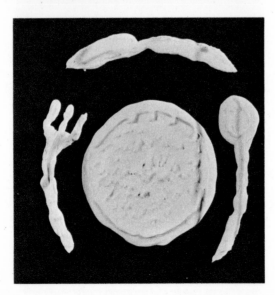

covered, polka-dot, plaster, cotton, glass. Knife becomes a unit of design and sensation rather than an object that cuts. Soft, harmless, playful, scissors may look like starfish or sea anemones, curling or cringing. Or like vehicles: doubled, their handles become wheels and their shadow a platform. Or they become acrobats with blades for legs, retaining vestiges of the 1959 plaster figurines.

They have histories of their own; they absorb the past like blotting paper. Recalling an early subject—the vase of flowers—and anticipating a later use of plastic flowers to make a chair, a familiar glass full of glass splinters is now tipped with manikin fingers to become a vase of flowers, along with other vases of equally improbable blossoms,[2] like Fabergé flowers of enamel or quartzite with translucent leaves and diamond dewdrops in rock crystal jars. Samaras anticipates his own future in more ways than one: in June, 1963, he had made a tinfoil stalk in an epoxy-filled cordial glass which he recorded in a sketch with the notation, "recollections of a Fabergé plant."

Transformation is a religious idea—it suggests transfiguration, transubstantiation. Involving belief and disbelief, it is also a science fiction idea—the invented materials, objects, worlds, creatures of science fiction are transformations of known things.[3] Samaras began reading science fiction in 1968, attracted to it beçause of its concern with materials and its "questions about transformation of the human being into another creature."[4] It may have been an influence on his futuristic boxes and his *Transformations*, "but then you can also phrase it—I am interested in science fiction because of certain concerns that I had a couple of years ago."[5]

Actually, the *Transformations* themselves began before 1968. The first, of eyeglasses, was done at the beginning of 1966,[6] along with the doodled sketches of Siamese-twin and double-decker pens and pencils, shoes, and eyeglasses. Soft, hard, halved, doubled, tripled, flattened, folded, crumpled, the eyeglasses can be knots, pyramids, cubes, slits, or targets—transformations of form as well as substance. The 1965 walking

shoes and tilting chairs are their prototypes, presenting preposterous fantasy variations on a single commonplace object, and, like Magritte, causing a visual double take.

At the end of 1966 Samaras made two more *Transformations*. One is of bracelets,[7] the other of boxes—a dozen little painted boxes in a Plexiglas case, their mouths open like baby birds, like gaping wounds or gasping oysters. Stepped, scalloped, or skeletal, or with built-in perspective impossibilities like the large drawings, the paradox of these boxes that could not close with lids that would not fit has its own strange logic: opened flat, a box may become a triangle.

The sketched pens and pencils reappear in a mixed transformation of painted cardboard cutouts done late in 1967 just before he began making cut paper drawings. Like the rest of his work at that time, this is flat.

Like the cargo cults that worship airplanes as gods, Samaras takes the most common utilitarian objects with which human bodies and hands come in contact, objects that are simple extensions of the body, and re-creates them as icons devoid of their original function. A paper knife does not cut, a chair made of flowers is certainly not to sit on, and you cannot see through eyeglasses made of rope. But you can look at them. Displacing their functions and forms and replacing them with new ones, Samaras substitutes a sensory logic. His objects are purified to a state in which they have no meaning other than what they are to look at. Plus the residue of what they simulate, substituting a comedy of mistaken identity for one of cruelty. Whatever threat there is in the frustration of the object's original function is exceedingly gentle. The organ of sensory satisfaction is ultimately the eye.

"Think of armchairs and reading-chairs and dining-room chairs, and kitchen chairs, chairs that pass into benches, chairs that cross the boundary and become settees, dentists' chairs, thrones, opera stalls, seats of all sorts, those miraculous fungoid growths that cumber the floor of the Arts and Crafts Exhibition, and you will perceive what a large bundle in fact is this simple straightforward term. In cooperation with an intelligent joiner I would undertake to

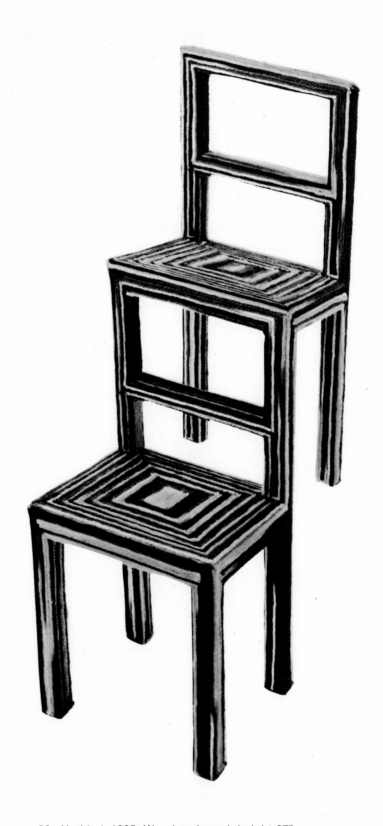

39. *Untitled*. 1965. Wood and wool, height 27".
The Harry N. Abrams Family Collection, New York

defeat any definition of chair or chairishness that you gave me." H. G. Wells, *First and Last Things*

In the fall of 1969 the chairs began to materialize again: chairs of cotton, chairs of tinfoil, of yarn, of glass and jewels, of painted wood. Chairs proliferate throughout the winter; gradually they take up the whole space of his large square room. More chairs appear; they are squeezed together, they sit on each other, they sit on the couch, they begin to climb toward the ceiling. A crumpled plaster and rag chair is wedged into the fireplace. The living room is packed with chairs, with only narrow spaces left for walking, for living. "Lucas, he is a different kind of artist," says his old landlord. "He doesn't paint, he—he makes things—furniture, chairs . . . things," he says helplessly.

"When Germans and then Italians took over our house for about a month all the furniture was piled up into a small room and we went to live with relatives. . . . When the Italians left our house the toilet bowl was half destroyed. We had it rehabilitated with cement. Your ass felt funny touching half cement and half porcelain." Samaras, "Autobiographic Preserves"

In Ionesco's play *The Chairs*, the guests are invisible. Samaras's chairs are his guests. Each has a distinct personality. They are fat or thin, squat or tall, silly, sexy, or severe. Their substances and shapes are their bodies, their gestures, and their clothing. There is a tinfoil high chair kicking up its heels, a jolly striped wheelchair, a taut linear rocking chair. A hinged chair that splits spart down the center of its seat, absurdly encrusted with clusters of cotton, wood shavings, and jewels and revealing a secret compartment painted with dots. A chair half of shiny white Formica and half of tangled bright yarn: the childhood toilet seat.

A wooden straight chair rises from a crate—hatched or resurrected—cut by real and painted zigzags as if split by lightning. There are curly cut-out chairs, a billowing wire mesh chair, the chair of quivering plastic flowers.[8] A cascade of paper chair shadows crumples collapsed on the floor. A single-minded narrow chair with crossed legs, burned carefully with a torch until its surface is a soft velvety black carbon, balances precariously on a railroad track. A chair made of mirror with no seat has one wide hollow leg that suggests a box or wastebasket, or a toilet bowl. Another chair is like lightning itself: a rusted steel bolt zigzagging toward the ceiling, diagonally stretching like a staircase or an acrobatic act.

In 1961 Samaras had an idea for a Happening that included a diagonal row of transparent chairs in the shape of human bodies. In 1965 he wanted to use real people as chairs. His new chairs refer more obliquely to human bodies, by mimicry, resemblance, and association rather than by imitation.[9] They are also like boxes, with secret compartments, hollow legs, drawers full of sparkling substances. And at the same time they question our assumptions about the object we call a chair: its substances, and its shapes and functions. They are impossible to sit on—they are split[10] or seatless, pierced by splinters or bristling with pins, or else they are too brittle or too soft, too fragile. Rusted or burned, slanted, spiked, squashed, or pierced, they bear the evidences of violence.

They also question the thing we call style. They reject history, stealing stylistic elements of the past as decorative possibilities, regurgitating Constructivism and Art Nouveau, Bauhaus and kitsch, camouflage and Minimal. The sprawling paper shadows mimic Robert Morris's felt. An elegant burned chair with drawers combines the look of a Nevelson with Dali's Venus and a drawing by Bracelli. Within one single chair, the one that is half Formica and half yarn, Samaras reenacts the battle between Classicism and Romanticism, between the Apollonian and Dionysian. He even parodies his own style.

An inventory of his substances, a collection of his forms, a series of mutations that come out of his earlier *Transformations* and refer back to his earlier chairs, the new chairs are answers to himself and to other artists who have used the chair; they are comments on art history. And they are seductive alternates to reality.

## NOTES

**1** Samaras's preoccupation with substances has a curious parallel in ancient Greek philosophy. "From the time of Thales through the time of Aristotle: 'Wonder' is directed to the reduction of the change and multiplicity of the phenomenal world to a unity of explanatory principle. As the problem is first approached, the unifying principle is interpreted in terms of a fundamental 'world substance' or 'world-stuff' which, by its transformations, produces the observed origin and destruction, change and recurrence, process and stability in the world," summarizes Milton C. Nahm in *Selections from Early Greek Philosophy*.

**2** Samaras remembers a grandmotherly next-door neighbor in West New York who used to make crepe-paper flowers. "She would make flowers for my mother; when I was making my flowers I was thinking of her—particularly the tinfoil one." The petals of those crepe-paper flowers became the stuffing in one of the first small plaster-filled boxes, entombing their memory.

**3** And transformation is an element of theater: a performer is involved in transformations of himself. Samaras takes on styles and mediums (as well as knives and flowers) the way an actor takes on different roles, remaining purely himself.

**4** Unpublished transcript of Paul Cummings's 1968 interview with Samaras.

**5** *Ibid*.

**6** In *World's Fair II*, a 1962 Oldenburg Happening, Samaras was the "man in pink sunglasses." The sunglasses were his addition. On July 25, 1963, a few days after he made the double target of yarn and pins that had a resemblance to eyeglasses, he covered a pair of sunglasses with cotton and sprayed them pink.

**7** The bracelets also may be traced back to 1963, when Samaras made some bracelets of pins and yarn on plastic as gifts, inspired by the memory of a Greek cartoon character from the 1940s, "Madame Sousou," who lived in squalor with pretensions of grandeur. The particular cartoon Samaras remembers showed Madame Sousou wearing a belt with spikes in a crowded subway.

**8** Under the chair and table filled with water and fish that Samaras sketched in 1964 he indicated a carpet of plastic flowers. The flower chair reminds Samaras of a Greek holiday just before Easter, *Epitaphios* (The Entombment), during which a large canopy-like framework covered with flowers ornaments the altar and serves as a resting place for the icon.

**9** To psychoanalysts an empty chair signifies an absent person. In the apses of Byzantine churches there is often found a scene called the *Etoimasia*—it shows an empty throne, awaiting the second coming of Christ.

**10** Along with the chairs, Samaras made meticulous pencil drawings of imaginary chairs split down the middle—futuristic double half-chairs that change style, sex, texture on each side of the central axis, combining science fiction surreality with furniture catalogue prosaicness. Shortly after making these, he made some small ink drawings from Polaroids of the actual chairs. The opposite of the split chairs, they look like etchings; surrounded by hatchings of hairy lines, they are like nineteenth-century Gothic illustrations for fairy tales, romantic and haunted. These in turn led to some small plaster chairs within womblike plaster grottoes.

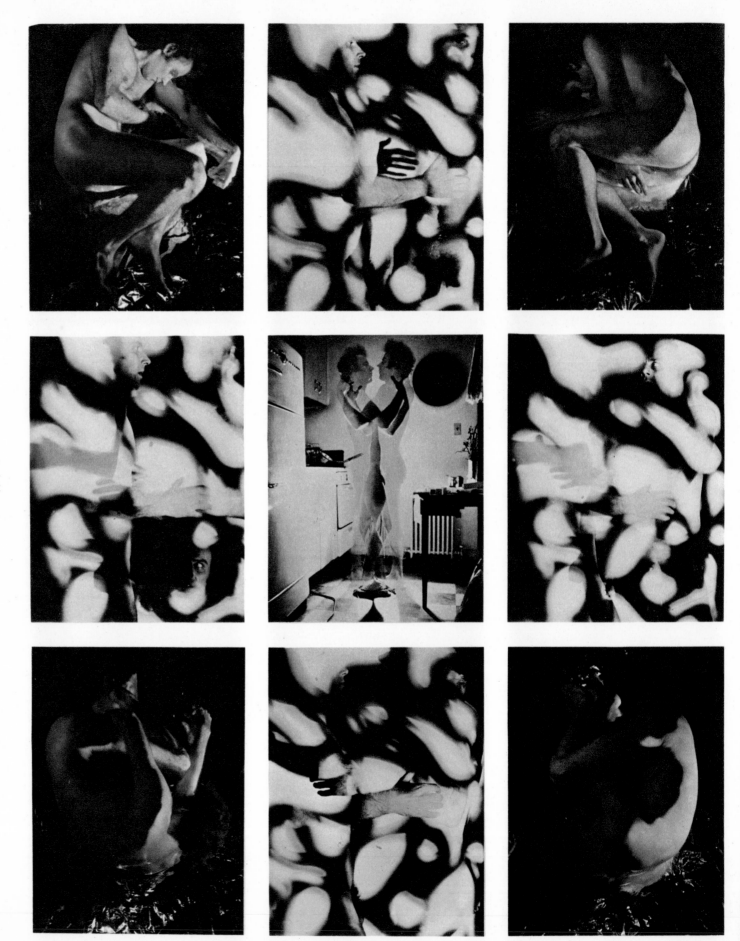

40. *Lucas Samaras.*
Autopolaroid. 1970–71.
Copyright the artist

I thought about the possibility of having a brother.
Not a brother with independent will, a brother who felt and thought
as I did. Then there would be two of us, two of me.
But what's so special about two? My father was a twin . . . I
must have known it as a child. Two of me would be able to cope
with the adults better. Two of me would be able to cope with
me better. The desire was very strong. I was willing to make
modifications. I now sometimes get a thrill at the thought of
it. Now however I am able to imagine that I have already fused
with such a double who is within me and the thrill is one of
independence.

Samaras, "Autobiographic Preserves"

doubles

Preserves: something to eat. Rich, sweet, concentrated jam or sour, acid-sharp pickles? Preserves: a safe place for wildlife. No hunting allowed. To preserve, to keep or perpetuate something of value, something precious; to embalm. Or to pre-serve. Has it been served before? Everything has layers. Everything is doubled, and doubled again. And if it is not doubled by twinning, it is doubled by splitting into halves, from the split substances of his Rutgers paintings to the split images of his chair drawings.

Boxes and books are single forms that split open, doubling and halving themselves in the process.

Samaras's "Autobiographic Preserves," which he has been writing since 1968, is an interior dialogue with himself, circuitous and circular, spiraling in and out of past and present, catching himself at poetics and bringing himself up short with irony. The same doubling or twinning of himself takes place in the self-interviews he wrote in 1963 and again in 1970, in which he is both questioner and answerer, alternating between hostility and candor.

Just as he creates alternate substances and alternate forms, his impulses toward autobiographic content are attempts at creating a double, an alternate image. He wants his work to contain the most of himself.

Samaras's plaster faces, twinned figurines, tinfoil

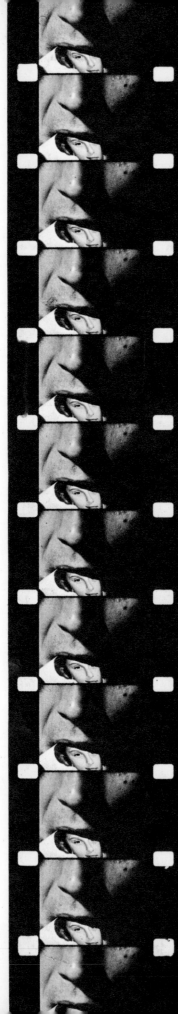

fingers, photographs and x-rays and mirror images, and even the manikin bust and the *L*'s and *S*'s were alternates to himself and to each other, just as the Room was an alternate to his New Jersey bedroom and the Mirrored Room was an alternate to the Room, and the other mirrored structures multiple alternates to it.[1] The Egyptians made statues as doubles to serve as repositories of the soul, as substitute bodies for it to inhabit, and they made duplicates, miniatures—even an inscription would do—in case the double was destroyed. For Samaras too, the name is a substitute for the self, just as a page was an alternate to a face. A shadow is a double. A mirror image is a reverse image, doubling like the double image of his nude photograph with the fingers. They all duplicate himself.

The alternate has to do with light; it is a fragile image. With film the medium is light—immaterial, flat, and transparent. It can contain anything. In *Self*, the movie Samaras and the author made in the spring of 1969,[2] Samaras turned film into a container of alternate images, duplicating himself and transforming the images of his art into real physical objects. A knife that had appeared in an acrylic painting or a flaming match from a silkscreen in *Book* became actual but not ordinary. The round lettering of his early word drawings became the edible alphabet-soup noodles that spell his name on a dinner plate. Messy breakfast and Grand Guignol dinner are like live enactments of earlier art objects. Looking equals eating, and remembering. Love equals annihilation as he swallows photographs of his parents, like Chronos eating his children.

Rooms as art environments turn into real rooms —bedroom, kitchen, bathroom—that contain him. One of his most recent boxes, containing himself as well as his familiar substances, is taken apart, un-made, destroyed—sacrificed to the sounds of bird cries. In preparation for shooting one day he turned his bathtub into a container for a collection of his objects, substances, works—and himself, immersed in them.

It is possible to see *Self* as an autobiography of his life[3] or of his art, or a parody of films about artists

41. Film strip from the movie *Self*. 1969

(Picasso paints a picture). Or a cannibalistic joke on himself: at the end he sticks out his tongue with the letters *s-e-l-f* on it and then eats them. Or simply a strange erotic evocation of "unreal reality," something to look at. It does not have to have significance. Besides being artifice, art is ritual, art is exorcism, art is absolution, it is a cleansing process. It is also eroticism displaced.

What Samaras wanted was eroticism dispersed to other parts of the body and to the things it touches —sheets, slippers, food, objects. A Freudian mystery of transubstantiation imbuing everything with sensuality. A faucet or a candle can be an extension of a bodily function, and if a piece of bread can be God, a knife can be the star of a movie (a knife that he had used as a boy scout). "I was trying to make it in a way that the objects had as much importance as the person, which is what an artist's perception is anyway," he says.[4]

Samaras had wanted to make a movie for a long time. A scrawled note to himself written October 28, 1963, reads: "There is action in dreams. And little reflection. Warhol wants to make a movie. Begin with bathroom, that is, me in bathroom. Go to kitchen—to bedroom to dress to living room to pose and talk and then out into cliffs. Movie about unreal reality." *Self* bears a strong resemblance to that long forgotten note. On the New Jersey cliffs, the site of his earlier dreams of glory, Samaras—as he looks at the New York skyline and eats his lunch—re-creates the war with sounds of shooting, playing his own enemy in a black leather coat.

"What I really wanted to be was an actor," he remarks; "basically I'm a performer." As a child in Greece, buttons and spools became people for him; as a boy in New Jersey, he would turn cardboard cartons into theaters, staging plays in them with a cousin's miniature dolls. His desire for theater became subsumed in his boxes—miniature stages in which events and acts take place, and in some of which he used a photograph of himself that was originally made to leave with theatrical agents. His appearance in *Self* is not only a continuation of his use of his body in his art—it is also acting.

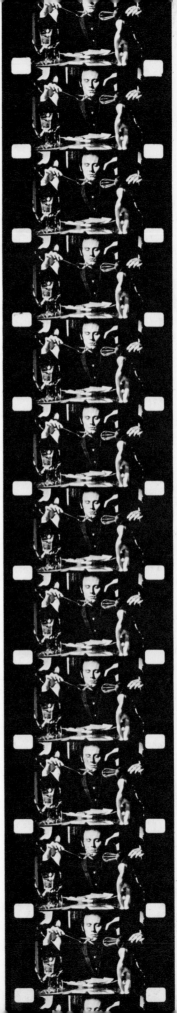

42. Film strip from the movie *Self*. 1969

43. *Lucas Samaras.* Autopolaroid. 1970–71. Copyright the artist

The film was also a prologue to his own use of photography. In December, 1969, Samaras began to make Polaroid photographs of himself.

Like knitting yarn, felt pens, cardboard cutouts, and paper doilies, Polaroids have associations with the amateur—the vacation snapshot, the family album. But whatever he touches, he annexes. Including Polaroids. Balancing precariously between parody and revelation, barely missing being corny or embarrassing, becoming art by an enigmatic necessity, he compiles a family album of himself that includes all the essential secrets that family albums omit.

Double exposures, triple exposures of his naked image, transparent, split and double like the chairs, outlined in light: Samaras embracing himself, kissing himself, making love to himself in the kitchen. Images of his profile, his hands and body fading in and out of the holes in his furniture. Or as Hamlet, bare-bottomed in yarn-covered jerkin, with a medical diagram of a vein-covered body as his double. The shadow of his face or his buttocks over the toilet; a nipple or a navel centered as a target between two strips of plaid shirt. Faces that turn into phalluses or other faces with four eyes and two mouths or halos of targets. Samaras swallowing the world, spitting out silverware like fangs, emitting sperm, contorting his body into abstract shapes, impersonating his art and other creative processes. Samaras as embryo bathed in lurid red and green light, having conceived of himself.

Or as a female: glamorous, grotesque, comic transformations of his face, using the hair from a dismantled box. When Duchamp made photographs of himself as a woman he was cool and clothed, dressed for a public afternoon. Samaras's are temptresses, seductive harlots making amorous faces in their private mirrors, practicing their art for an audience of one. Presentations of the alternate sex, of the transvestite or hermaphrodite, or evidences of androgynous desires— the wish to return to the lost whole—they are always more than disguises: they threaten the viewer's sexual identity.

The *Autopolaroids* re-do the imagery of his pastels;

among their ancestors are some pornographic pastels that he made in 1960 and 1965, and the pornographic photos he occasionally used in boxes. In the *Autopolaroids* he has used himself. The self-revelation is obvious; he seems to expose himself totally. But that makes them no less enigmatic: balancing nakedness and secretiveness, they are private, exposed, vulnerable, and yet all is facade, artifice, invention, like the "Autobiographic Preserves." Alternating between absurdity and obsession, balancing attraction and repulsion, hanging between the commonplace and the miraculous, they reveal everything and nothing. For whatever privacy is revealed is not left intact, is not *cinéma vérité*: passed through the sieve of art, it is less a personal secret than a human secret. Exposing himself, he exposes everyone.

And just when he seems to have revealed himself, he turns his body into a piece of Neoclassic statuary; no longer naked and exposed, he mocks artistic conventions of nudity with ideal "artistic" poses and a bouquet of plastic flowers or a giant peony as a phallic figleaf. Or with exaggerated perspective distortions he mocks the conventions of photography and makes mutations of the body. And he turns the Polaroid into a piece of "art" by drawing decorative striped and dotted backgrounds around himself with colored felt pens. Life is only the germ, the sketch, for art. "I am my own investigation territory,"[5] he wrote in 1966 concerning his use of the photograph of his own face. Other artists sublimate their egos; Samaras puts himself in his work. His transgressions expose the fact that art begins as autobiography and is couched in eroticism.

## NOTES

**1** For Samaras the double is never singular. The multiplication of the double appears throughout his work, most obviously in the multiple mirror images. Boxes that split into several segments recur (the first contained mirror; another contained a series of pinnacles). Their sectioned accordioning form relates not only to his accordion folding but to the form of a book, which can split as many times as there are pages. This multiplication of images and forms is also closely related to the particle nature of his surface . It is interesting that Oldenburg also felt the need of a double; his was a personified object, "Ray Gun."

**2** *Self* was written and directed by Samaras, photographed and edited by Kim Levin.

**3** The dinner sequence in *Self*, for example, refers to horror films and to a dinner scene he did in Ray Saroff's film in 1963 in which he used *Small Breakfast*, as well as to his own Dinners, one of which was dedicated to Bela Lugosi. A brief sequence of a bowl of spinning milk on a tapestry is a purely visual image (the whirlpool), but for Samaras it has a complex iconography. The tapestry, of

Pericles addressing the Athenians, was damaged when a shell fell into his house in Kastoria, killing his grandmother. Pericles is a symbol of his Greek ancestry and of his grandmother; into the spinning maternal milk he puts a spoon of red ink (blood) in a reversal of eating.

**4** An attempt was made by the author to shoot things as if seen through Samaras's eyes, as if the camera were inside his head, to show the preliminary stages of creation.

**5** From a letter to Martin Friedman. Taking a cue from Pollock's handprints or Duchamp's impressions, recent use of the artist's body has been mostly matter of fact and abstract, like Johns's body fragments or Morris's *I Box*. Where Samaras transgresses, and pioneers, is in his expressionism, in using himself as an erotic object. If his art resembles self-analysis, this comes out of a tradition: the artist's search for identity was central to Abstract Expressionist imagery, and the Surrealists intellectually explored the unconscious.

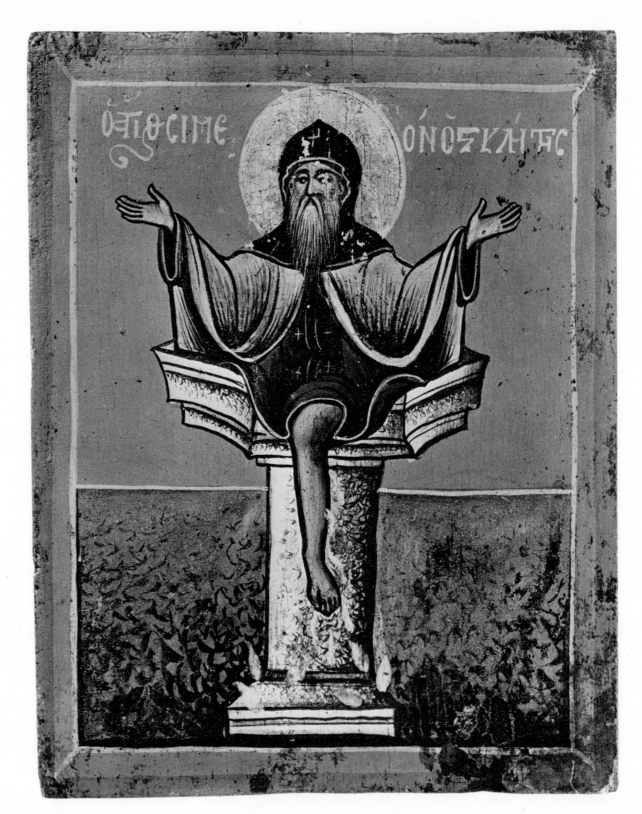

44. *St. Simeon Stylites.*
Byzantine icon Samaras bought in Greece
in 1967

Once out of nature I shall never take
My bodily form from any natural thing,
But such a form as Grecian goldsmiths make
Of hammered gold and gold enamelling
To keep a drowsy Emperor awake;
Or set upon a golden bough to sing
To lords and ladies of Byzantium
Of what is past, or passing, or to come.

W. B. Yeats, ''Sailing to Byzantium'

In the spring of 1969 Samaras went to Yale to teach a seminar. He went like a new Prometheus with a valise containing nineteen different kinds of fire. He wanted the students to pick a word and make sculptural visualizations of that word. His example was fire. His demonstration took place in a darkened room: it included a lit match, a burning candle, a propane torch, a fake-flame light bulb, chemical flames, electrical flames like lightning sparks from an electrostatic machine that had been made for him by his physicist friend Tsipis,[1] and a Victorian bulb that gave off a spark—supposedly to cure rheumatism. The demonstration had a strong element of magic, also of evil: to the students he was the demonic magician, playing with fire.[2] By coincidence the Yale Art School burned that summer.

A fascination with light pervades Samaras's work. The things that attract him are things with an affinity for light. Glass, water, lenses, prisms. Shadows and transparencies. Flames and smoke. Things that transmit light, catch light, bend it, deforming images or separating into elusive spectrum colors. Shimmering, ephemeral Tiffany, carnival glass, oxidized glass, oil slicks, rainbows. Iridescent veils. Glistening objects: sequins, jewels, stars, butterfly wings, peacock feathers. Surfaces that shine and reflect: mirror, metal, Mylar. The moon is on his ascendant.

Light itself, and images of light: early pastels of faces illuminated in the conical beam of a flashlight or hands holding lit matches up to faces with cigarettes; later acrylic paintings of hands, flaming matches, and smoke. And the effects of light: steel-wool shadows.

the last byzantine

45. Samaras's parents and relatives at a carnival in Kastoria. 1934

shadowy x-ray images, immaterial shadows used to trace profiles or, before any of these, the smoke from a candle used for drawing on tinfoil. From his "invitation to a burning" in 1960 to his 1970 use of actual flame to create the charred velvety black surface on chairs, and his use of matchsticks to make a miniature chair that threatens to ignite, he has sought luminosity.

Light has always been a vehicle for revelation, reverence, awe. It carries religious information. Luminosity or "illumination" has been equated with visionary experiences—drug-induced or religious—in which the radiance of light and the intensification of color are joined with a recognition of heightened significance, but a significance in which objects do not stand for anything but themselves. Aldous Huxley proposed that a common vision of paradise exists in everyone's unconscious. He classed as vision-inducing material things which are self-luminous: gems and flames, and gemlike things—glass, flowers, shells, feathers, candles, metals, "the transfiguring light of dawn or sunset," and geometric patterning.[3] Dionysius the Areopagite, citing Biblical descriptions of God, wrote: "And they call Him a Sun, a Star, and a Fire, and Water, a Wind or Spirit, a Dew, a Cloud, and Archetypal Stone, and a Rock."[4]

Religious art invokes the supernatural with splendor and with light. It aims at the marvelous and the terrifying, tempting and threatening alternates: the promise of paradise or the menace of hell. Samaras's art has all the trappings of religious art, but from the time of the glass "altarpiece" it has been used in enacting profane liturgies, psychological dramas of creation.

His innovations are in the area of sensibility, in the stating of a perverse eroticism, a sexuality "so extreme as to be barely recognizable as such."[5] The importance of his polymorphous *oeuvre* is in its transformation of psychological secrets into visual forms, in its materialization of the unconscious in ways the Surrealists never dreamed of.

For the formal mainstream concerns of the 1960s are a strong undercurrent in his work. He shares with his contemporaries a conceptual concern with structure, a formalist approach. He diverges in placing this structure at the service of dreams, fears, and desires. In his use of basic forms to create post-Surrealist fantasies and post-Dada frustrations, formalism dissolves into illusionism and is consumed by metaphor.[6] But the process is very concrete, very literal.

The importance of his work is also in its cryptic attitude toward style. It is at once formalist, illusionist, expressionist, but in its stylistic excesses are allusions to the absurdity of style.[7] And in his absorption of minor art forms is an attack on the ruling arts. He rejects the past, not by denying it but by weaving into himself a web of predecessors and competitors. He insists on acknowledging all historical debts, real or imagined, unraveling his own originality from them in the guise of commentary.

Are you neo-Dada? If I were to be Dada I don't know how I could improve upon or dazzle Duchamp. I'd probably sign my name on his lips or on his hands. Beyond that I wouldn't want to be neo anything. But if you had to give me an old name otherwise you'd feel bad, then call me the last Byzantine." Samaras, self-interview, December 1 and 2, 1963

"*Byzi* in Greek means breast," Samaras added to lighten the epithet, but his work does have the subtlety, the complexity, the refinement, the artifice of the Byzantines. The shimmering immateriality, the material splendor. Byzantium: enameled glass and carved ivory, silver filigree, beaten gold, silks and goblets and glittering glass mosaics. Encrustations. Jewels. Hagia Sophia. Galla Placidia. Where artificial birds twittered in brittle metallic trees and peacock's flesh was held to be incorruptible. "Before the Emperor's seat stood a tree, made of bronze gilded over, whose branches were filled with birds, also made of gilded bronze, which uttered different cries, each according to its varying species. The throne itself was so marvelously fashioned that at one moment it seemed a low structure, and at another it rose high into the air," recorded Liuprand of Cremona on a visit to the Byzantine emperor in A. D. 949.

Byzantium has the connotation of toys, trinkets, and luxury. Of escape, of fantasy pleasures and formal

ritual. But the ascetic monastic ideal of renunciation was also highly developed. "I wanted to become a monk and live serely on a mountainside monastery. I also wanted to become a doctor so that I could use delicate instruments tweezers knives scissors razors —instruments that would extend and improve my hands," Samaras wrote in 1963.

For the Byzantines, light was equated with God. "Fire itself is splendid beyond all material bodies," said Plotinus.[8] And so there was in Byzantium "an absorbed interest in optics, which led not only to many experiments in perspective but to a concentration on Light —conceived as in itself incorporeal, though finding expression in contrasted colours."[9] Besides a delight in optical contrivance there was a love of symmetry, rhythm, "constantly altering geometric patterns," and a "taste for the sumptuous haphazard."[10] The sense of touch was highly prized among the Byzantines, for the minor arts in which they excelled depend on tactile sensation. Highly formal and with a highly charged imagery, Byzantine symbolism involves objects with a cluster of associated images conveying hidden meanings to the initiated. All of this is applicable to Samaras's work.

Just as it was forbidden to touch certain religious objects, certain icons were meant to be touched. The iconodulists venerated miraculous icons, supposedly made by God in a manner not unlike Samaras's tinfoil impressions: "When the painter could not paint because of the light that shone from His countenance the Lord Himself put a garment over His own divine and life-giving face and impressed on it an image," according to St. John of Damascus.[11]

The Iconoclasts burned the hands of a monk who was an icon-painter, as punishment. Byzantium was a place where art was stronger than life, where art caused wars and revolutions. It was also a place where icons were made which portray courtesans, lyre players, and dancing girls.[12]

Samaras is both iconoclast and iconodulist. In Vasiliev's *History of the Byzantine Empire* it is stated that "the image-worshippers sometimes took the adoration of pictures too literally, adoring not the person or the idea represented by the image, but the image itself or the material of which it was made." On the other hand: "Images were broken, burned, painted over, and exposed to many insults."[13] Samaras embodies the spirit of both: the love of objects, images, and the materials of which they are made, and also the ruthless will to destroy them. The attraction and the fear of beauty or pleasure: it is evil, the devil's temptation. Lucas equals St. Luke, the Macedonian physician who is the patron saint of artists, and Lucas equals Lucifer, who would be god.[14]

## NOTES

**1** Tsipis made this for Samaras in 1965. Samaras never used it in his work, though John Gruen oddly mentions it (in "The Art of Cruelty," *World Journal Tribune*, October 9, 1966) as being in the 1966 exhibition, which it was not. Says Tsipis about Samaras: "He always had a certain amount of respect and awe for science. He was fascinated by the little tricks you could do, like making bubble chamber pictures. I made him a 'Jacob's ladder,' an electronic machine that the sparks travel up like rungs of a ladder. We were going to make a spark chamber, a device which shows the track of a cosmic ray as a luminous beam, but it involved high voltage in public." Though Samaras used a carpenter as early as 1960 to build some of the boxes, and the mirror rooms are constructed by others from Samaras's diagrams, his art is basically antitechnological: craftsmanship is more important. He uses the materials of technology but he treats technology as a craft.

**2** According to Stuart Shedletsky, who was a student in that class, Samaras's work always offers extremes: if the eccentric spectrum stripings of his yarn suggest light at its most seductive, broken into spectrum colors, his use of the flame is light at its most threatening.

**3** "Religious art has always and everywhere made use of these

vision-inducing materials. The shrine of gold, the chryselephantine statue, the jeweled symbol or image, the glittering furniture of the altar—we find these things in contemporary Europe as in ancient Egypt, in India and China as among the Greeks, the Incas, the Aztecs,'' writes Aldous Huxley in *Heaven and Hell*.

**4** Quoted from notes made by Samaras while studying Byzantine art history. A list more appropriate to Samaras's work, containing a remarkable number of objects used by him, is mentioned by Mircea Eliade in *Mephistopheles and the Androgyne*: "The *Shvetasvatara Upanishad* (II, II) carefully notes the 'preliminary forms (*rupani purassarani*) of Brahman' which reveal themselves during yogic practices in the form of luminous manifestations. These are mist, smoke, sun, fire, wind, phosphorescent insects, lightning, crystal and moon. The *Mandala Brahmana Upanishad* (II, I) gives quite a different list: the form of a star, a diamond mirror, the orb of the full moon, the sun at midday, a circle of fire, a crystal, a dark circle, then a point (*bindu*), a finger (*kala*), a star (*naksatra*), and again the sun, a lamp, the eye, the radiance of the sun and of the nine jewels."

**5** Peter Schjeldah, "Boxie Was a Cutie Was a Sweetie Was a Blondie Was a Pootsy," *The New York Times*, Sunday, August 24, 1969.

**6** Boxes and rooms are expressive or illusionistic cubes, geometric shapes as well as Freudian containers.

**7** The smiling face that recurs in Samaras's pastels and Polaroids is less an echo of the archaic smile of Greek *kouroi* or an antithesis to Pergamene agony or Munch's scream than an acknowledgment that, as Ortega y Gasset proposed: "Art is appreciated precisely because it is recognized as a farce . . . laughing off everything, itself included." The joke, however, is demonic, not jovial.

**8** *Ennead*, I, 6, 3,

**9** Gervase Mathew, *op. cit.*, p. 1.

**10** *Ibid.*, pp. 4, 60.

**11** *De Fide Orthodoxa*, III, 16.

**12** Mathew, *op. cit.*, pp. 74–75.

**13** A. A. Vasiliev, *History of the Byzantine Empire*, The University of Wisconsin Press, Madison, 1952, pp. 256, 261.

**14** Since 1970 when this text was written, the chairs and the *Autopolaroids* have been exhibited. New boxes have been made: rusted Cor-ten steel boxes in 1971, and painted wire-mesh boxes in 1972. Samaras's work has been seen in a retrospective at the Whitney Museum. And new Polaroids, made with the SX-70 in 1973–74 and called *Photo-Transformations*, have appeared. Throughout the 1960s Samaras's work stood apart, alien to the mainstream. With the dissolution of formalism the situation began to change; both the art world and Samaras's stature in it are different now. To trace his new work or his relevance to recent art by tacking on extra chapters would be inadequate. A different book would have to be written. I prefer to leave the text as it was and these other tasks to the future.

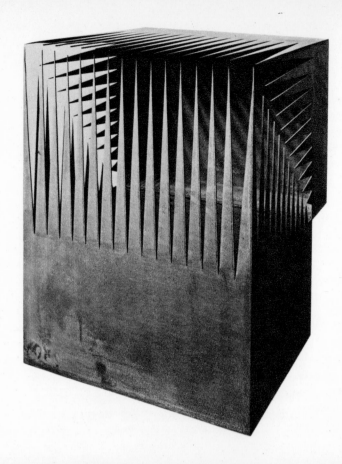

47. *Stiff Box #7*. 1971. Cor-Ten steel,
20¼ × 16 × 16″.
The Pace Gallery, New York

46. *Stiff Box #12*. 1971. Cor-Ten steel, 75½ × 55½ × 14″.
The Solomon R. Guggenheim Museum, New York

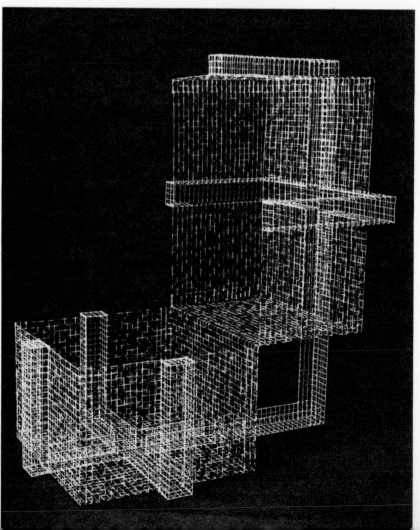

48. *Chicken Wire Box #41*. 1972.
Acrylic on wire mesh, 32 × 18 × 28″.
Collection Mr. and Mrs. George Waterman, New York

PLATES

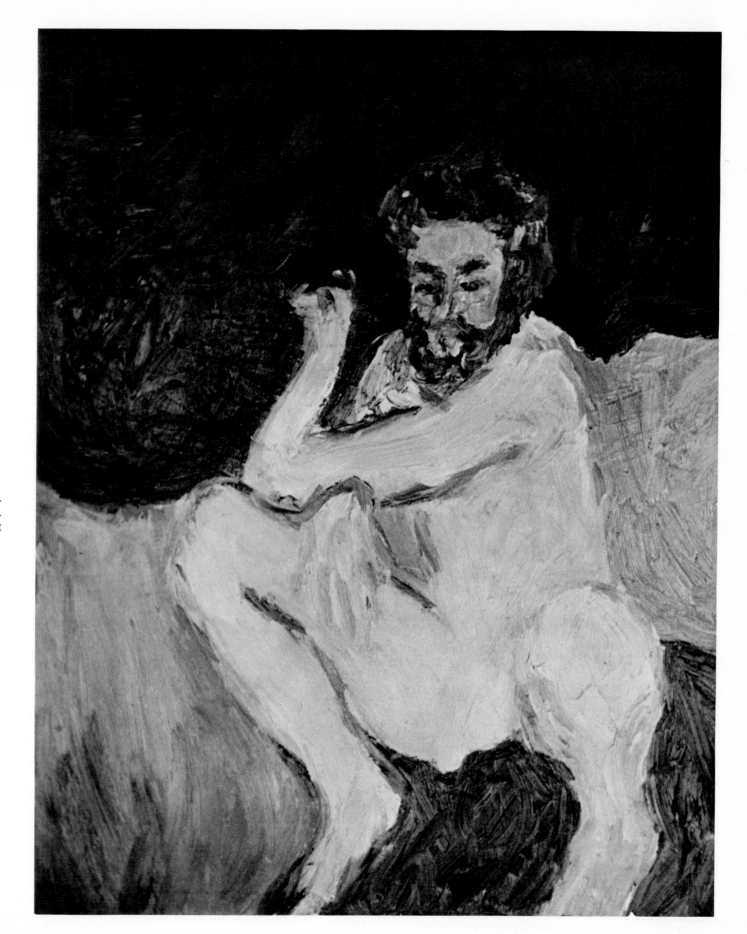

49. *Untitled* (self-portrait).
1958–59. Oil, 36 × 28″.
Collection the artist

50. *Untitled.* 1959. Pastel, 9 × 12″. Private collection, New Jersey

51. *Untitled*. 1958–59.
Oil, 18 × 14″.
Collection the artist

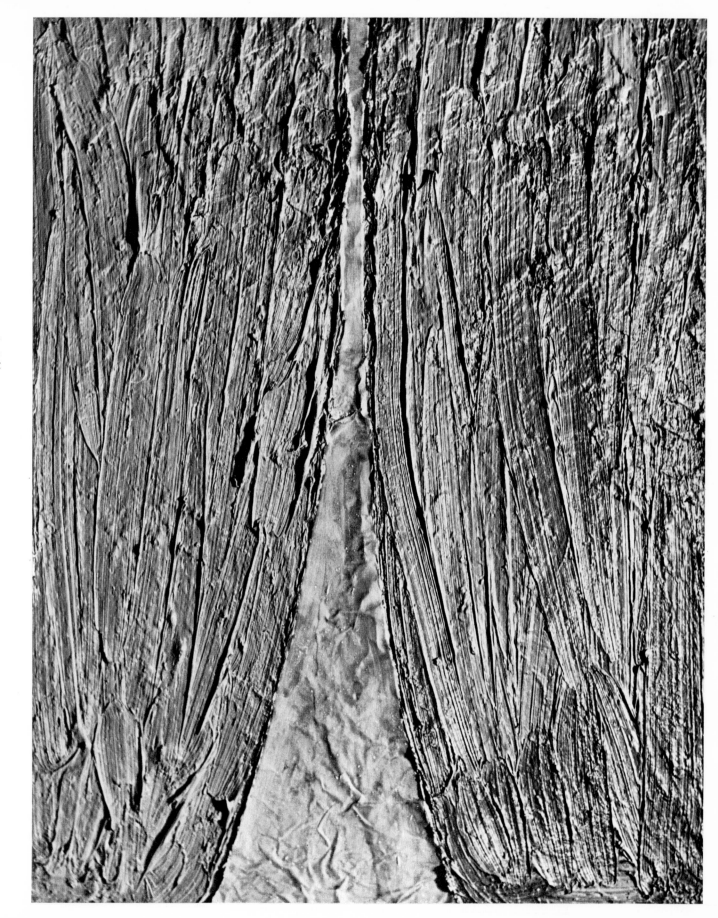

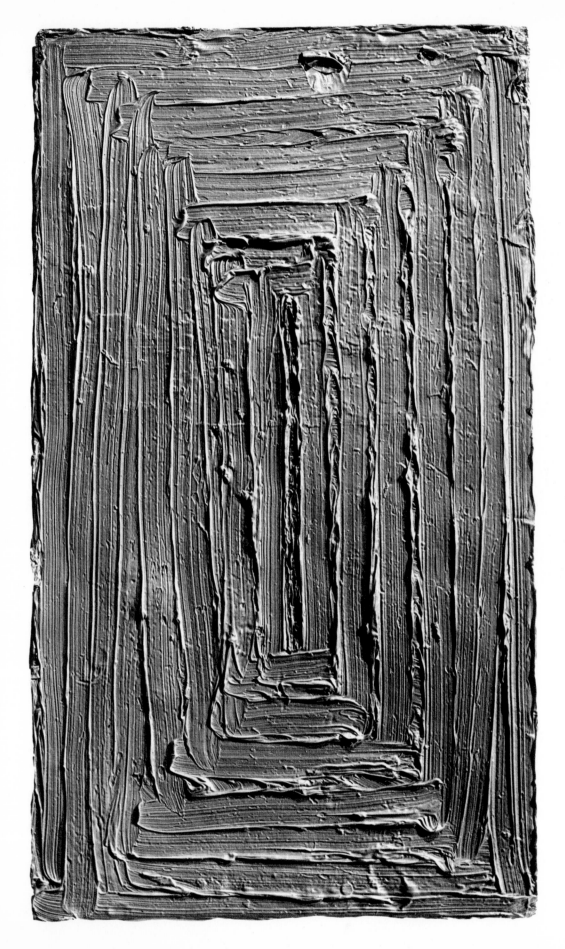

52. *Untitled.* 1958–59. Oil, 24¼ × 14¼″.
Collection the artist

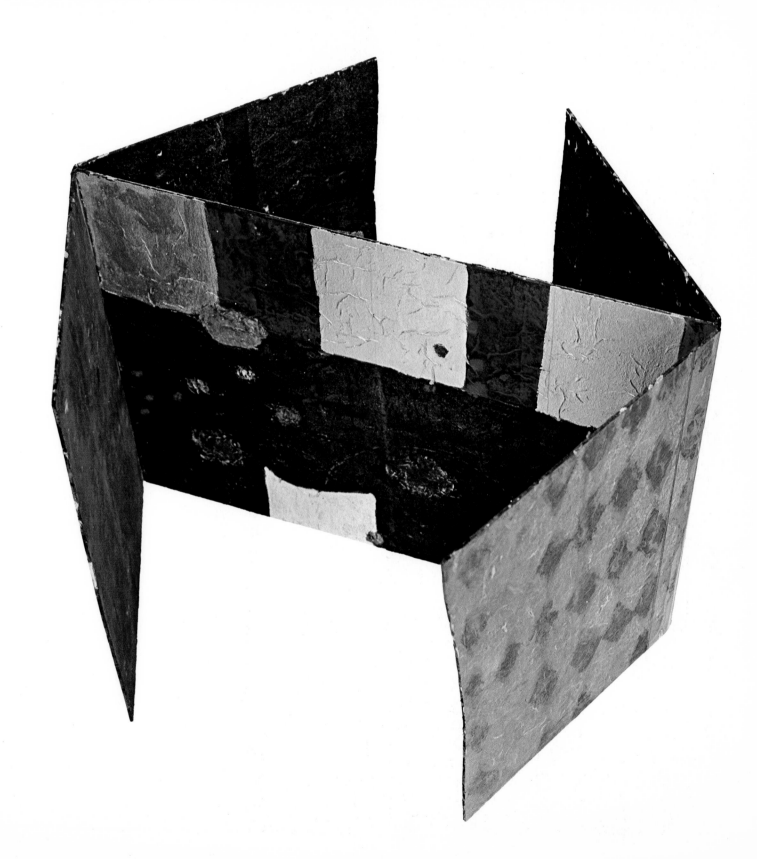

53. *Untitled*. 1958–59.
Glass, toilet paper, and paint,
12¼ × 16″ (closed).
Collection the artist

54. *Untitled*. 1959–60.
Plaster and cloth, 6 × 12 × 5″.
Collection the artist

55. *Untitled*. 1959–60.
Plaster and cloth, 8½ × 8 × 6¼″.
Collection the artist

56. *Untitled*. 1959–60.
Plaster and cloth, 11¼ × 9½ × 8″.
Collection the artist

57. *Untitled*. 1959–60.
Plaster and cloth, 9 × 7 × 8″.
Collection the artist

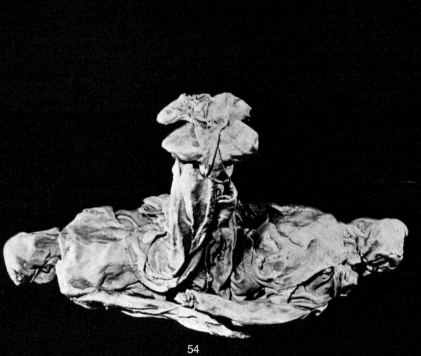

54

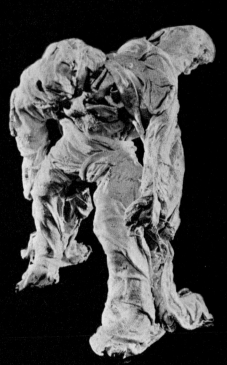

55

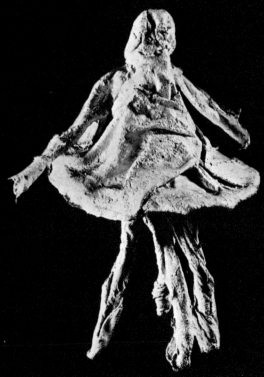

56

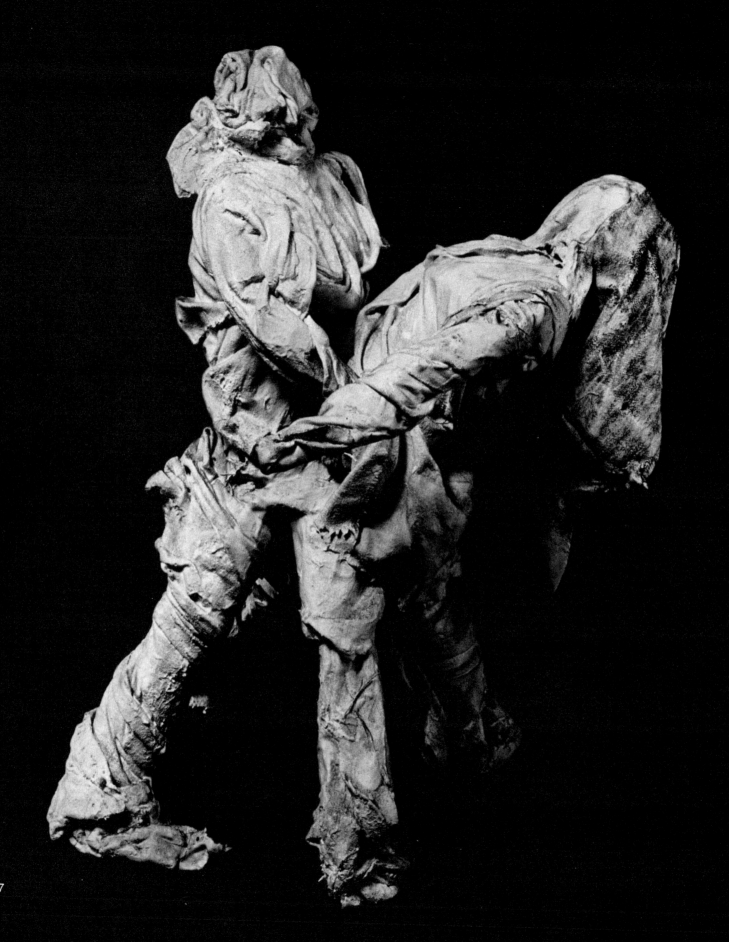

58. *Untitled*. 1960. Wood, plastered feathers, and cloth, 11 × 12 × 9″. Collection the artist

59. *Untitled*. 1961. Pastel, 12 × 9″.
Collection the artist

60, 61. Above: Samaras with untitled plaster piece (destroyed) and *Large Untitled Jigsaw Puzzle*. Left: *Large Untitled Jigsaw Puzzle* (detail). 1960. Oil on cardboard. Collection the artist

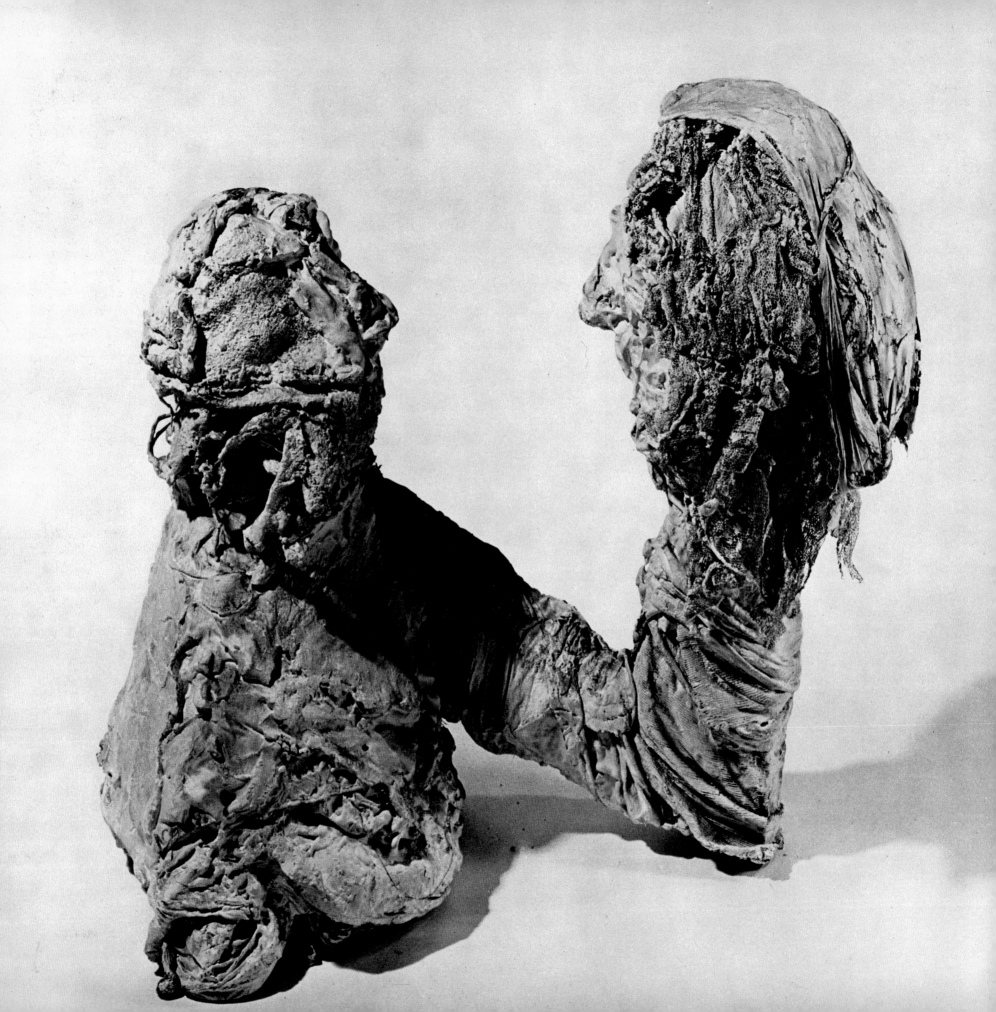

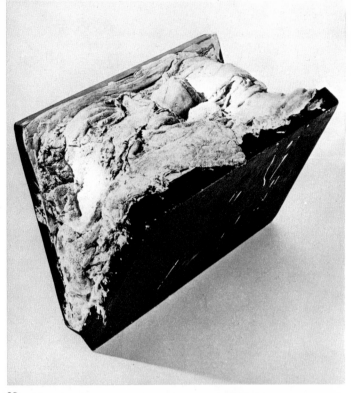

◀ 62. *Untitled.* 1960. Mixed mediums,
25 × 24 × 15″. Collection the artist

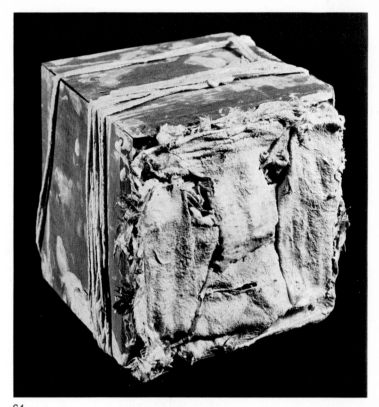

63

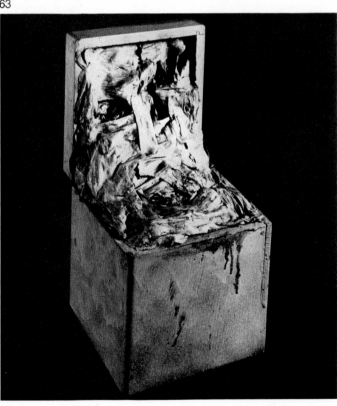

63. *Untitled.* 1960.
Mixed mediums, 13 × 13 × 18″.
Collection the artist

64. *Untitled.* 1960.
Wood, plastered feathers, cloth,
and string, 5 × 5 × 5″.
Collection the artist

65. *Untitled.* 1960.
Wood, plastered crepe paper,
and feathers, 10¾ × 6 × 7″.
Collection the artist

66. *Untitled.* 1960.
Wood and plastered cloth,
9 × 11 × 8″. Collection
the artist

64

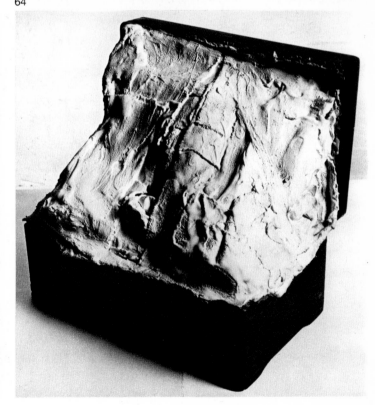

65

66

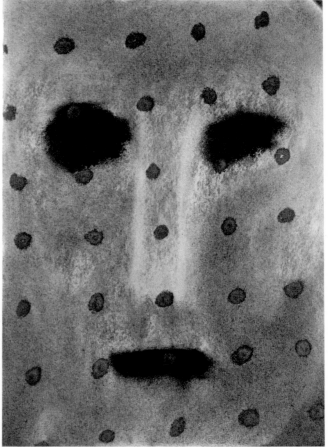

68. *Untitled.* 1960. Pastel, 12 × 9″.
Collection Marion B. Stroud, Philadelphia

69. *Untitled.* 1960. Wood, plaster, ▶
mirror, and tacks, 27½ × 17½ × 1½″ (closed).
Collection Mr. and Mrs. Guy A. Weill, New York

67. *Untitled.* 1960. Pastel, 12 × 9″. Collection the artist

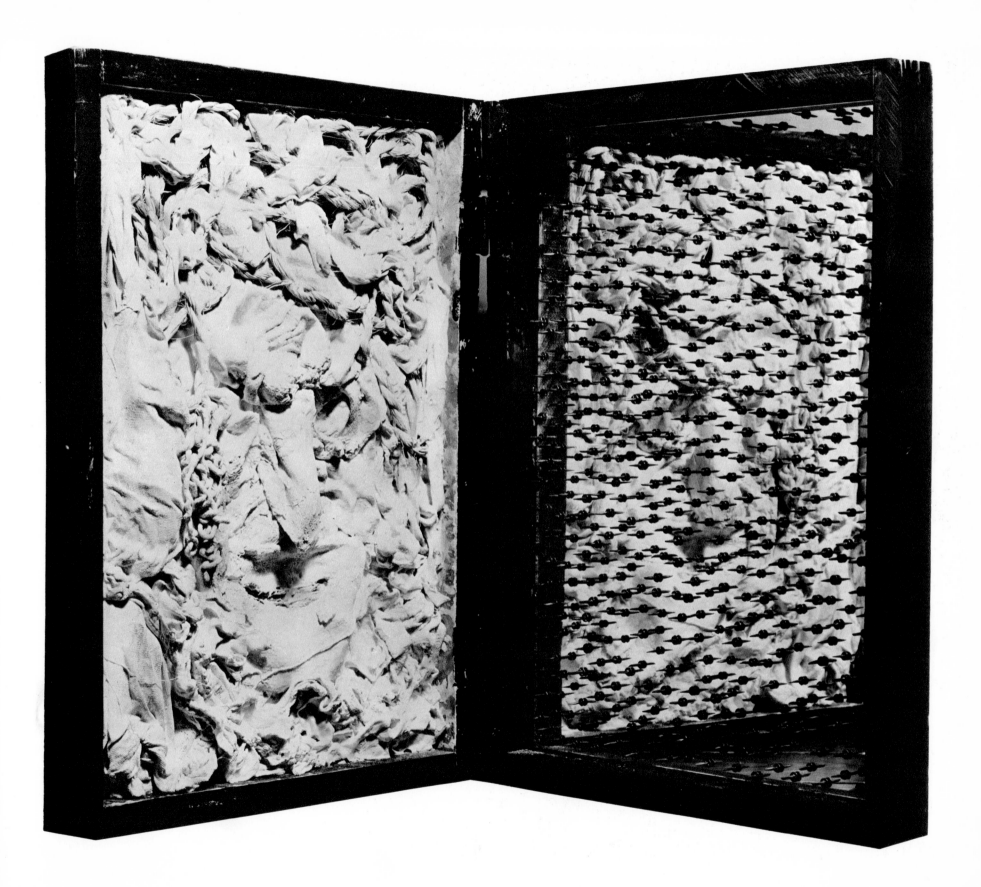

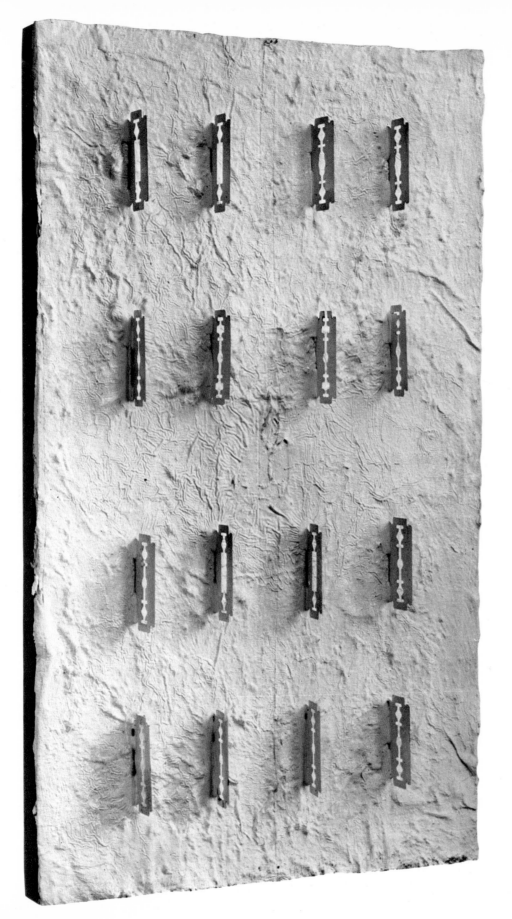

70. *Untitled*. 1960. Wood, metal printing plate,
toilet paper, razor blades, and paint, 15 × 9¼ × 1¾".
Collection the artist

71. *Untitled*. 1960. Wood, Masonite, ▶
toilet paper, nails, and paint, 16 × 17½ × 2¼".
Collection the artist

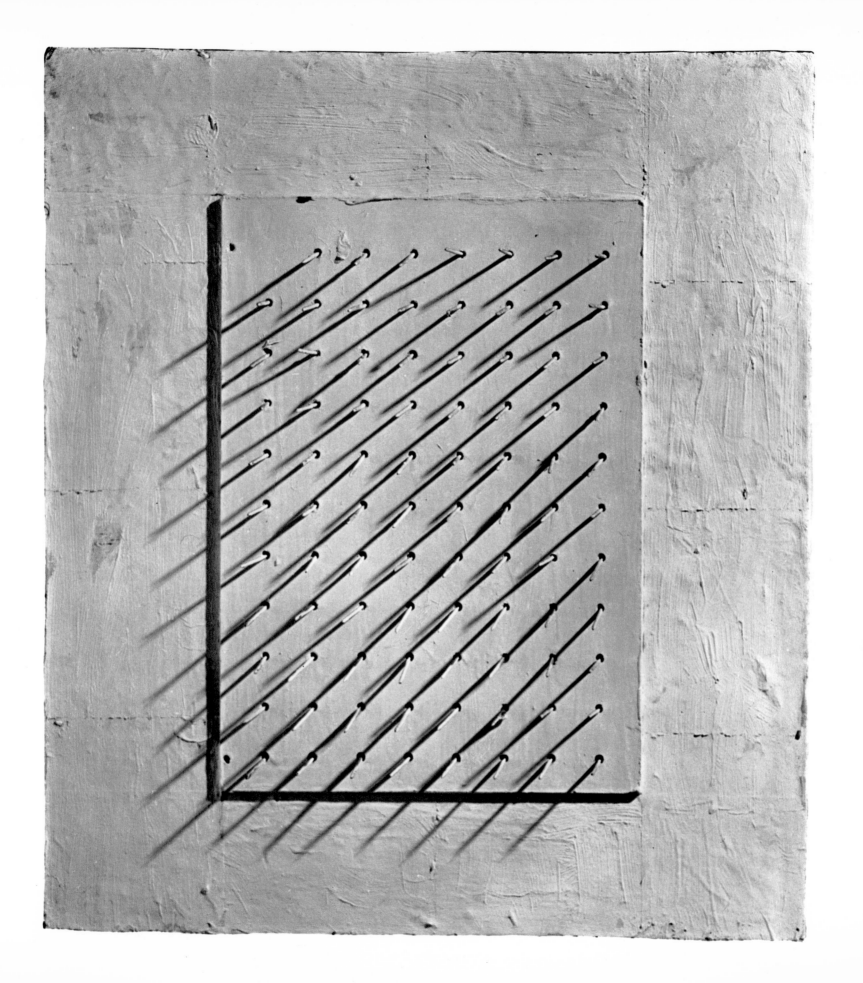

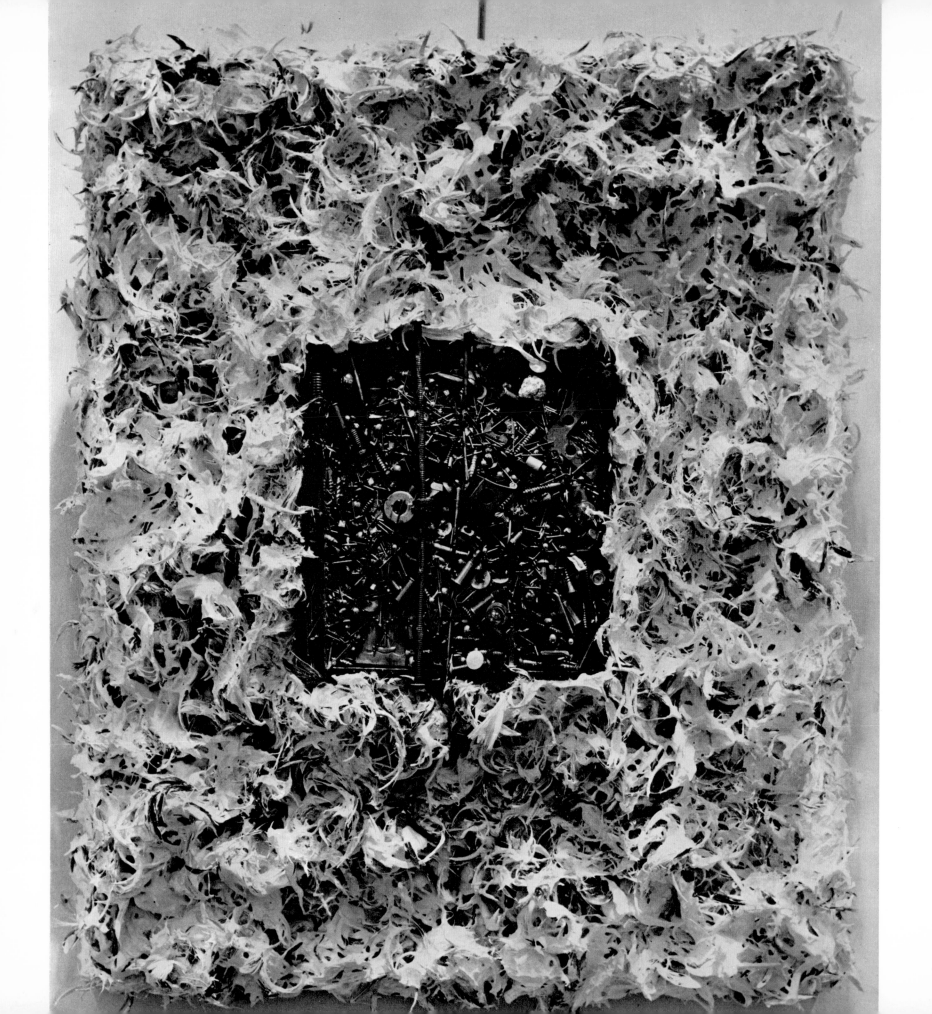

72. *Untitled.* 1960–61. Plastered feathers
and hardware, 23 × 18½″.
The Museum of Modern Art, New York.
Larry Aldrich Foundation Fund

73–75. Below: *Untitled.* 1961. Mixed mediums,
3½ × 5½ × 5½″. Bottom left: *Untitled.*
1961. Mixed mediums, 4½ × 4¼ × 1⅛″.
Bottom right: *Untitled.* 1961. Mixed mediums,
4 × 2 × 1″. Collection the artist

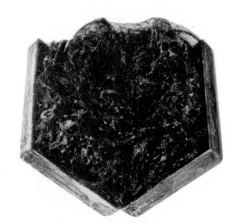

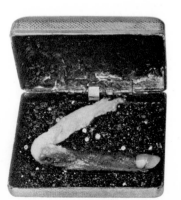

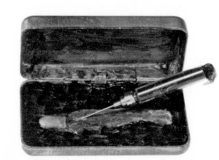

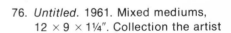

76. *Untitled.* 1961. Mixed mediums,
12 × 9 × 1¼″. Collection the artist

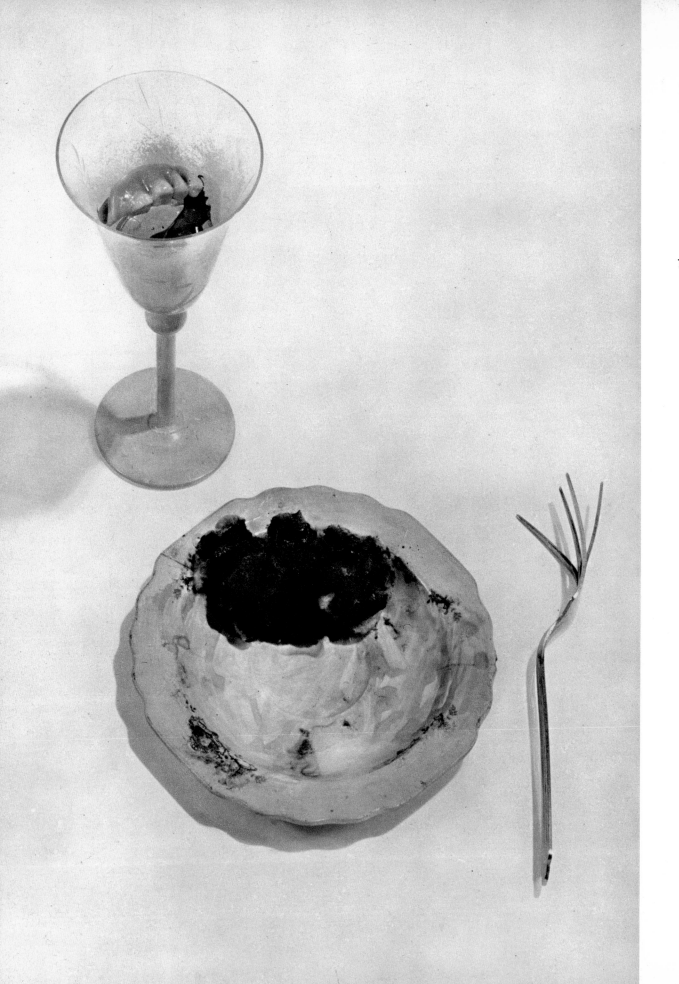

77. *Small Breakfast.* 1961. Mixed mediums,
12 × 7 × 7″. Collection the artist

78. *Untitled.* 1961. Mixed mediums, ▶
18 × 15 × 3″. Collection the artist

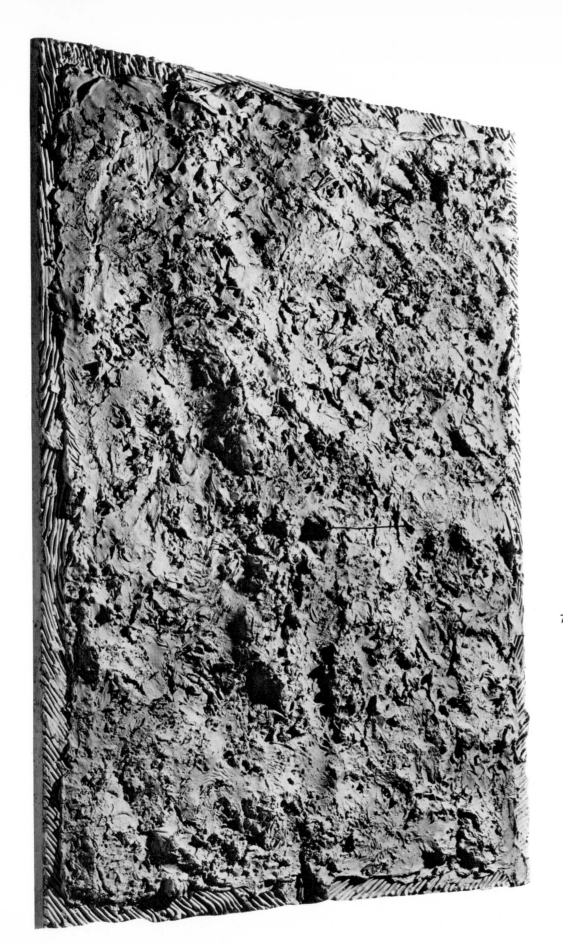

79. *Untitled.* 1961. Liquid aluminum,
Sculpmetal, and straightened safety pin,
24 ×18 × 6″. Collection the artist

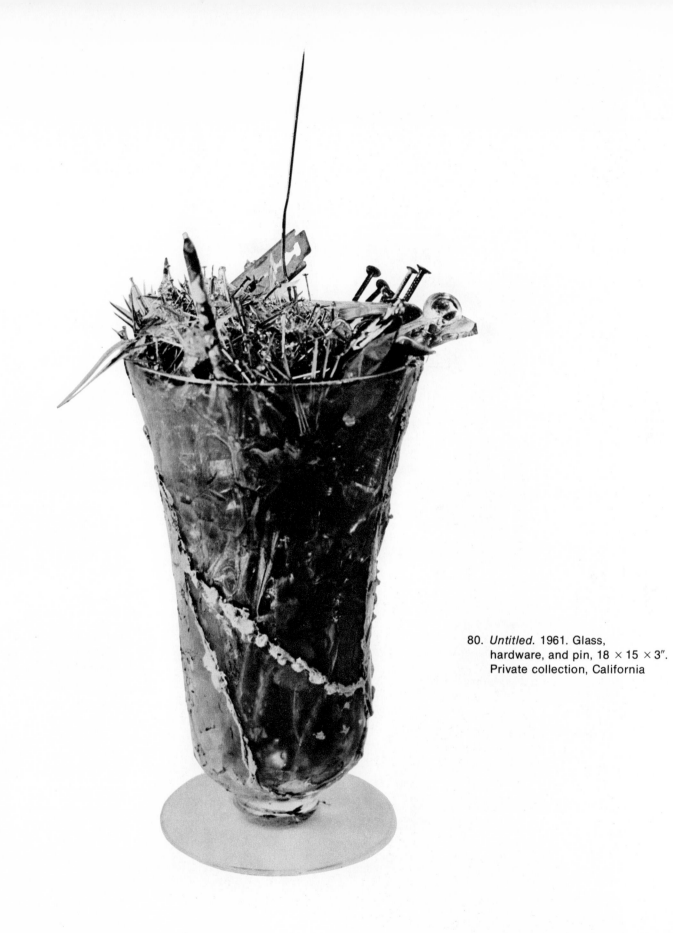

80. *Untitled.* 1961. Glass,
hardware, and pin, 18 × 15 × 3".
Private collection, California

81. *Untitled.* 1961.
Pastel, 12 × 9″.
Collection the artist

82. *Untitled.* 1961 ▶
Liquid aluminum
and spoon, 30 × 24″.
Collection the artist

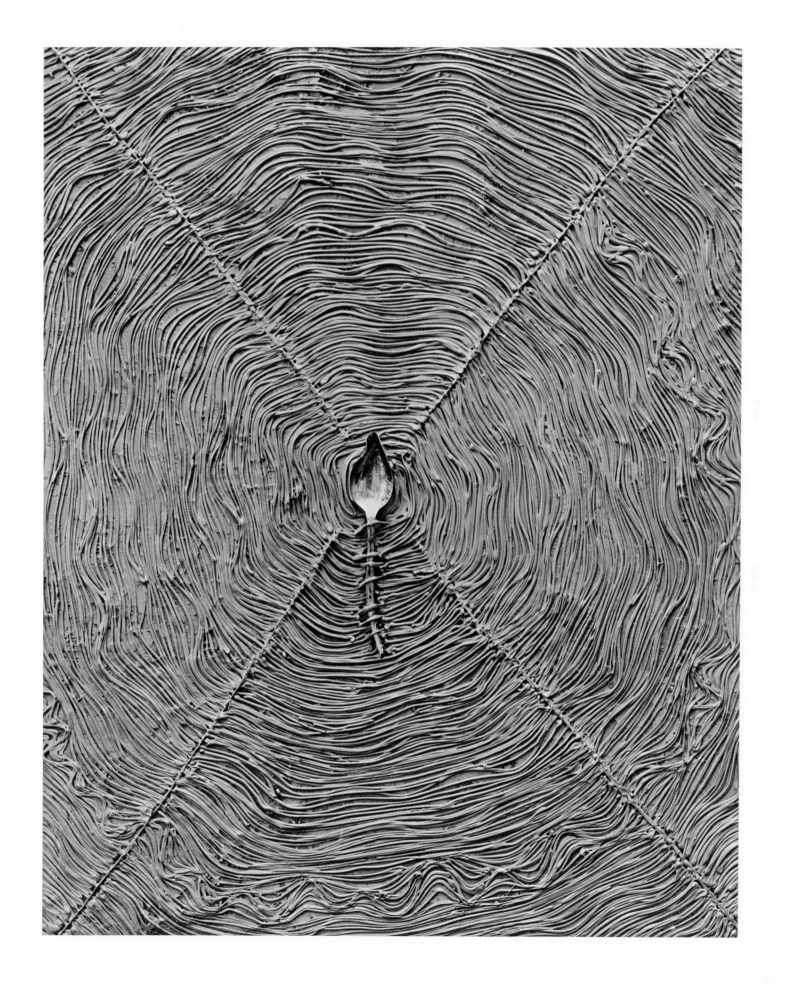

84. *Floor Piece* (in sixteen parts).
1961. Sculpmetal, 48 × 48″. Collection the artist

83. *Drawing.* c. 1961. Ink, 11 × 8½″. Collection the artist

85. *Untitled.* 1961.
Pastel, 12 × 9″.
Collection the artist

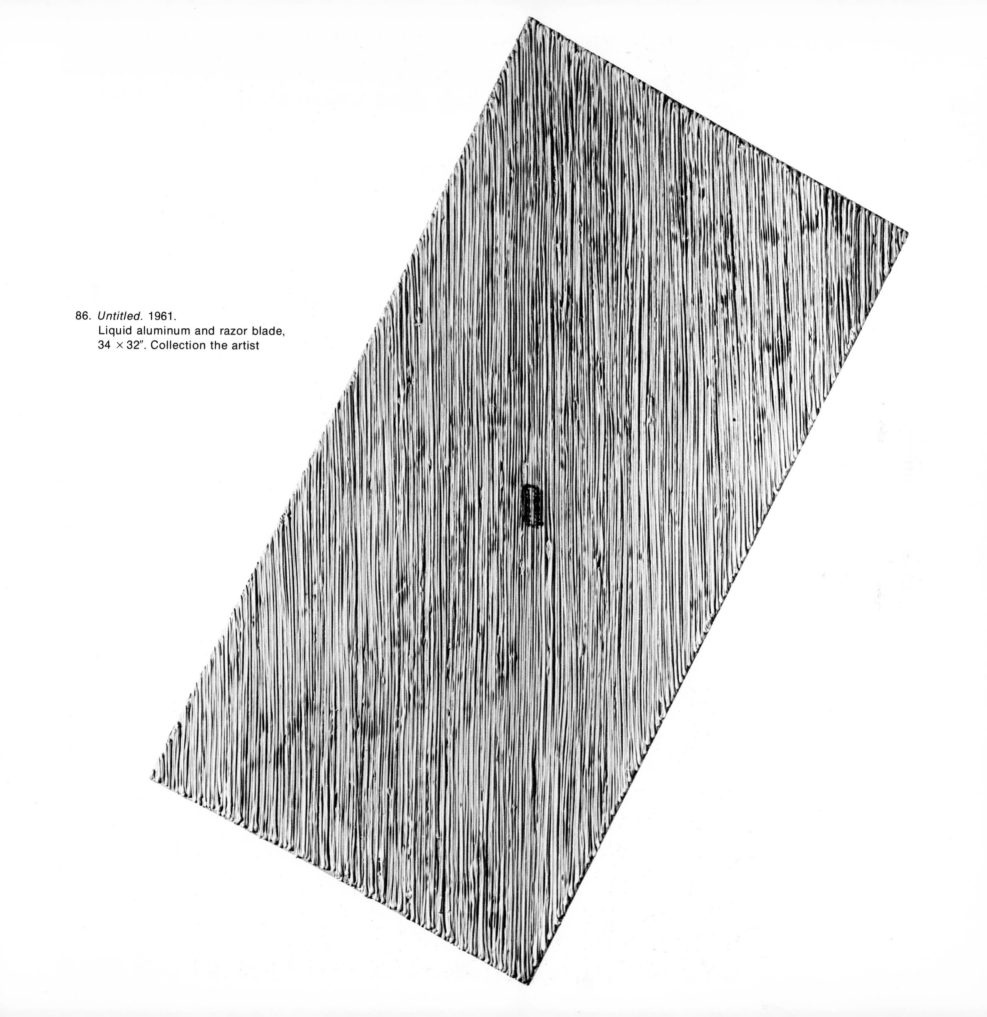

86. *Untitled.* 1961.
Liquid aluminum and razor blade,
34 × 32". Collection the artist

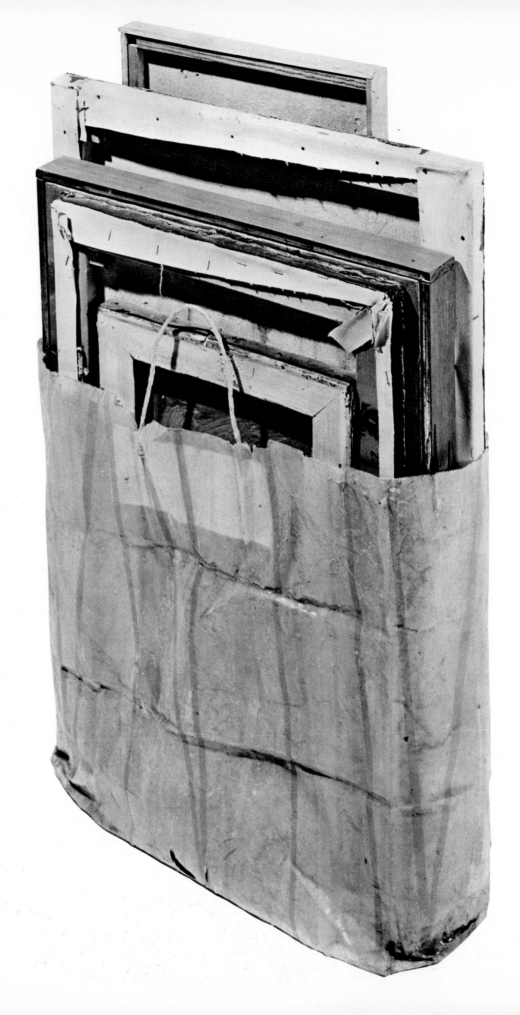

87. *Paper Bag #3.* 1962. Paper bag
with paintings and scratched mirror,
31 × 22 × 9″. Collection the artist

88. *Dinner #0.* 1963. ▶
Mixed mediums, height 21¾″.
Collection Mr. and Mrs.
Jack W. Glen,
Corona Del Mar, California

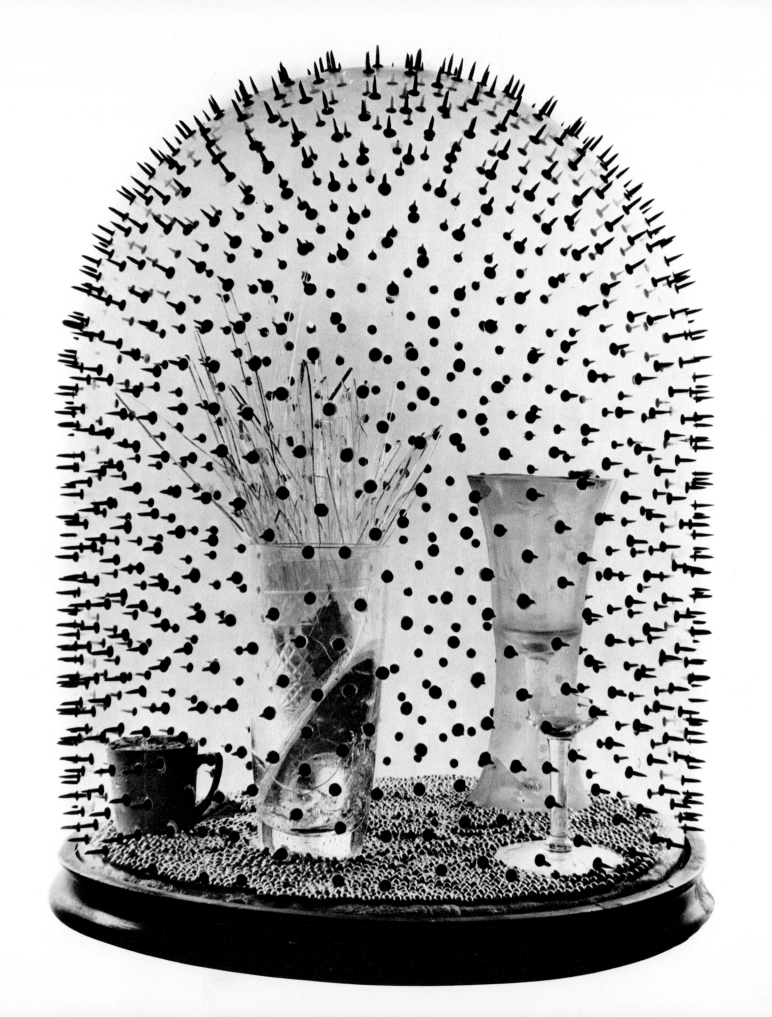

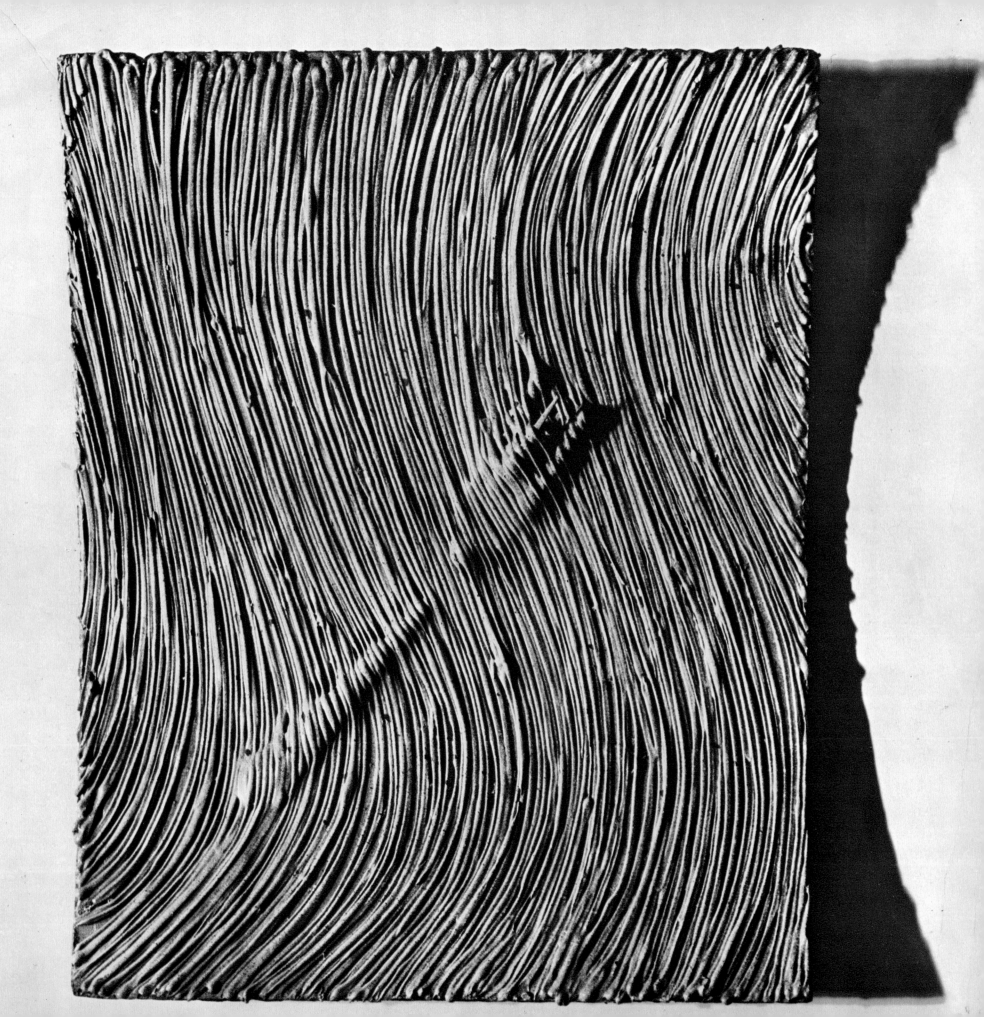

◀ 89. *Untitled.* 1961. Liquid aluminum and fork, 11 × 9 × 3″. Collection Mr. and Mrs. B. H. Friedman, New York

90. *Lucas Loves.* 1962. Ink, 11 × 8½″. Collection the artist

91. *Lucas Is Crying.* 1962. Ink and epoxy, 9½ × 7″. Collection Millie Glimcher, New York

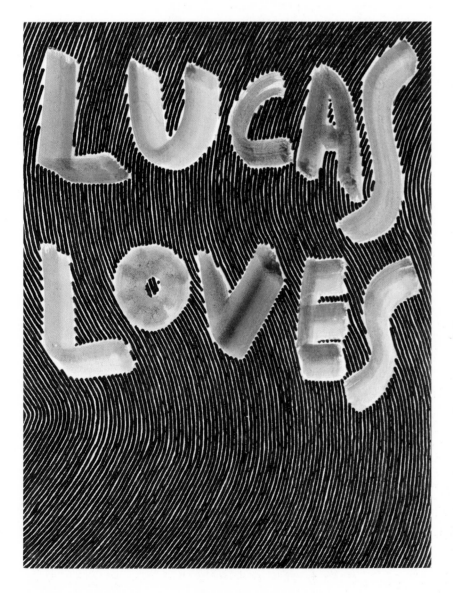

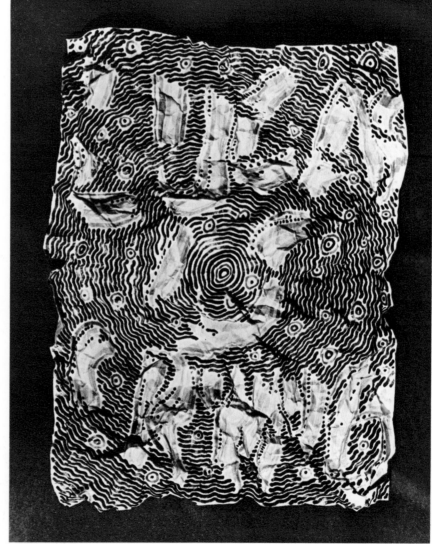

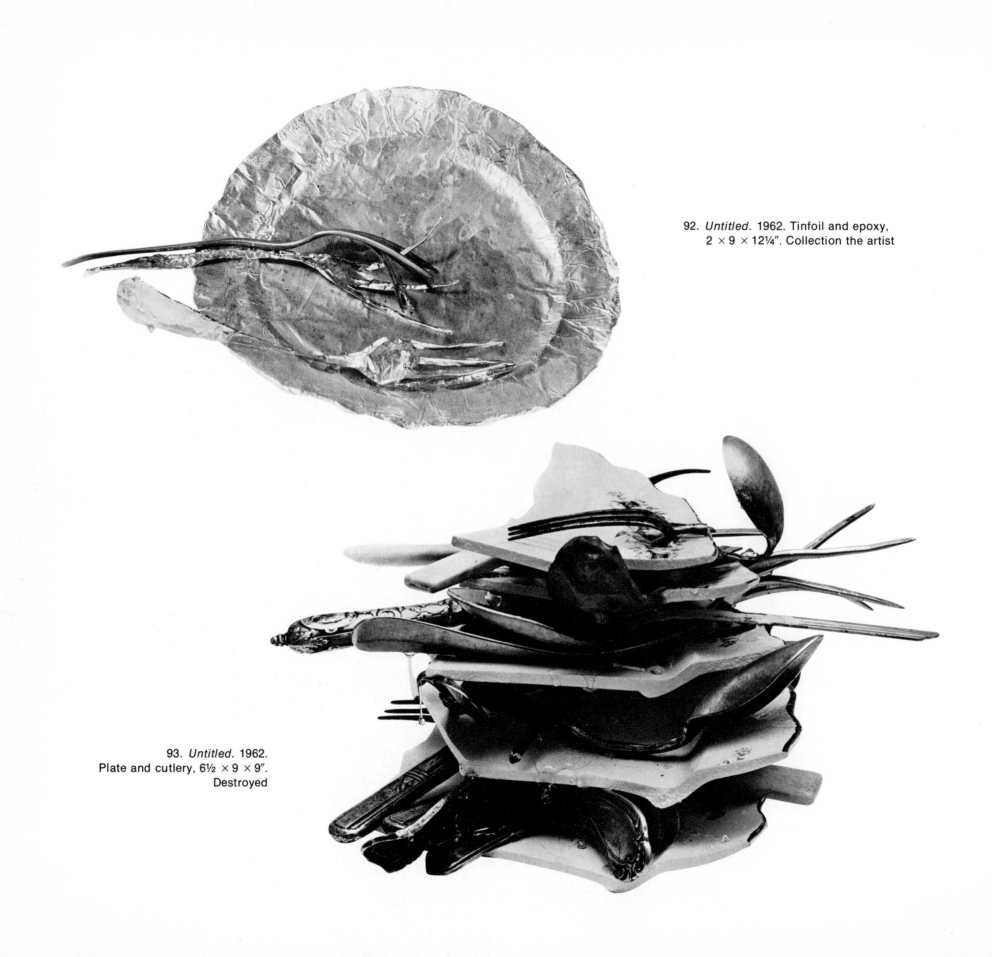

92. *Untitled.* 1962. Tinfoil and epoxy,
2 × 9 × 12¼″. Collection the artist

93. *Untitled.* 1962.
Plate and cutlery, 6½ × 9 × 9″.
Destroyed

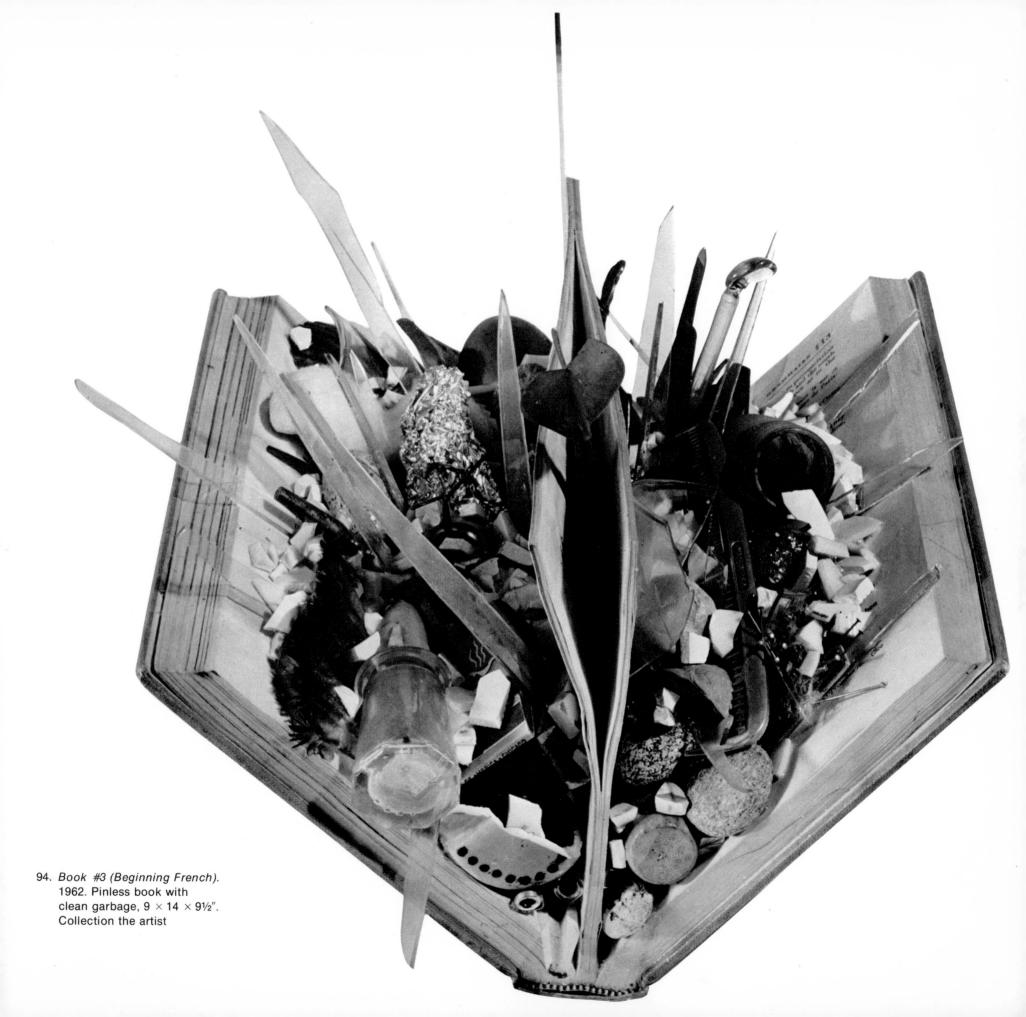

94. *Book #3 (Beginning French).*
1962. Pinless book with
clean garbage, 9 × 14 × 9½".
Collection the artist

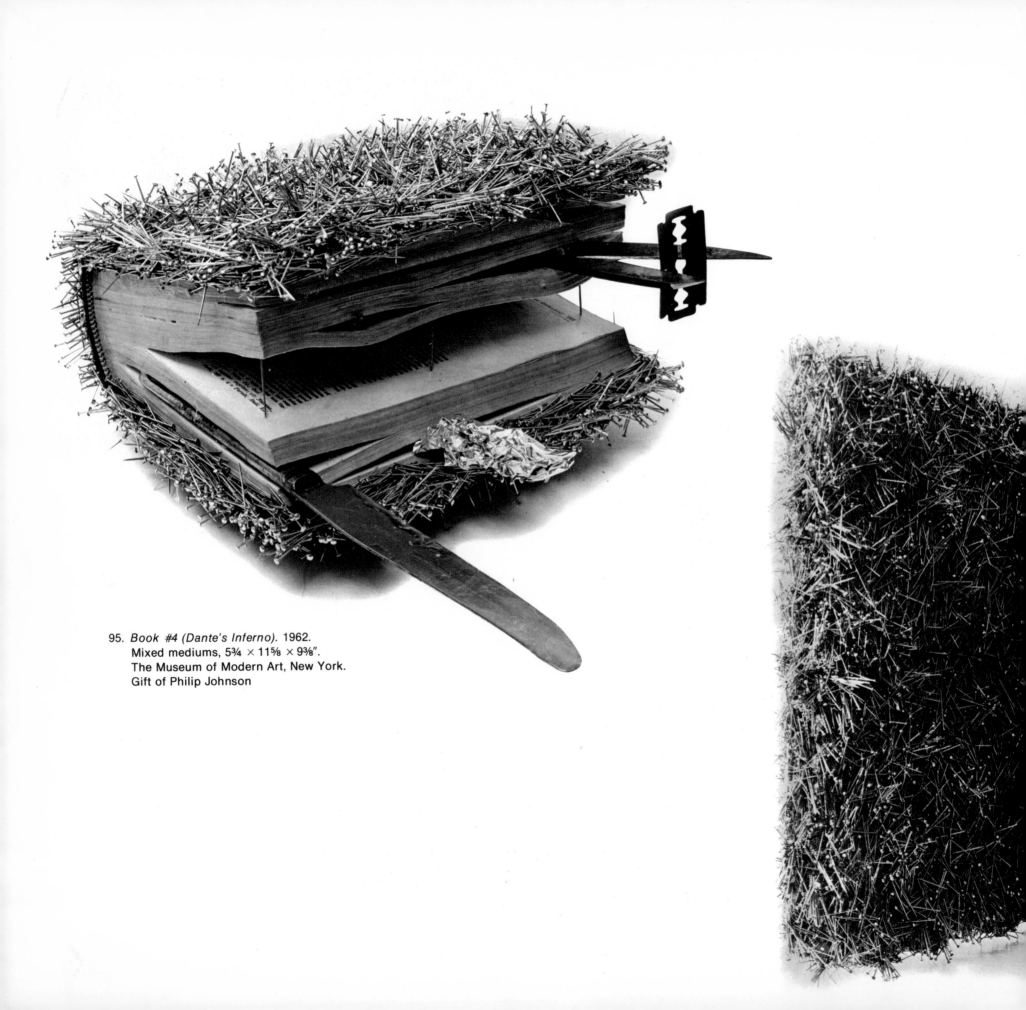

95. *Book #4 (Dante's Inferno).* 1962.
Mixed mediums, 5¾ × 11⅝ × 9⅜".
The Museum of Modern Art, New York.
Gift of Philip Johnson

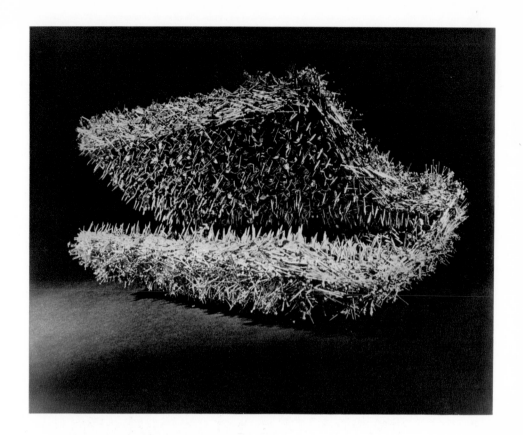

97. *Book #10 (Treasures of the Louvre)*. 1962.
   Book, pins, and carpet tacks, 7 × 14 × 11″.
   Collection Mr. and Mrs. Adam Aronson, Clayton, Missouri

96. *Book #6 (Treasures of the Metropolitan Museum)*. 1962.
   Books and pins, length 17½″. Hirshhorn Museum and Sculpture Garden,
   Smithsonian Institution, Washington, D.C.

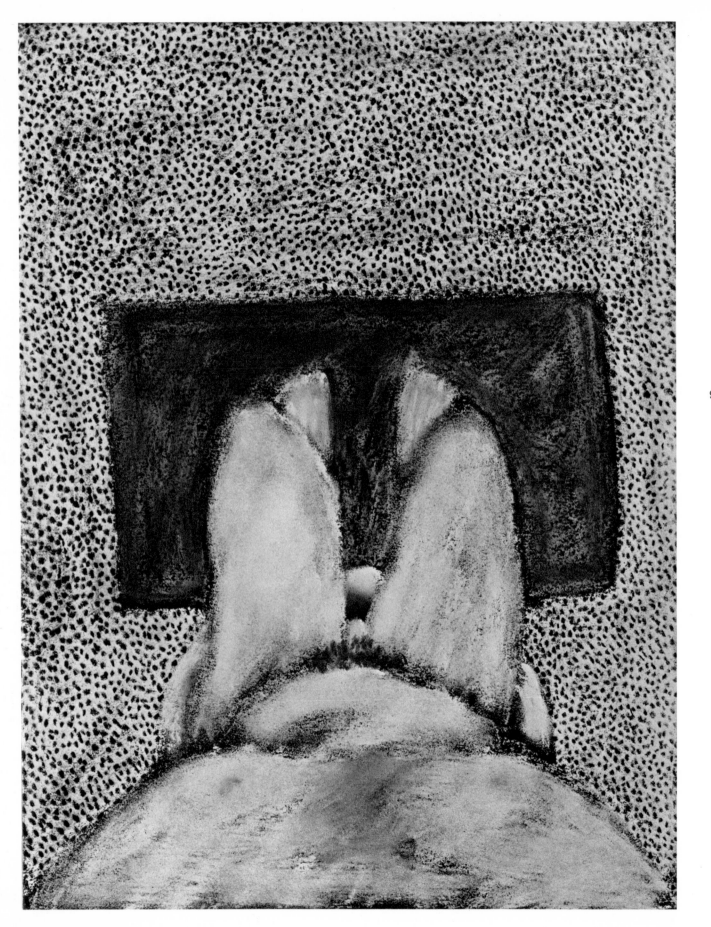

98. *Untitled.* 1962.
Pastel, 12 × 9″.
Collection the artist

99. *Untitled.* 1962.
Pastel, 12 × 9″. Collection
A. James Speyer, Chicago

100. *Untitled.* 1962.
Pastel, 12 × 9″.
Collection the artist

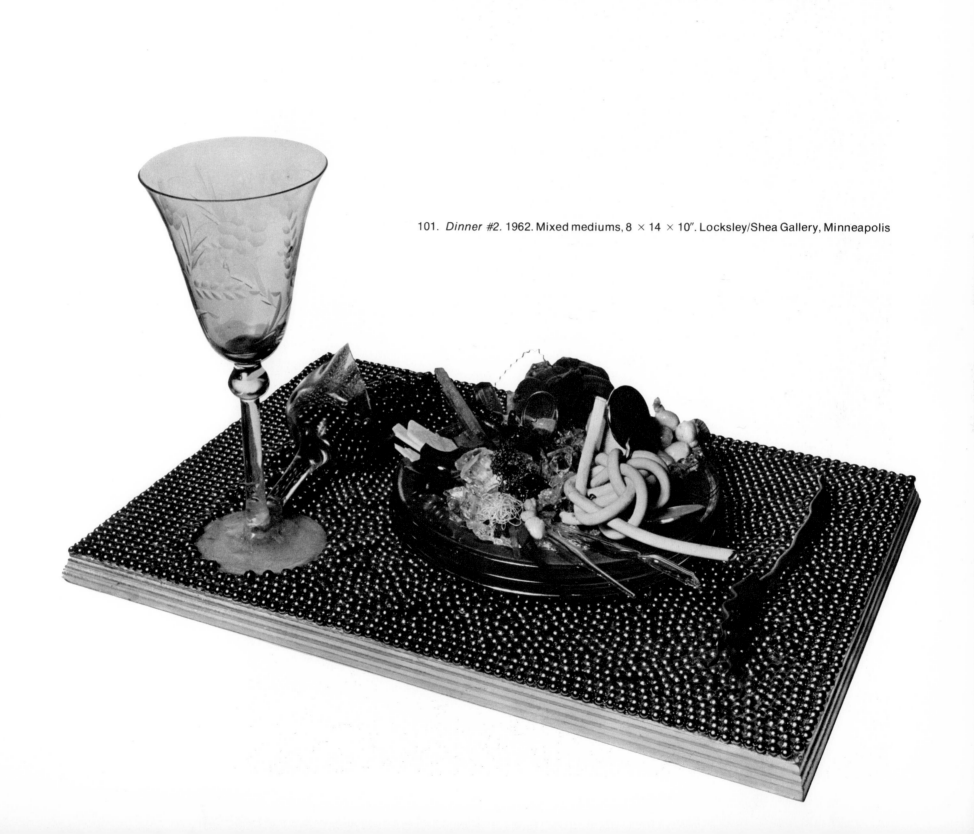

101. *Dinner #2*. 1962. Mixed mediums, 8 × 14 × 10″. Locksley/Shea Gallery, Minneapolis

102. *Box #1*. 1962. Mixed mediums, 9 × 16½ × 17".
Collection Mr. and Mrs. Morton Janklow, New York

103. *Box #3*. 1963. Wood, pins, rope,
and stuffed bird, 24½ × 11½ × 10¼".
The Whitney Museum of American Art, New York.
Gift of the Howard and Jean Lipman Foundation

104. Opposite page:
*Box #6*. 1963.
Mixed mediums, 11½ × 14 ×9".
Collection the artist

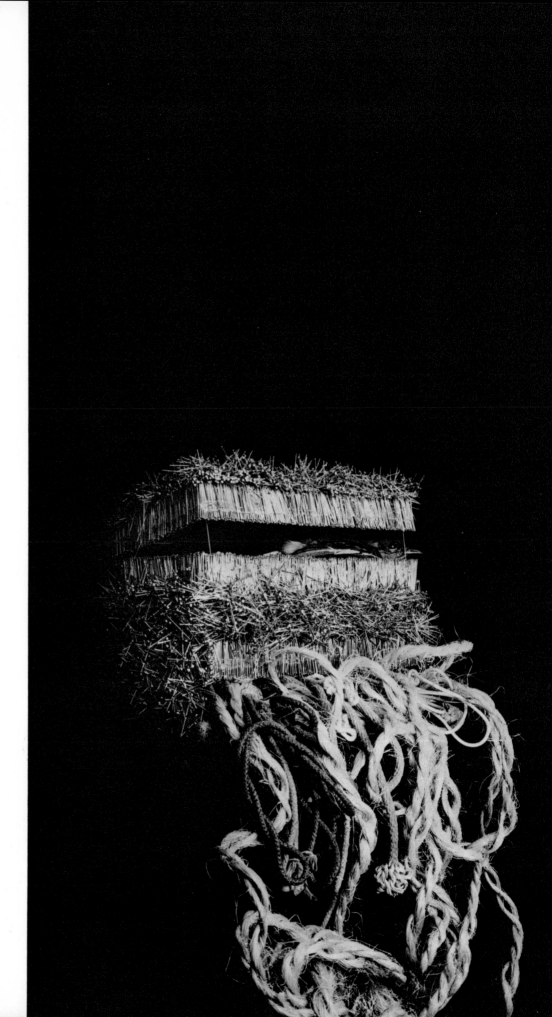

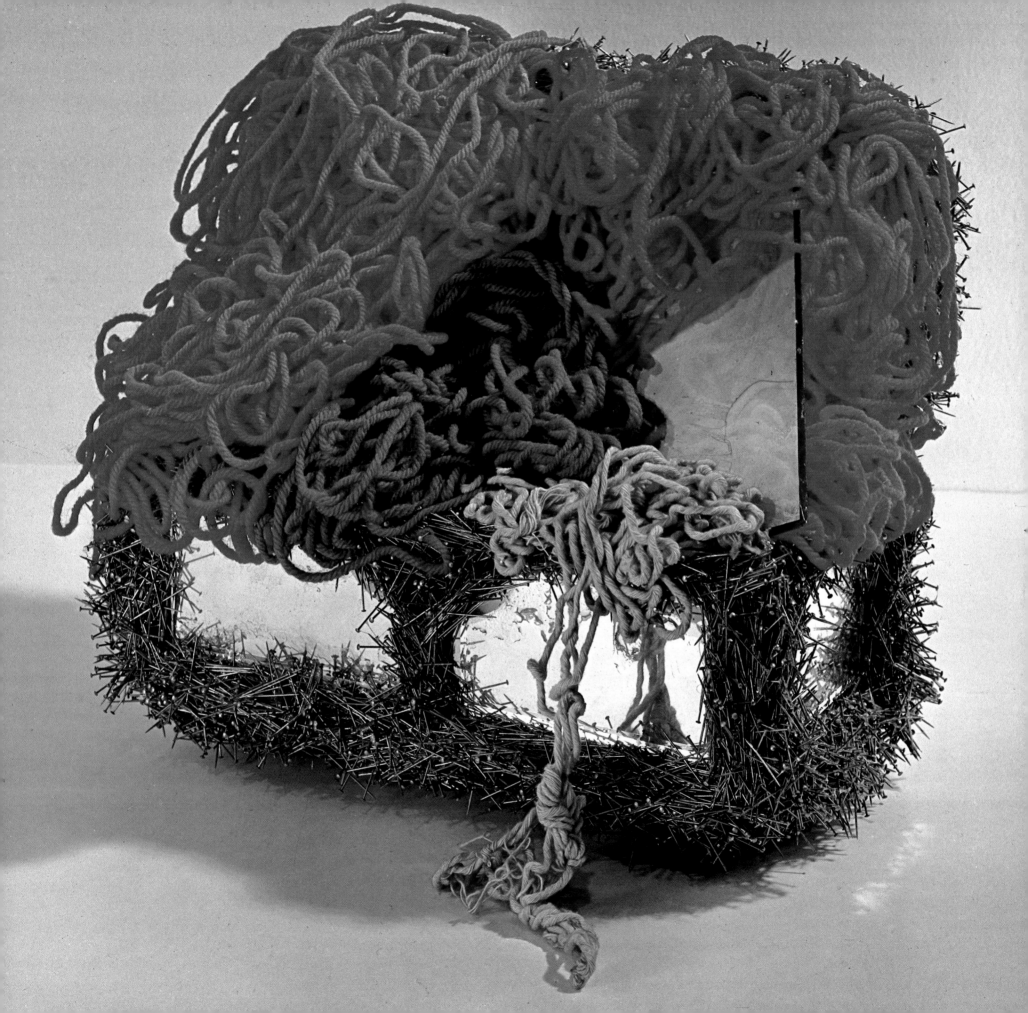

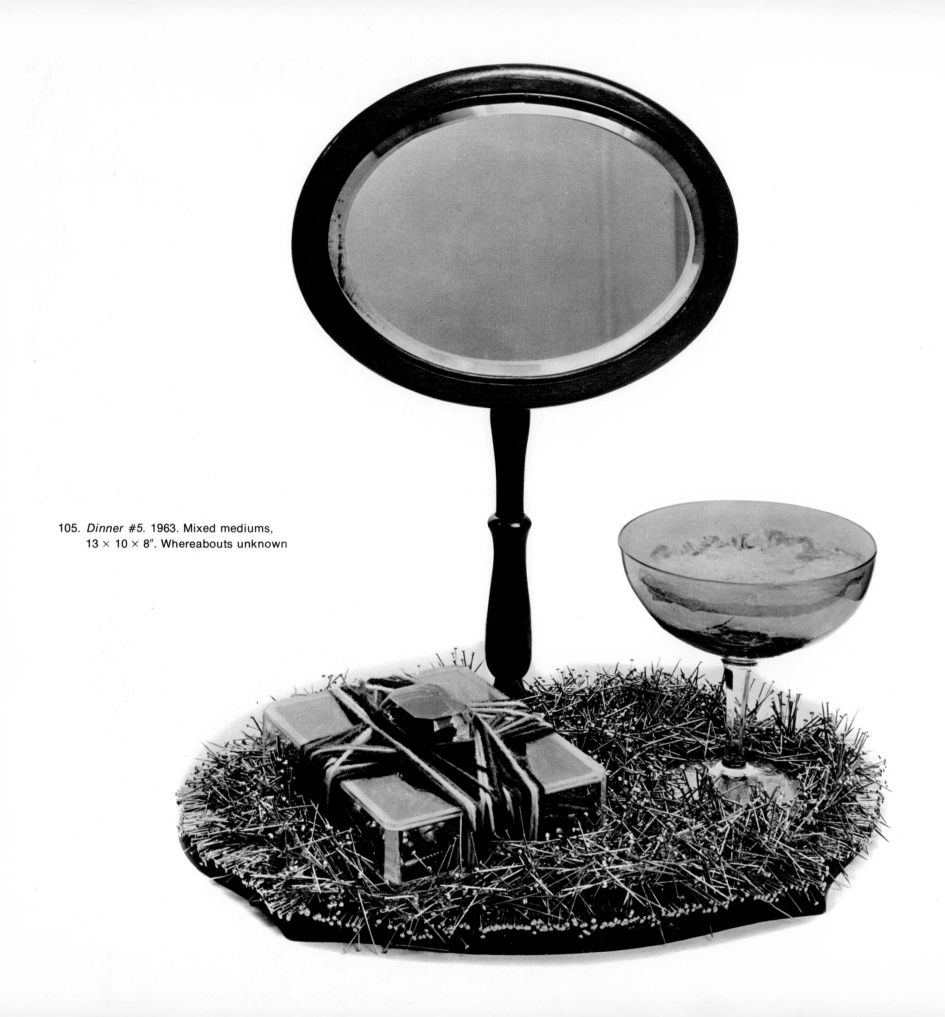

105. *Dinner #5.* 1963. Mixed mediums,
13 × 10 × 8″. Whereabouts unknown

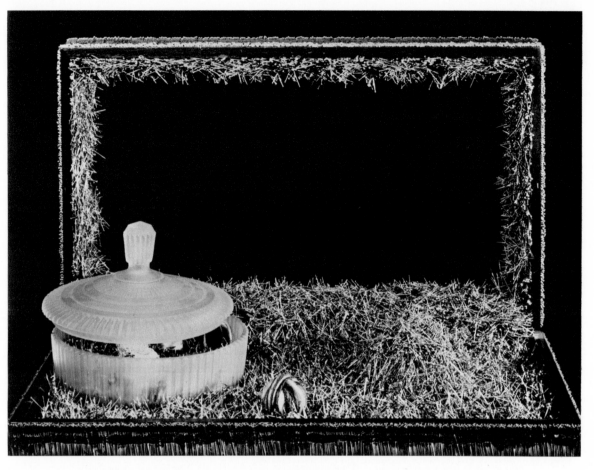

106. *Dinner #7*. 1963. Mixed mediums,
12 × 19 × 10¾". Collection Mr. and Mrs. Robert B. Mayer,
Winnetka, Illinois

107. *Dinner #8*. 1963.
Mixed mediums, 18½ × 8½".
Lo Quidice Gallery, Chicago

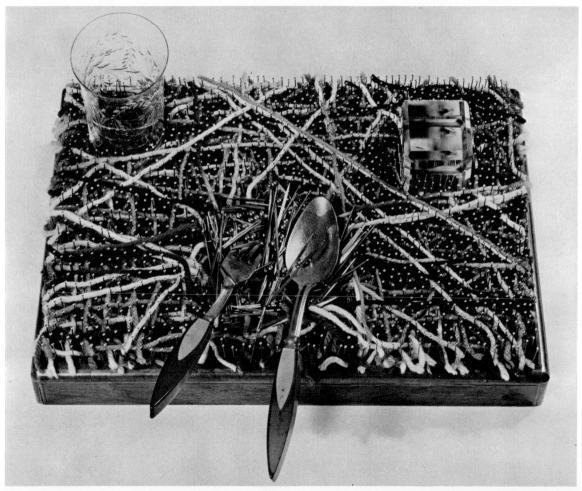

109. *Box #11*. 1963. Wood, wool, pins, and rocks, ▶
10 × 13 × 8″. Private collection, Virginia

108. *Untitled*. 1963. Wood, photograph, pins, and wool, 10½ × 15 × 18½″. Collection Mr. and Mrs. Michael Blankfort, Los Angeles

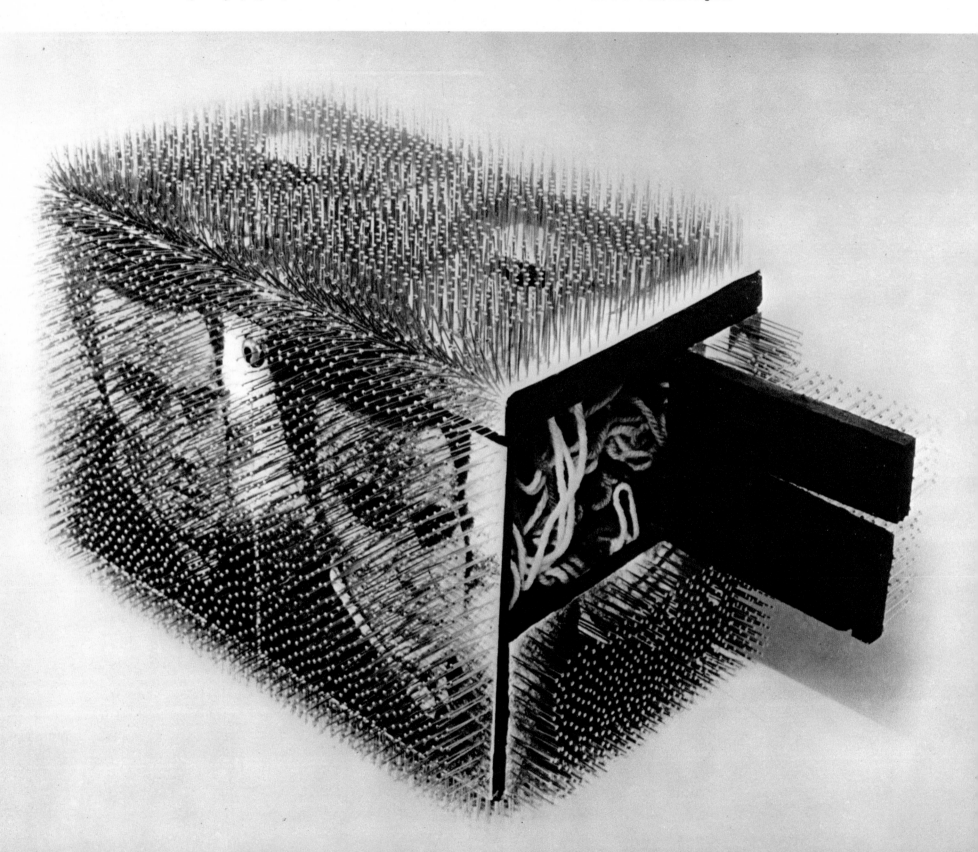

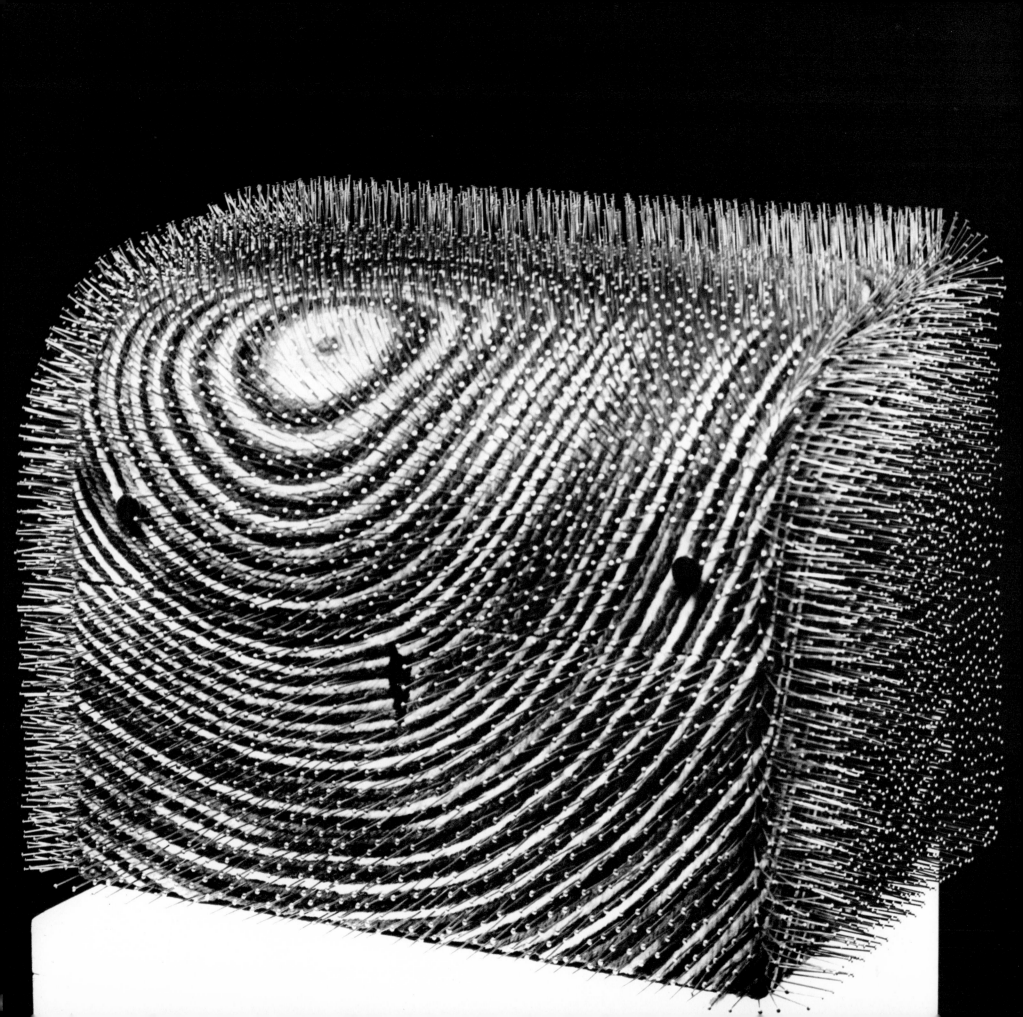

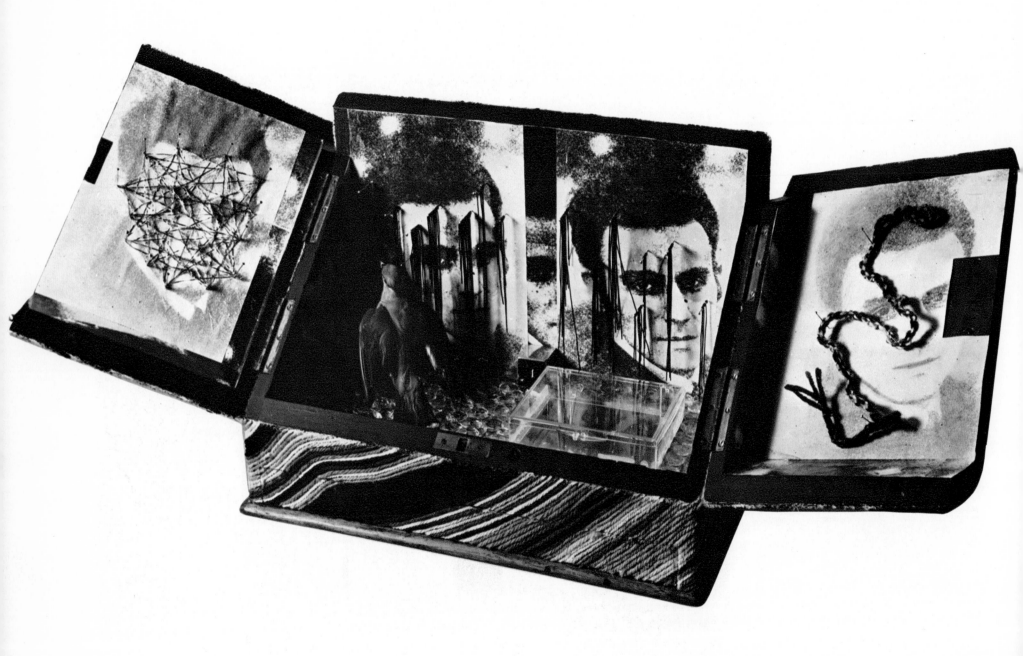

110. *Box #8.* 1963. Mixed mediums, 11 × 15 × 8″ (closed). Collection Jon Nicholas Streep, New York

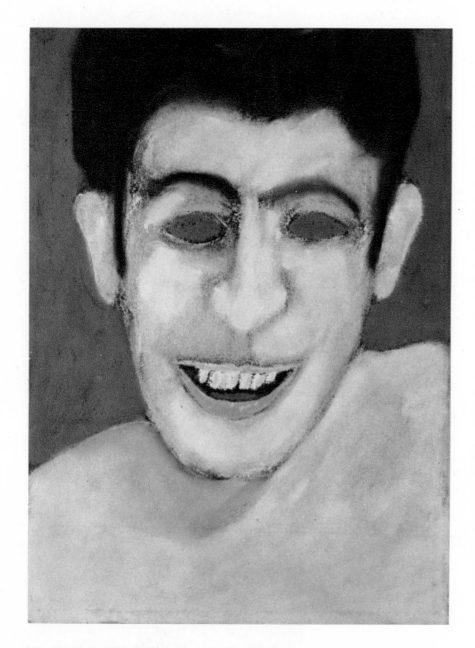

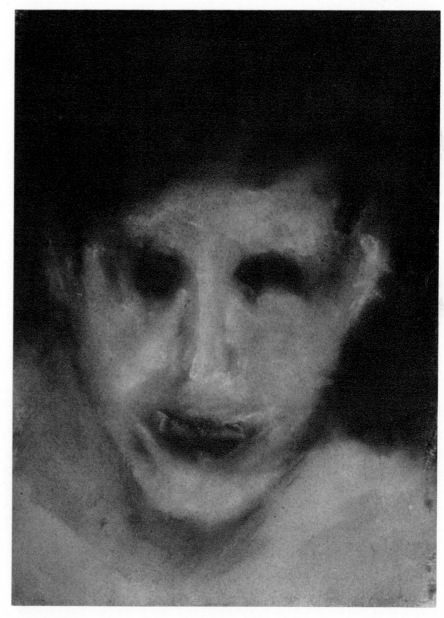

111. *Untitled.* 1962. Pastel, 12 × 9″. Collection the artist          112. *Untitled.* 1960. Pastel, 12 × 9″. Collection the artist

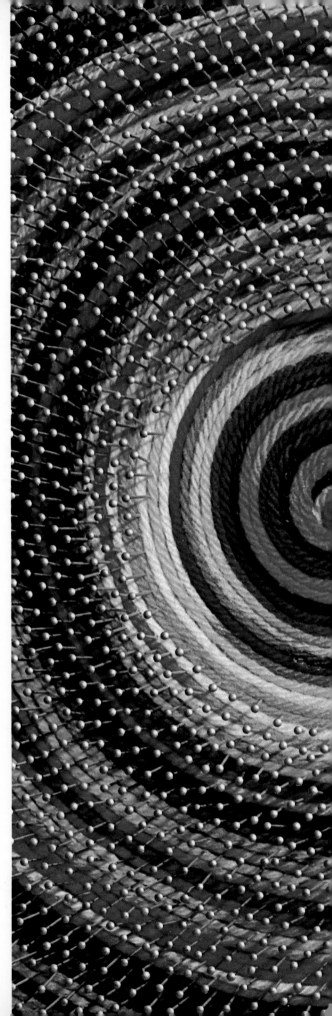

114. *Untitled.* 1963. Wood, cardboard,
pins, and wool, 11½ × 16 × 2¾".
The Harry N. Abrams Family Collection,
New York

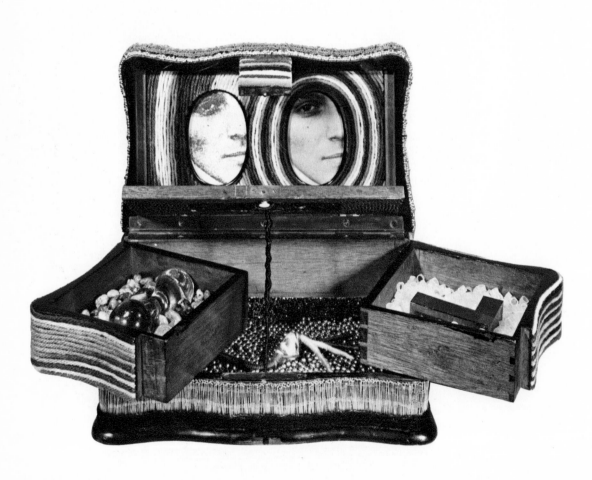

113. *Box #10.* 1963.
Mixed mediums, 6¼ × 10⅞ × 6⅝".
Collection Mr. and Mrs. Max Wasserman,
Chestnut Hill, Massachusetts

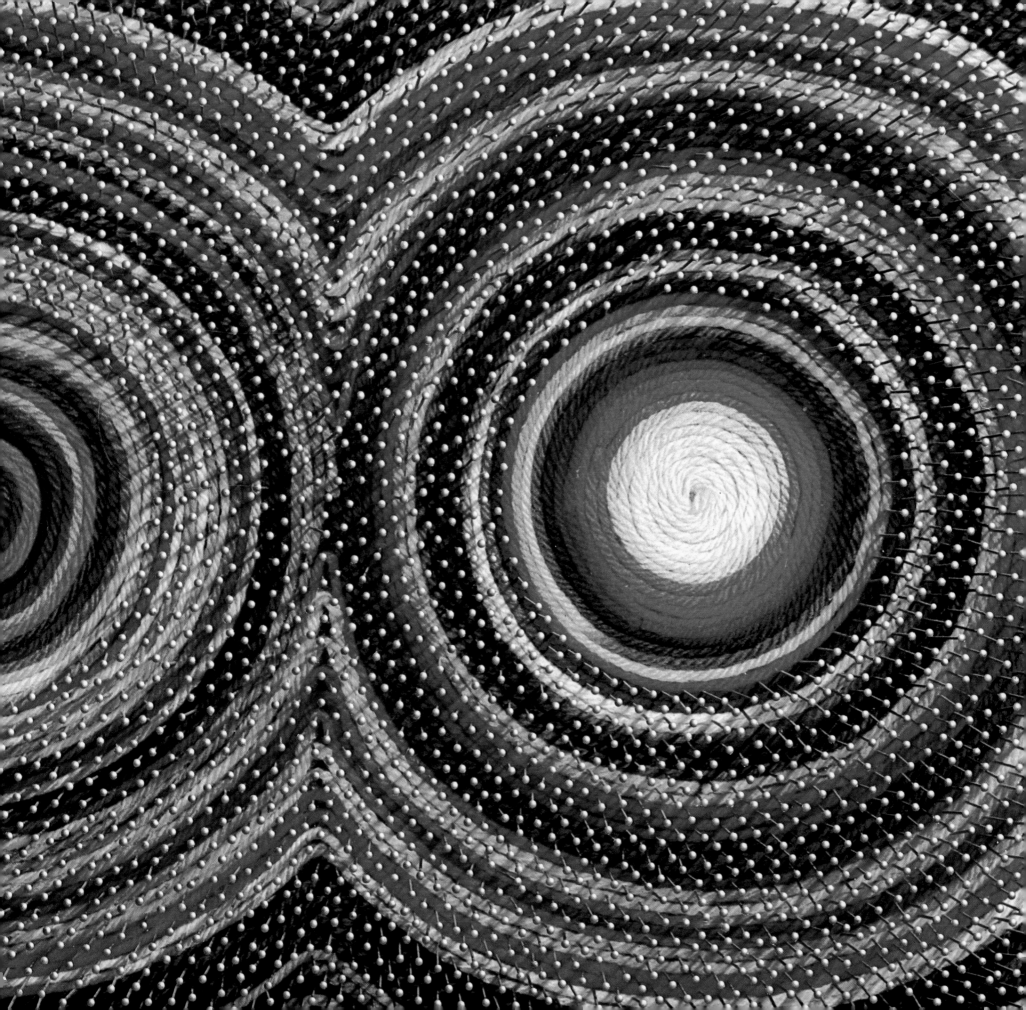

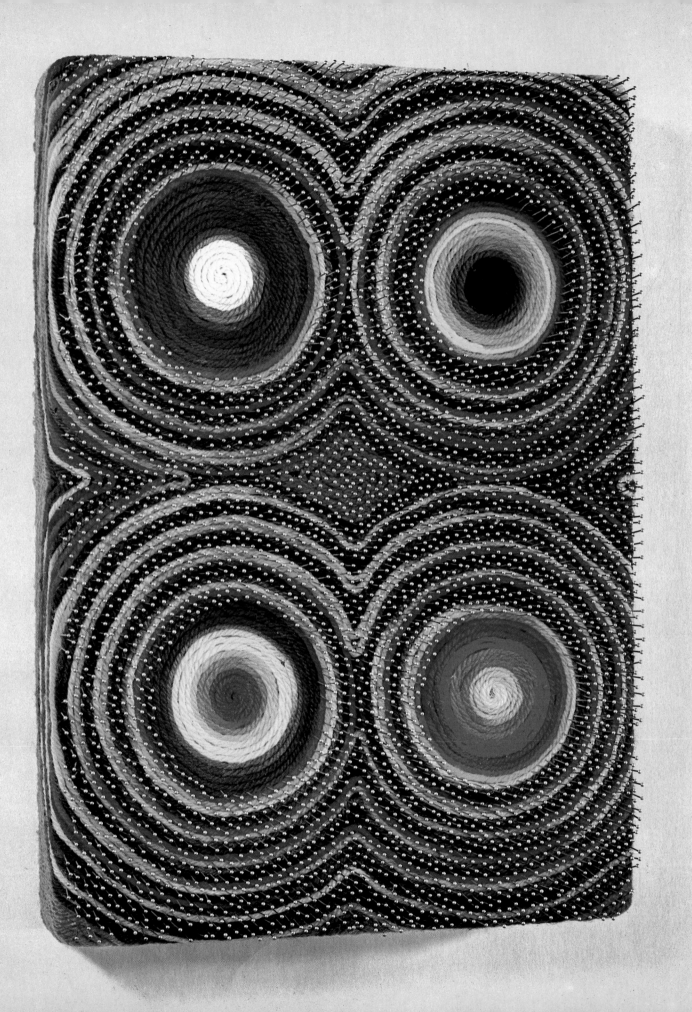

115. *Untitled.* 1963. Wood, wool,
cardboard, and pins, 16 × 12 × 2¾".
Collection Richard Brown Baker,
New York

116. *Untitled.* 1964. Wool and pins on wood, 25 × 25″.
Collection Mr. and Mrs. Robert C. Scull, New York

117. *Untitled.* 1964. Pins and wool on wood, 25 × 25″.
The Pace Gallery, New York

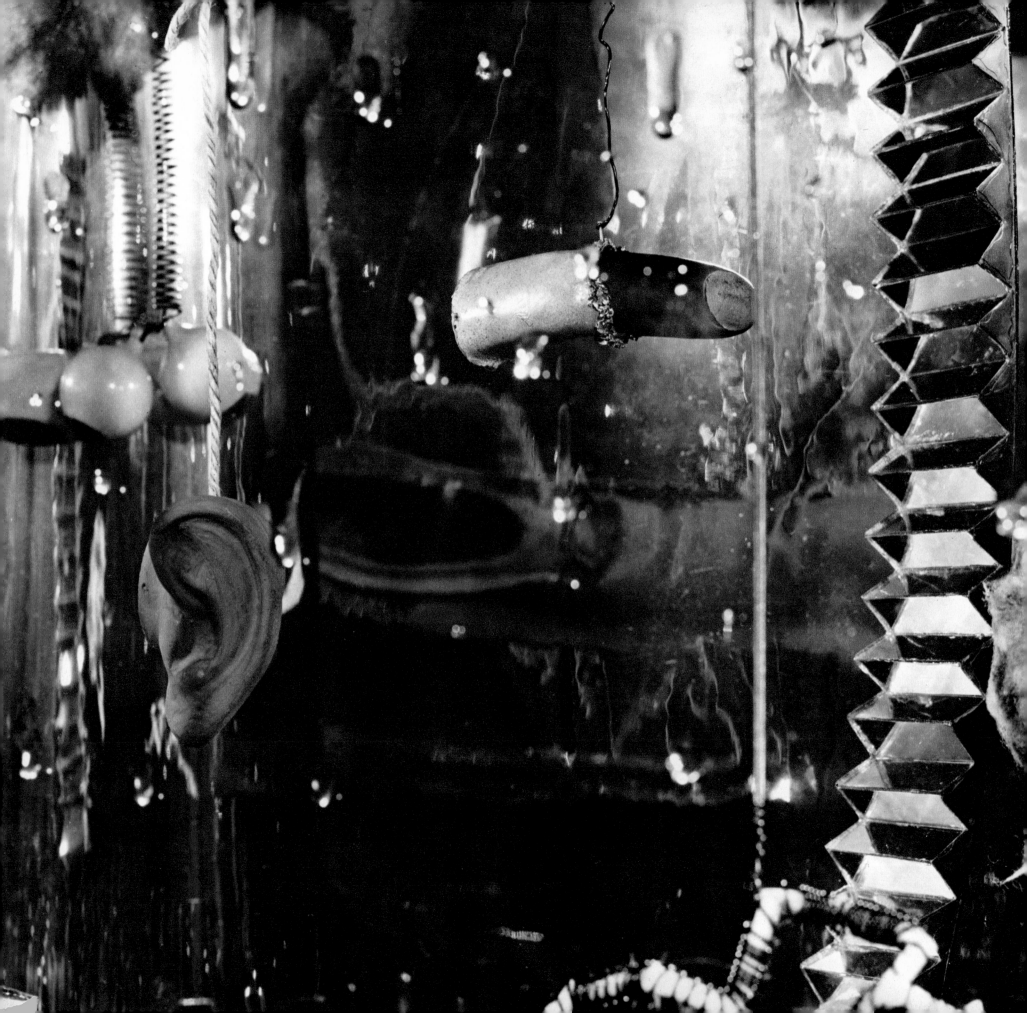

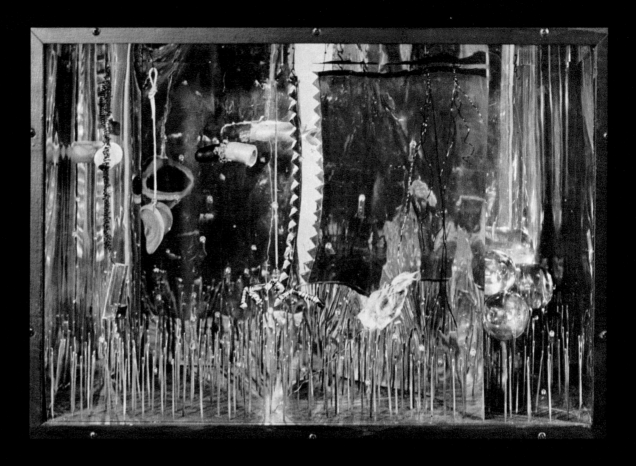

119. *Box #15 (the L Box).*
1964. Mixed mediums, 17 × 25 × 11¼".
The Aldrich Museum of Contemporary Art,
Ridgefield, Connecticut

◄ 118. *Box #15 (the L Box)* (detail).

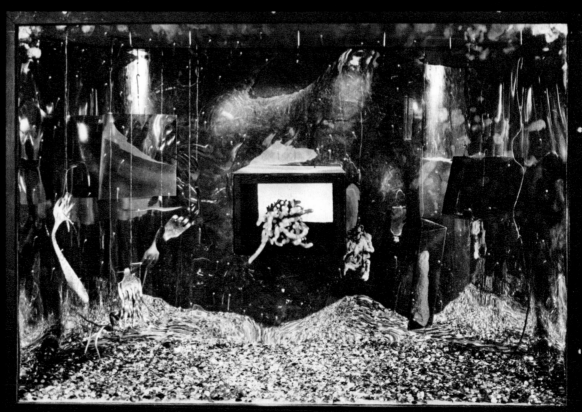

120. *Box #18 (the A Box).*
1964 (photographed before hair was added).
Mixed mediums, 20 × 30 × 16".
Destroyed

121. *Untitled*. 1962. Pastel, 12 × 9″. Collection the artist

122. *Box #17 (the C Box)*. 1964. Mixed mediums, 15 × 31 × 15¼″. Collection the artist

123, 124. *Untitled*. 1962. Two pastels, each 12 × 9″. Collection the artist

126. *Box #19 (the S Box).* 1964. Mixed mediums,
20 × 20 × 21″. Collection the artist

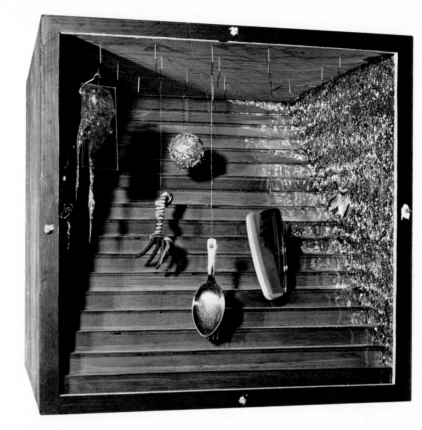

125. *Box #23.* 1964.
Mixed mediums, 16 × 17 × 10½″.
Collection Carol Samaras, New York

127. Overleaf, left:
*Untitled.* 1964.
Pins on wood, 17 × 17 × 17″.
Collection the artist

128. Overleaf, right:
Installation at the Green Gallery, New York,
with plastic shapes. 1964

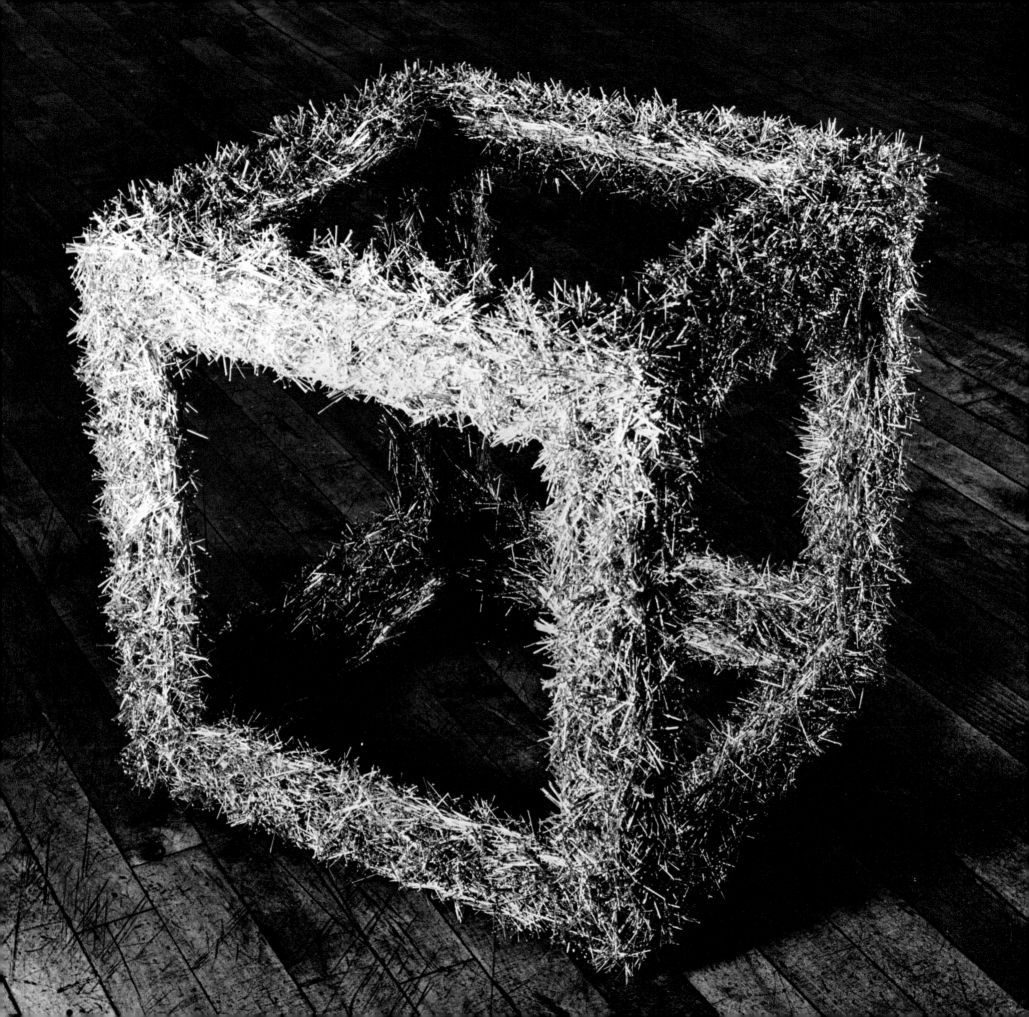

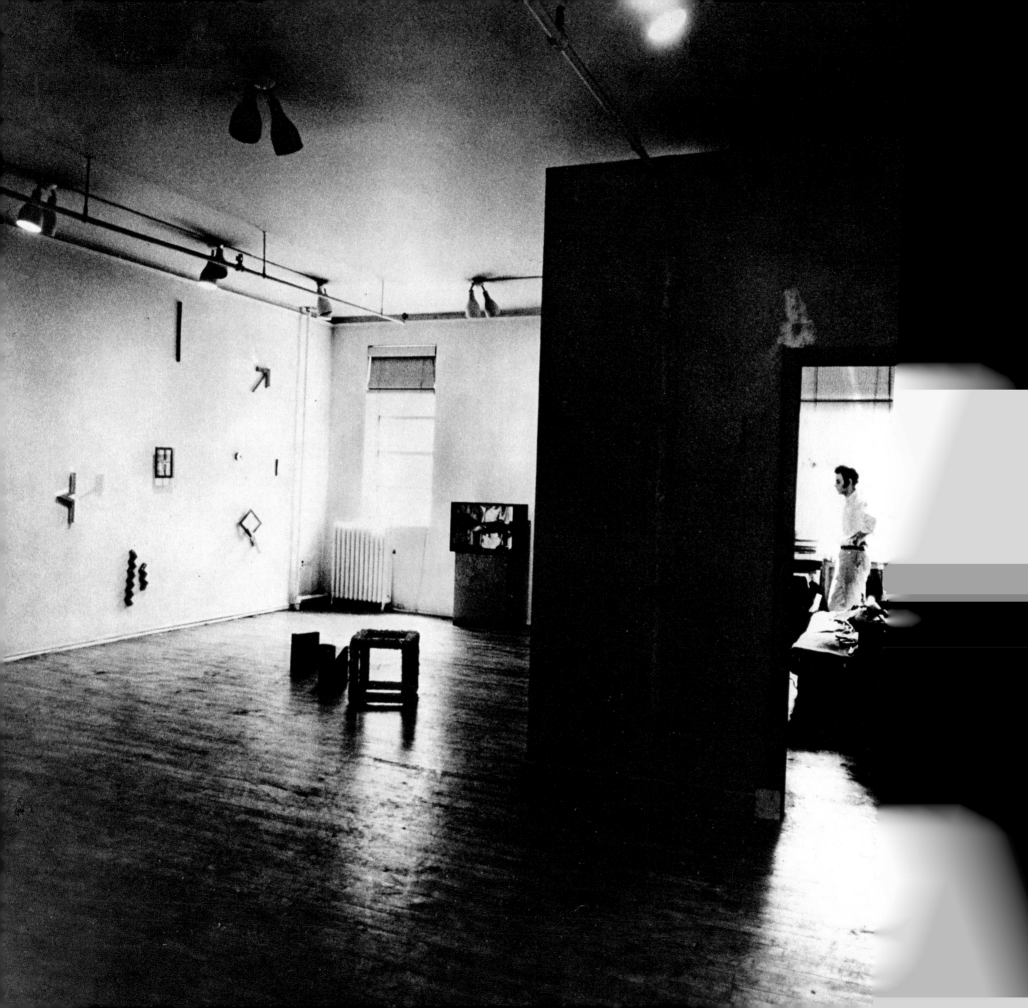

129. *Untitled.* 1961. Pastel, 12 × 9".
Collection the artist

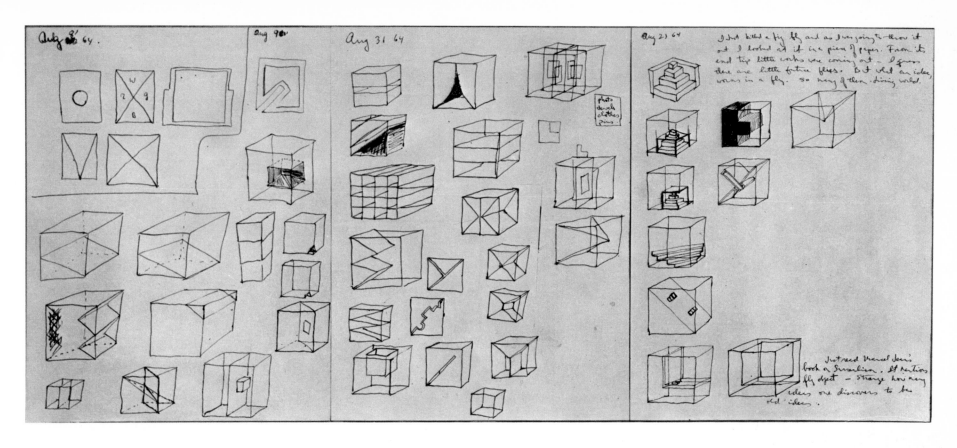

130. Three sketches for plastic cubes. 1964. Ink, each 11 × 8½″. Collection the artist

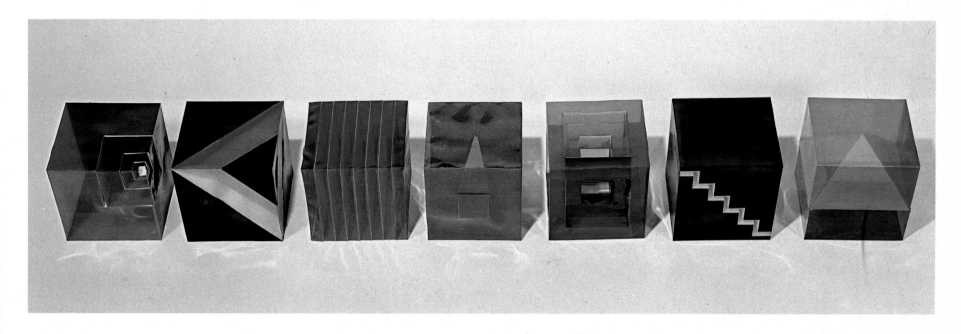

131. *Untitled*. 1964. Plastic, 6 × 6 × 6″. Collection the artist

132, 133. Overleaf: *Room #1*. 1964. Mixed mediums, 10 × 15 × 7½″. Destroyed

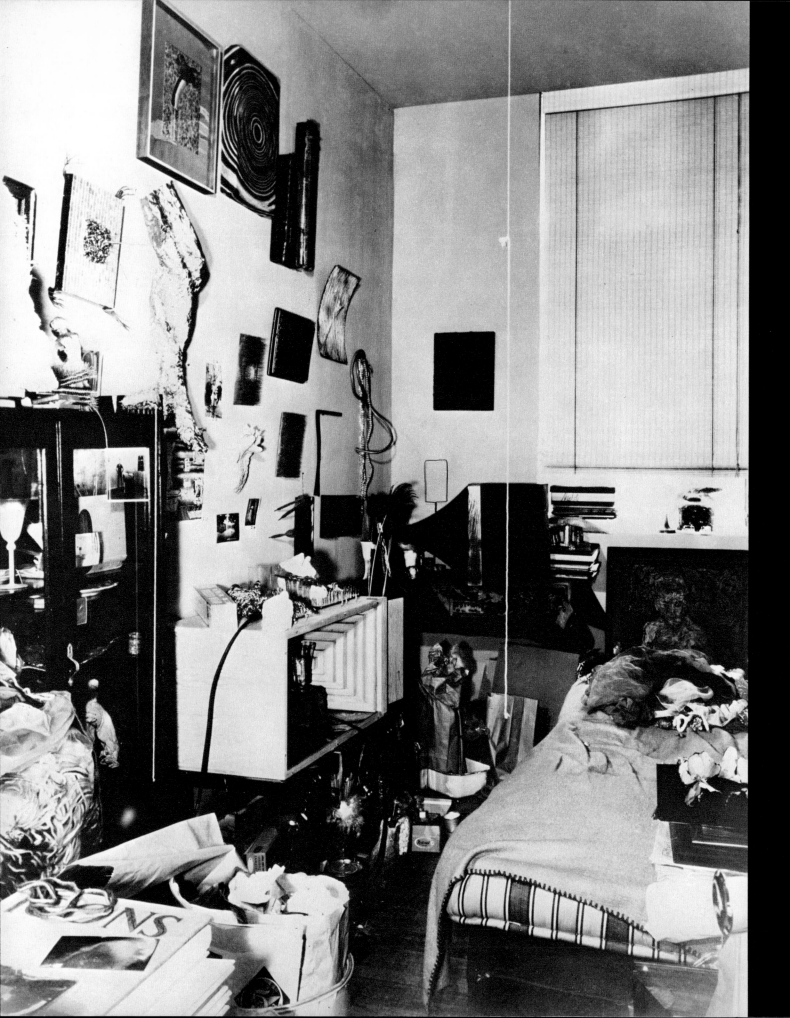

134. *Dinner #14*. 1964. Mixed mediums. Destroyed

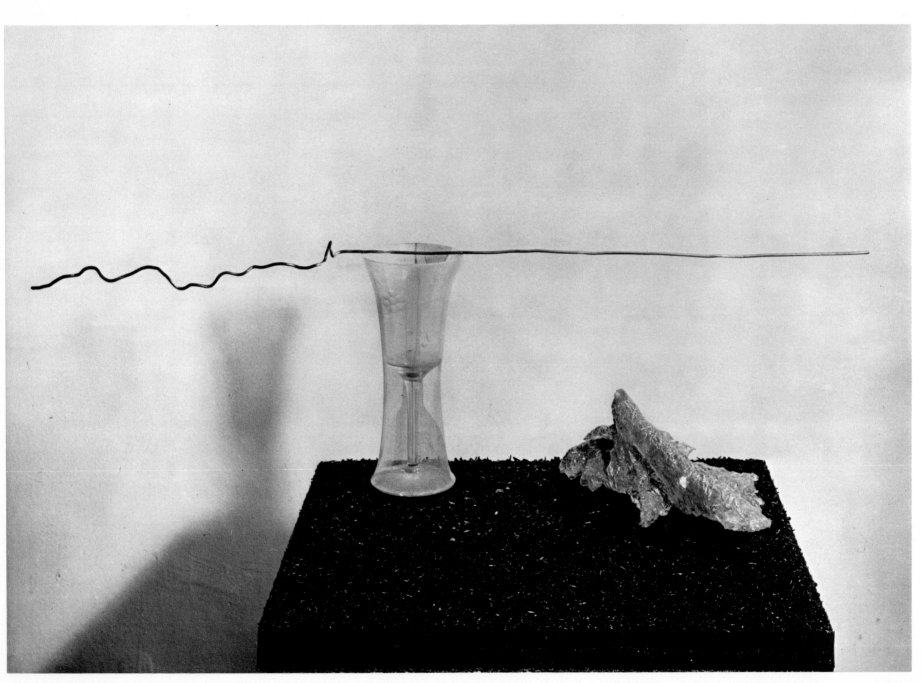

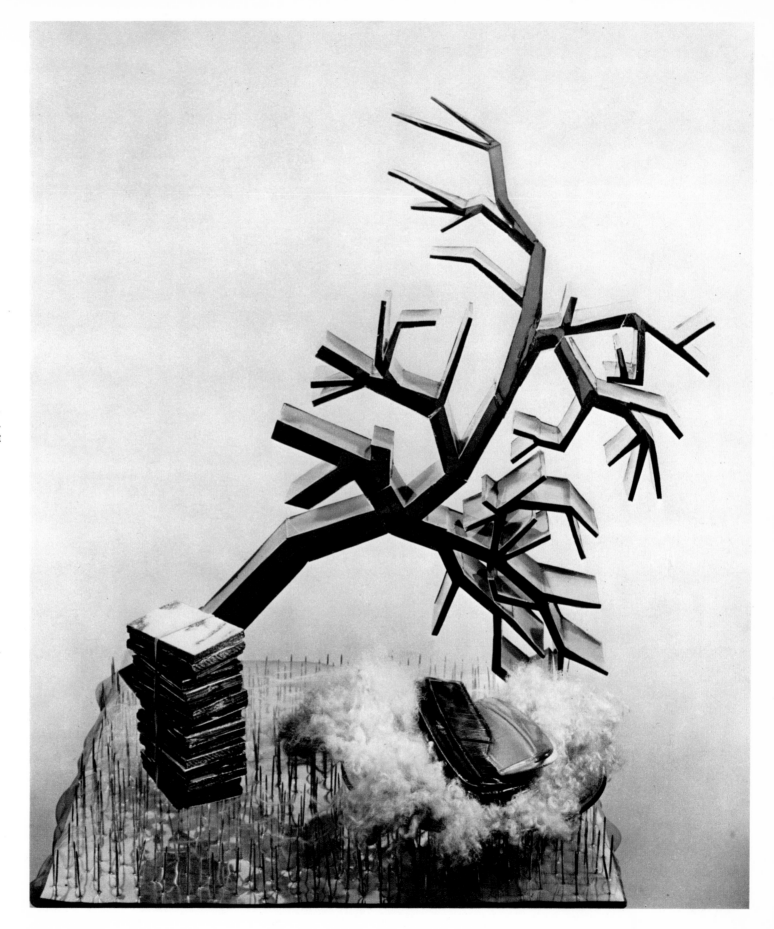

135. *Dinner #13.*
1964. Mixed mediums, 18 × 12½ × 11″.
Collection the artist

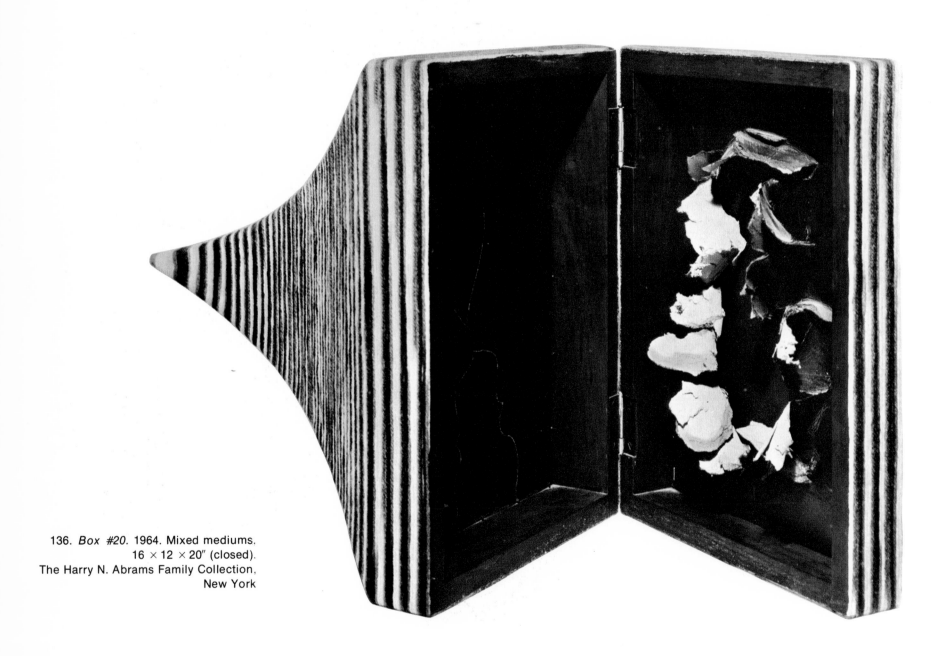

136. *Box #20*. 1964. Mixed mediums.
16 × 12 × 20″ (closed).
The Harry N. Abrams Family Collection,
New York

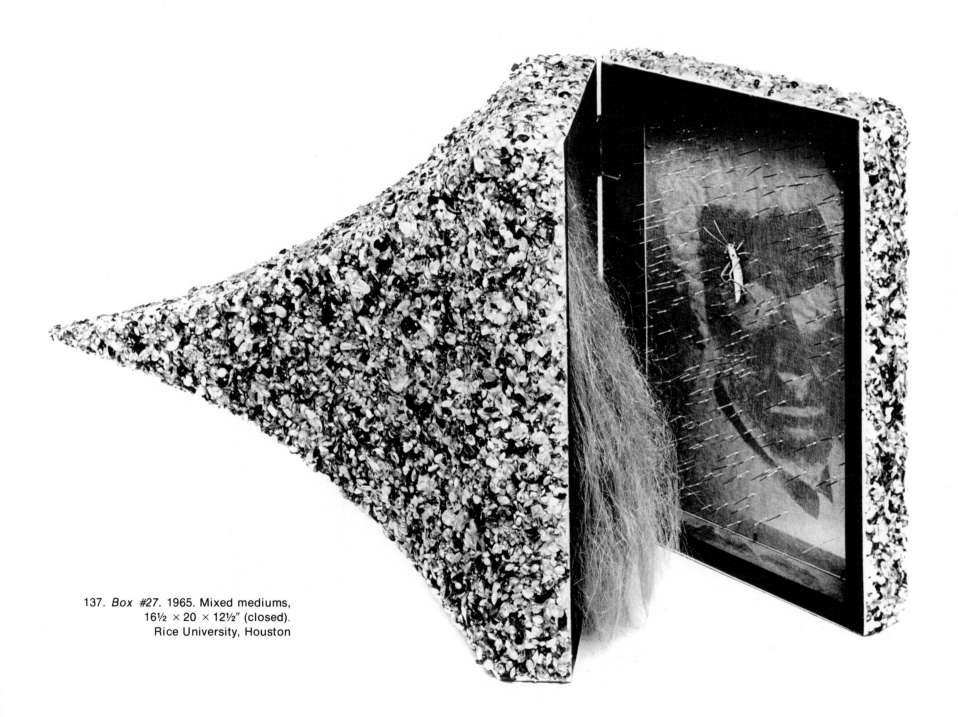

137. *Box #27.* 1965. Mixed mediums,
16½ × 20 × 12½″ (closed).
Rice University, Houston

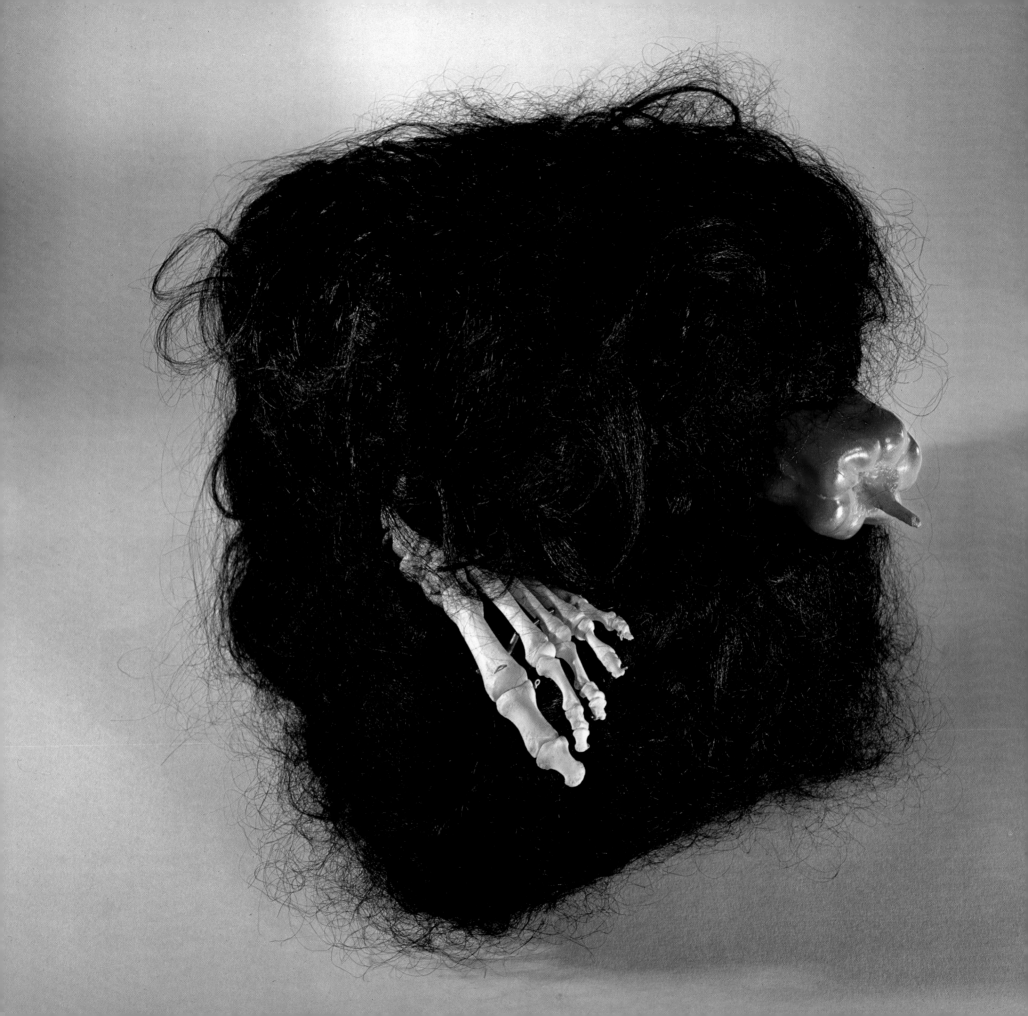

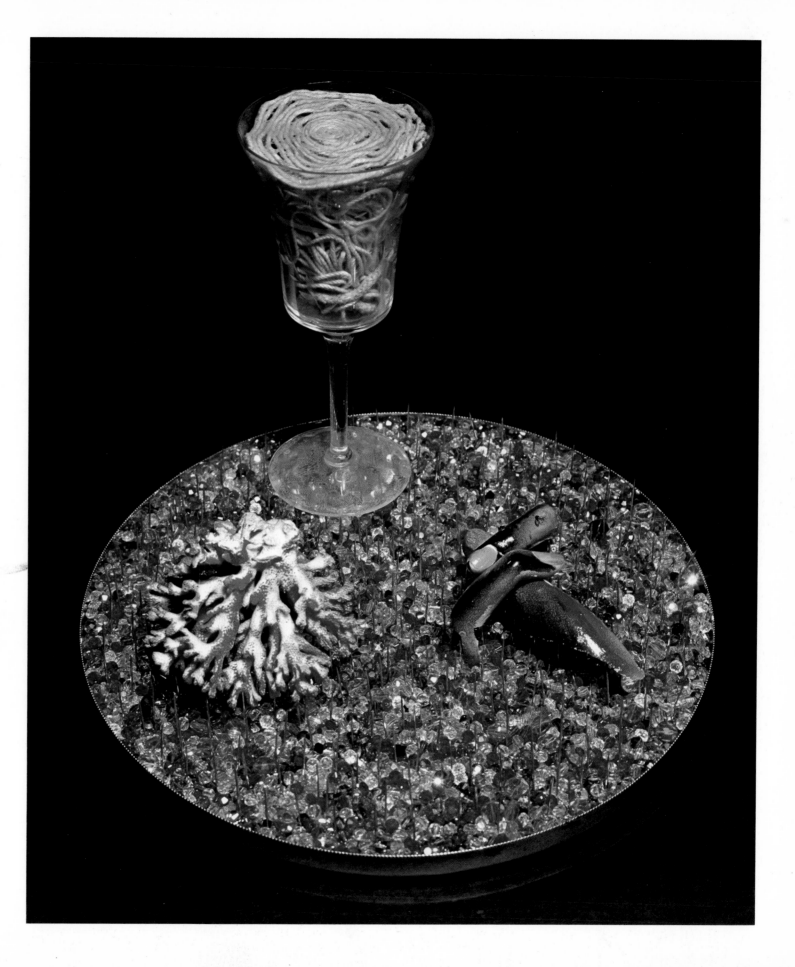

◄ 138. *Box #32.* 1965. Wood,
artificial hair, bones,
and plastic, 13 × 10 × 15".
Collection the artist

139. *Dinner #15.* 1965.
Mixed mediums, diameter 12",
height 8½". Collection
Howard and Jean Lipman,
New York

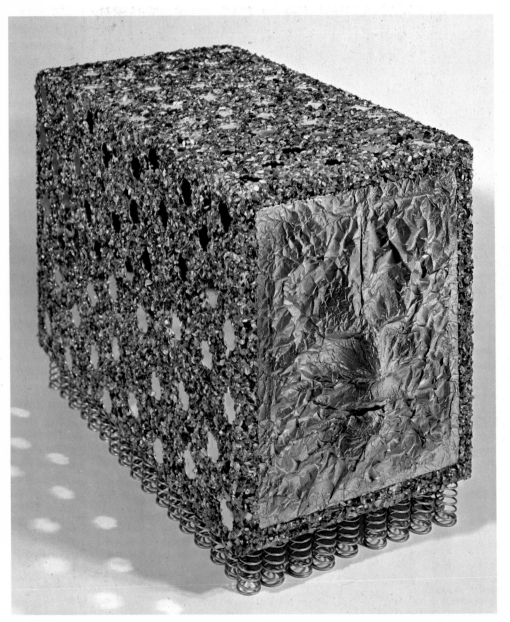

140. *Box #31*. 1965. Mixed mediums, 20¼ × 15¼ × 28½".
Collection the artist

141. *Untitled*. 1965. Jeweled tinfoil, 12 × 8 × 11".
Collection the artist

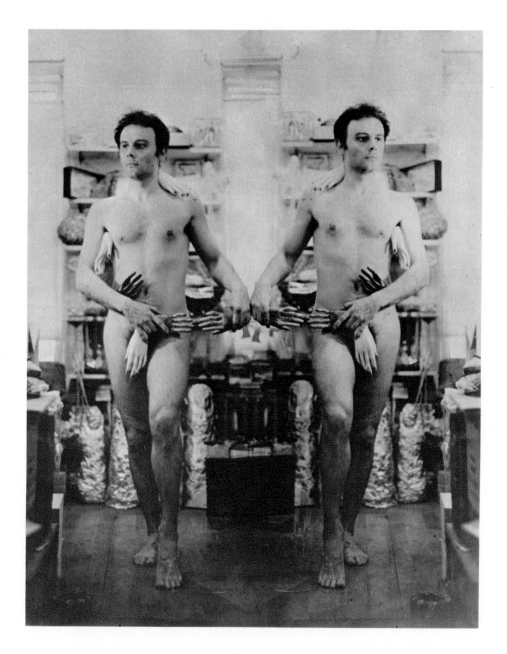

142. Double nude photograph with *Large Tinfoil Fingers* (destroyed). 1966

143. *Untitled.* 1965. Pastel, 12 × 9″. Collection the artist

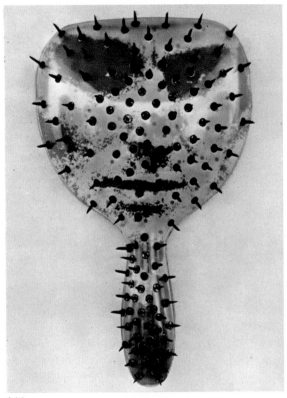

144

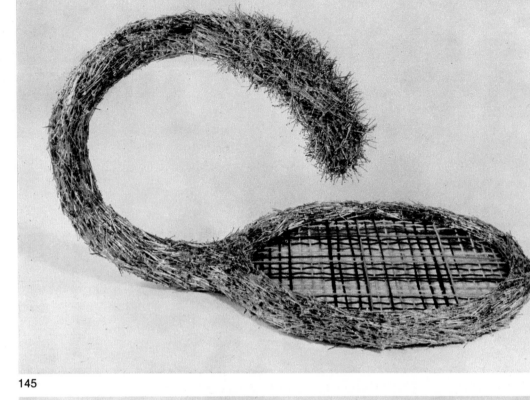

145

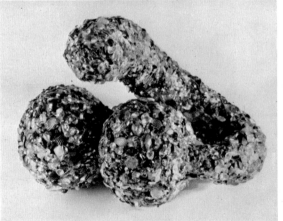

146

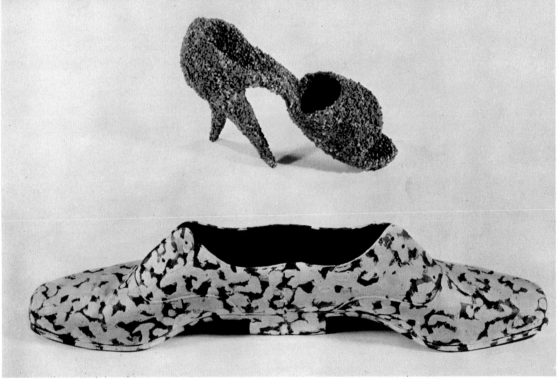

147

144. *Untitled.* 1965. Hair spray mask,
photograph, and tacks, 9½ × 6½ × 2¼″.
Collection the artist

145. *Untitled.* 1965. Tennis racket, pins, and yarn,
11½ × 10½ × 20″. Collection the artist

146. *Untitled.* 1965. Tinfoil and jewels,
7½ × 8½ × 7½″. Collection the artist

147. *Shoes.* 1965. Male: shoes and paint, 20 × 4 × 4″;
female: tinfoil and ceramic jewels,
11¼ × 7 × 3½″. Collection the artist

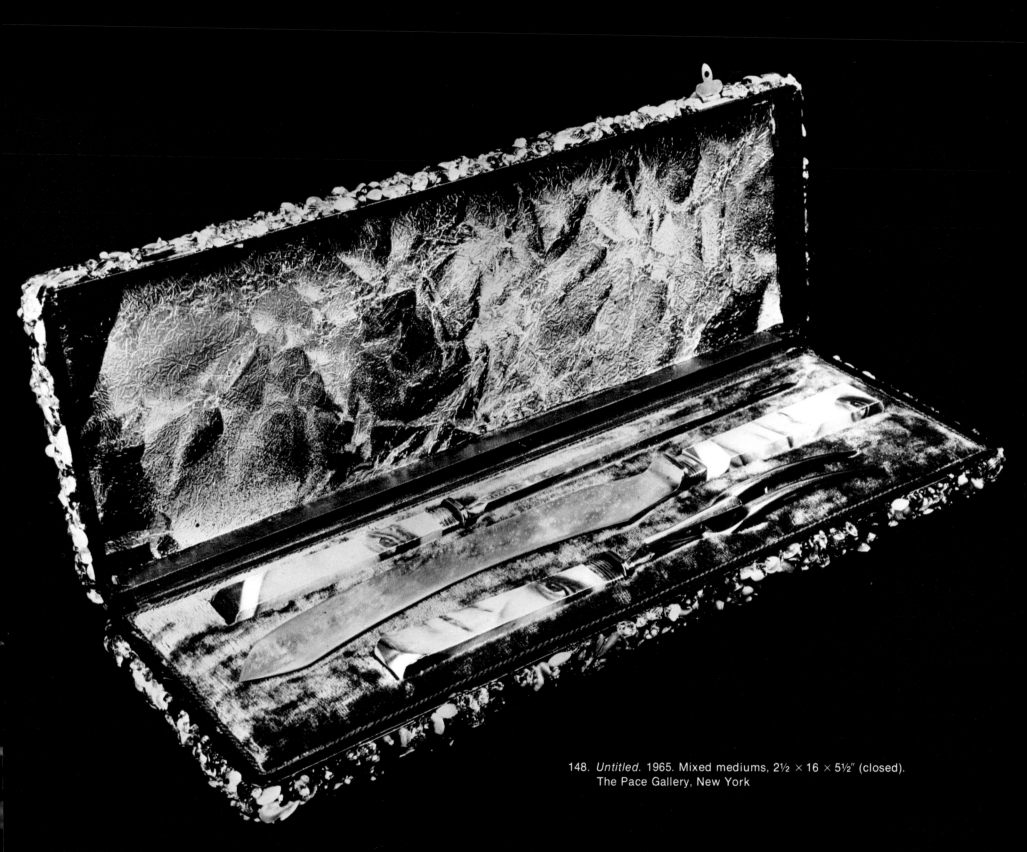

148. *Untitled.* 1965. Mixed mediums, 2½ × 16 × 5½" (closed).
The Pace Gallery, New York

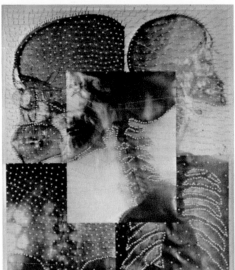

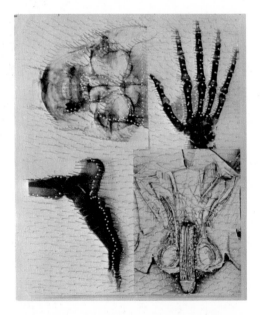

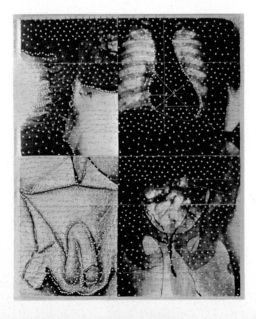

149–51. *Untitled.* 1965. Pins and anatomy book, each 12 × 10 × 1".
Collection Mr. and Mrs. Robert C. Scull, New York

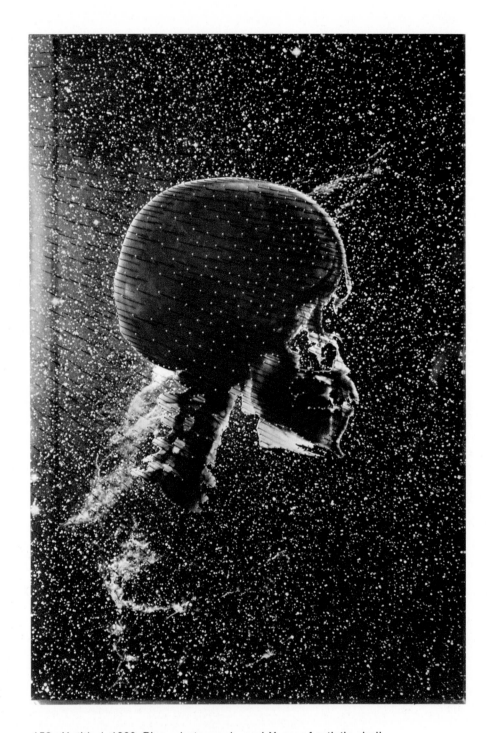

152. *Untitled.* 1966. Pins, photograph, and X-ray of artist's skull,
35¾ × 23½ × 2½". Collection Fred Mueller, New York

153. *Untitled.* 1965. Wood, pins, and wool, each 35½ × 61 × 20". ▶
Walker Art Center, Minneapolis

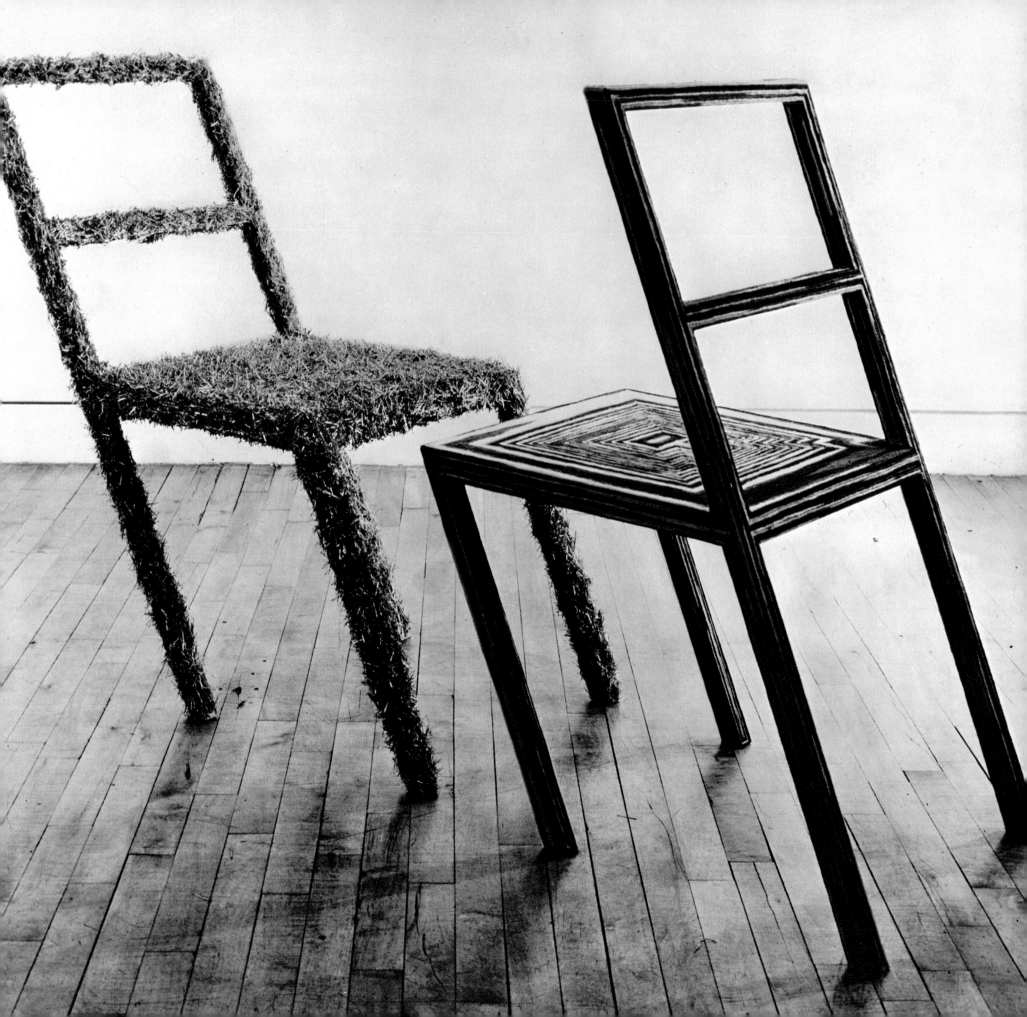

154, 155. *Large Drawings #38 and #39.* 1966. Pencil and colored pencil, each 17 × 14″.
Collection Howard and Jean Lipman, New York

156. *Extra Large Drawing #3*. 1966.
Pencil, graphite, and colored pencils, 29 × 23″.
Collection the artist

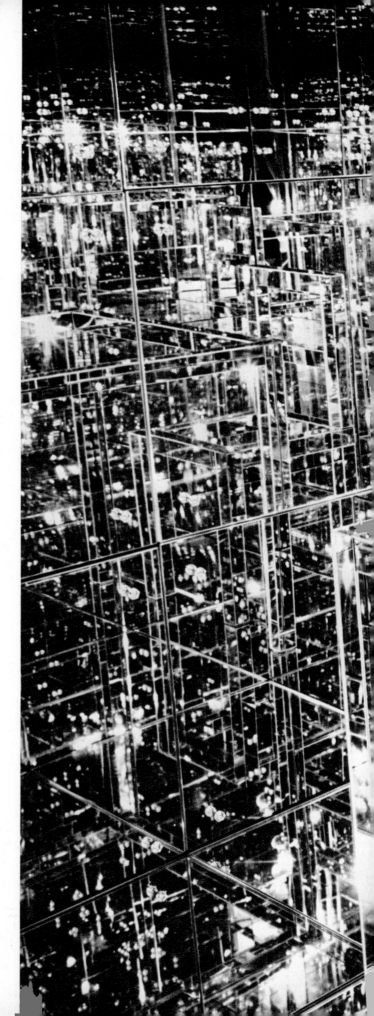

157, 158. *Room #2* (above, exterior view; right, interior view).
1966. Wood and mirror, 8 × 10 × 8'.
Albright-Knox Art Gallery, Buffalo.
Gift of Seymour H. Knox

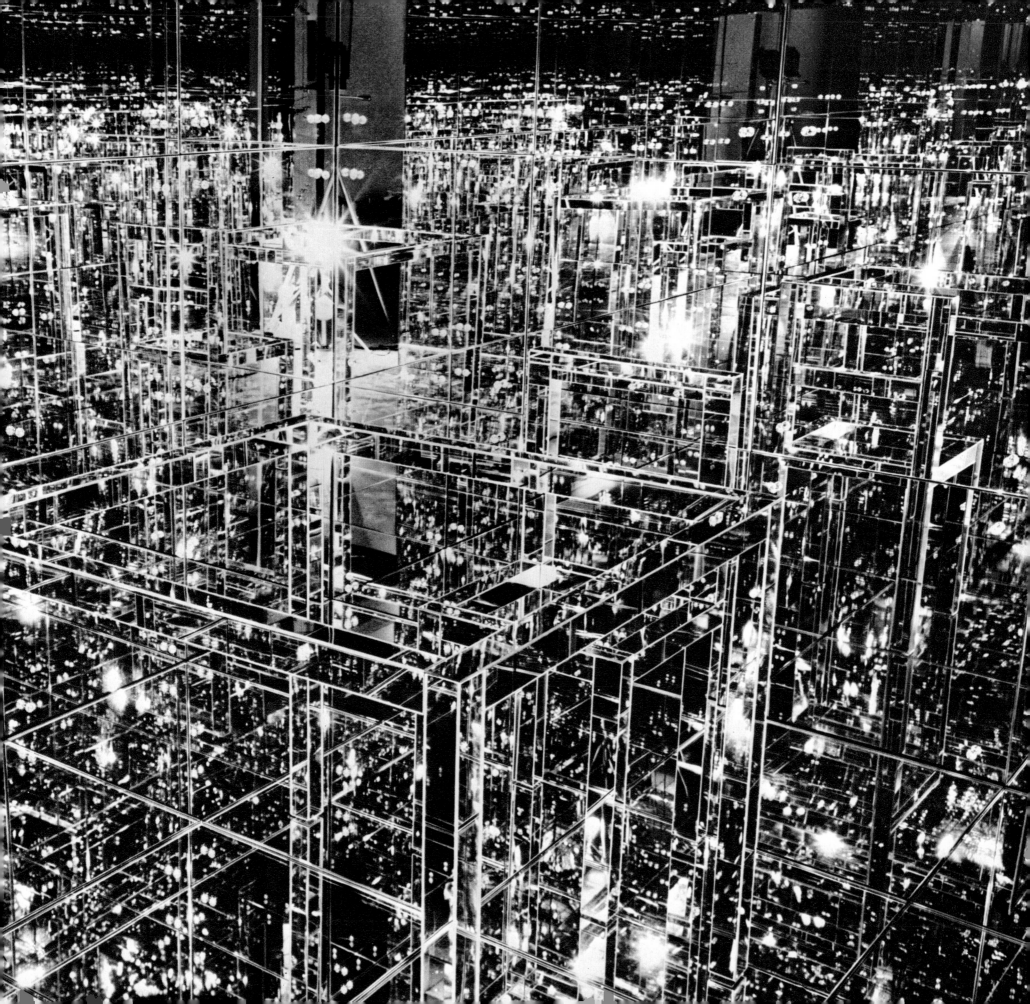

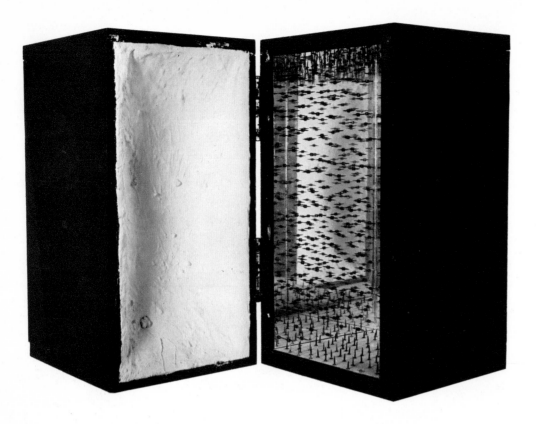

159. *Untitled.* 1961. Box with plaster,
mirror, and tacks, 16½ × 18 × 9″ (closed).
Collection Mr. and Mrs. Robert Rowan,
Los Angeles

160. *Box #7.* 1963.
Wood, mirror, and tacks,
16½ × 24½ × 10″ (closed).
Private collection

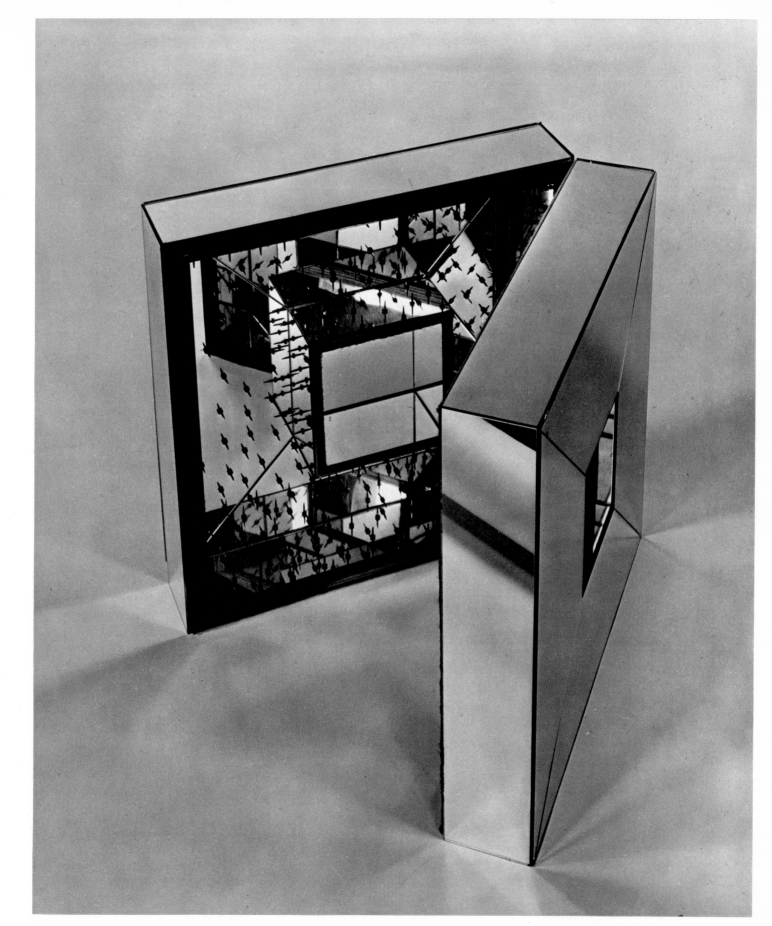

161. *Untitled.* 1965.
Mirror, wool, and tacks on wood,
16 × 16 × 6″ (closed).
Private collection

162. *Untitled.* c. 1954. Pencil, 9 × 12″. Collection the artist

163. Plan for *Corridor #1* (second of three). 1966.
Pencil, 14 × 17″. Collection the artist

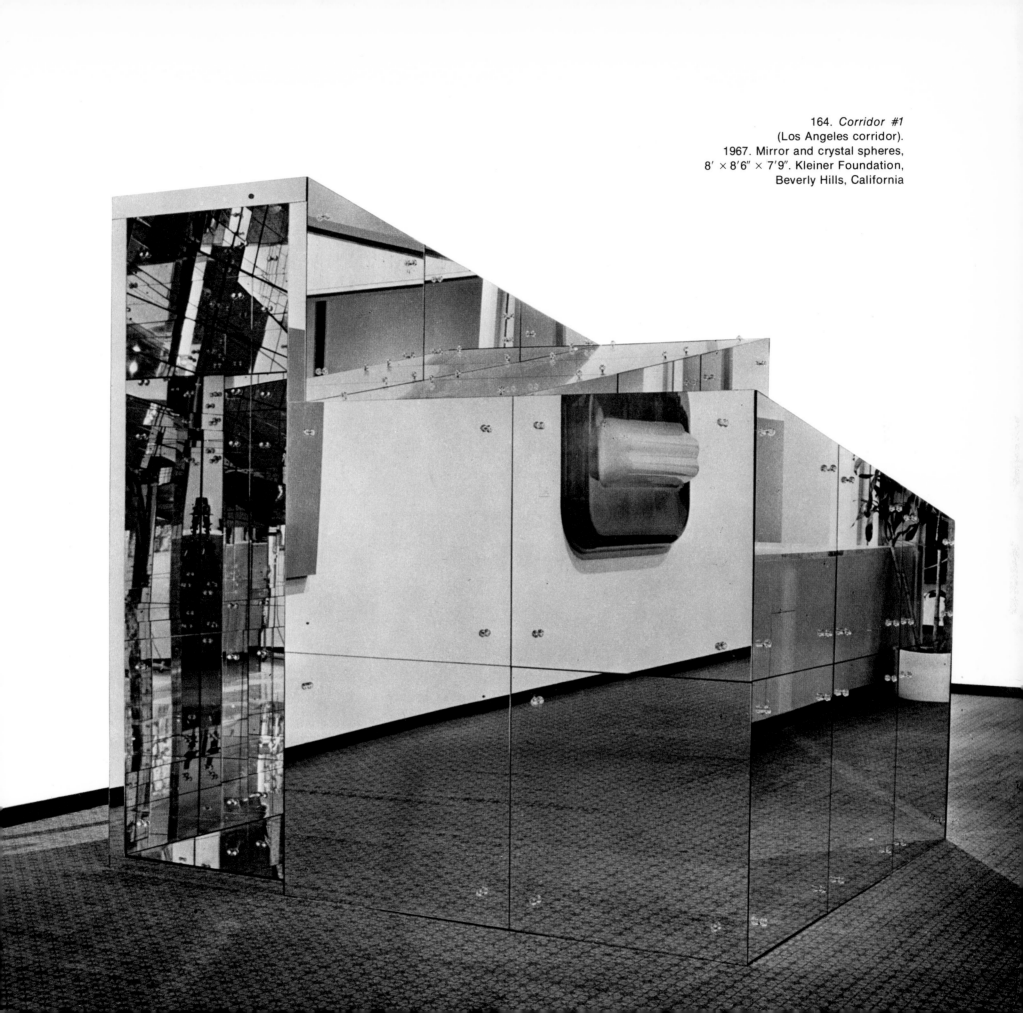

164. *Corridor #1*
(Los Angeles corridor).
1967. Mirror and crystal spheres,
8′ × 8′6″ × 7′9″. Kleiner Foundation,
Beverly Hills, California

165. *Drawing.* 1966.
Ink, 14 × 16¼″.
Collection the artist

166. Drawing for *Corridor #2*
(Philadelphia corridor).
1966. Ink, 14 × 16¼″.
Collection the artist

167. Plan for *Corridor #2* ▶
(Philadelphia corridor). 1966.
Pencil, 14 × 16¼″.
Collection the artist

$7\frac{1}{2}'$

$2\frac{1}{2}'$

$2\frac{1}{2}'$

30'

50'

each panel $2\frac{1}{2}'' \times 2\frac{1}{2}''$

168. Plan for *Room #3.* 1967. Pencil, 14 × 16¼″. Collection the artist

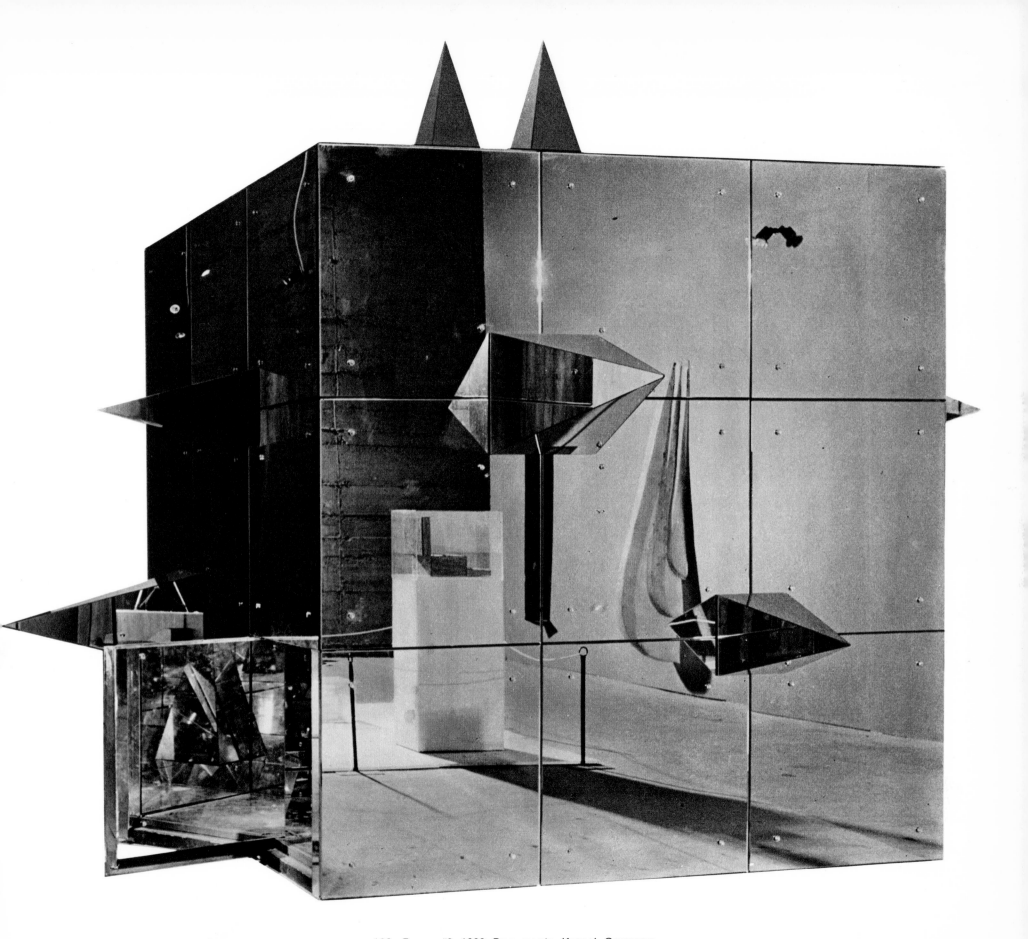

169. *Room #3*. 1968. Documenta, Kassel, Germany

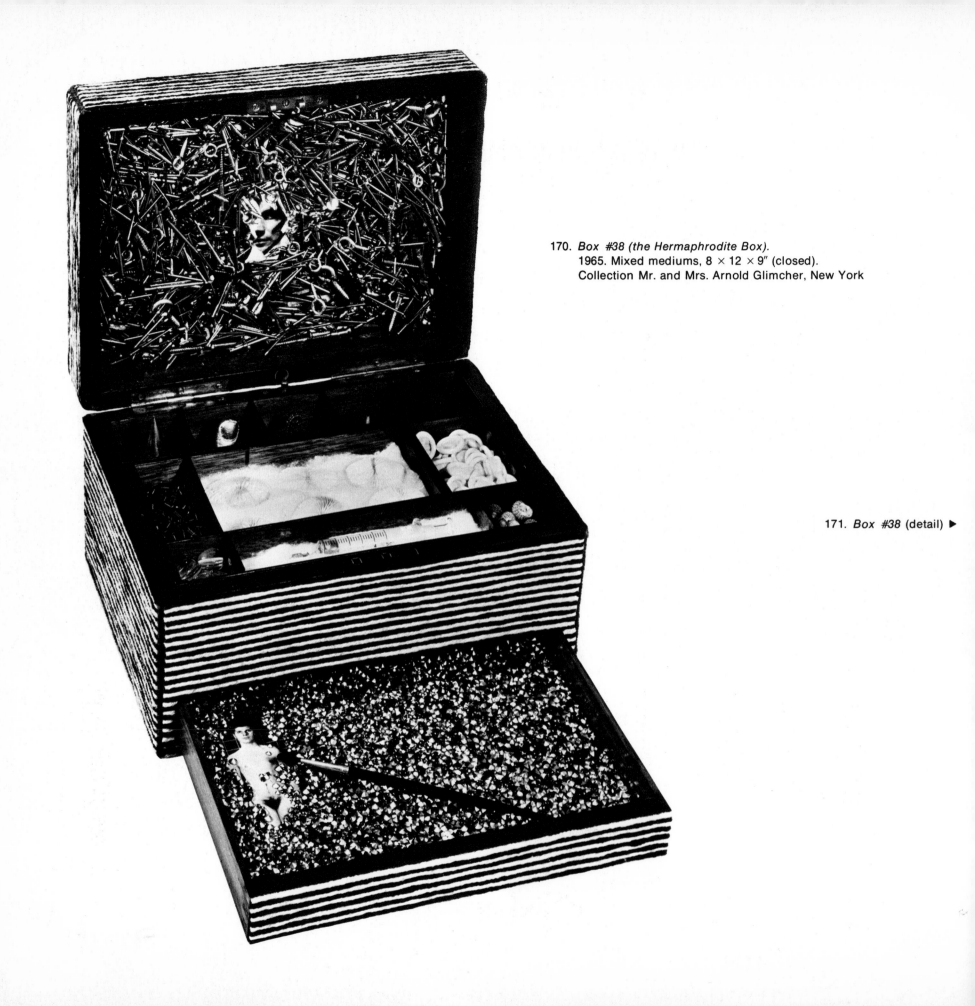

170. *Box #38 (the Hermaphrodite Box).*
1965. Mixed mediums, 8 × 12 × 9″ (closed).
Collection Mr. and Mrs. Arnold Glimcher, New York

171. *Box #38* (detail) ▶

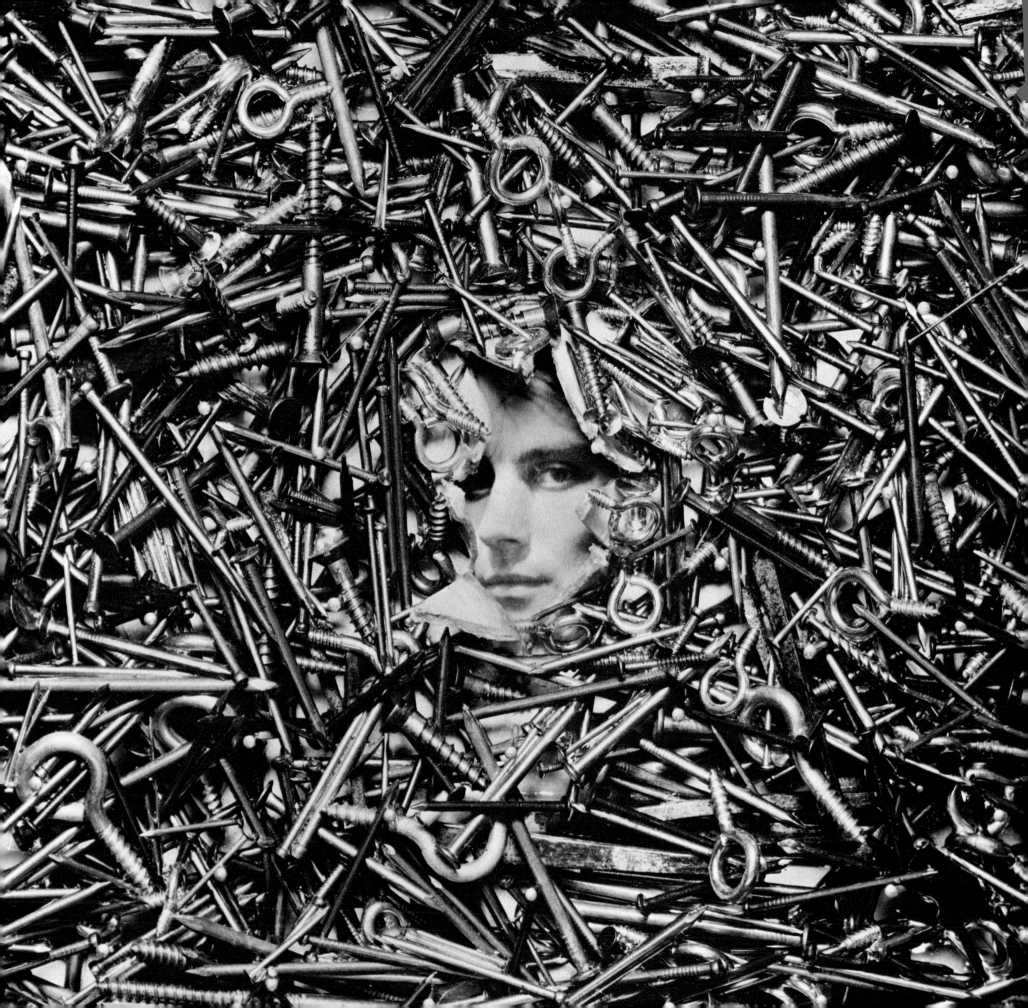

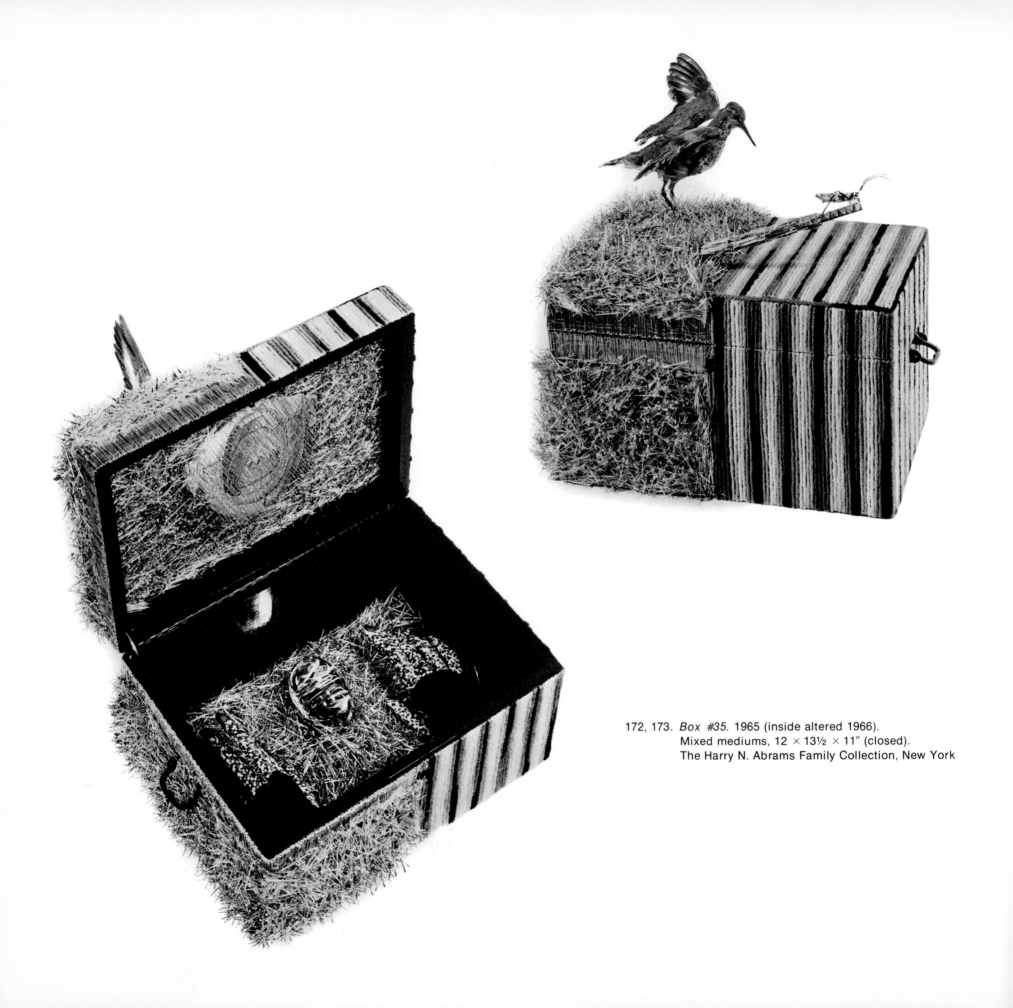

172, 173. *Box #35*. 1965 (inside altered 1966).
Mixed mediums, 12 × 13½ × 11″ (closed).
The Harry N. Abrams Family Collection, New York

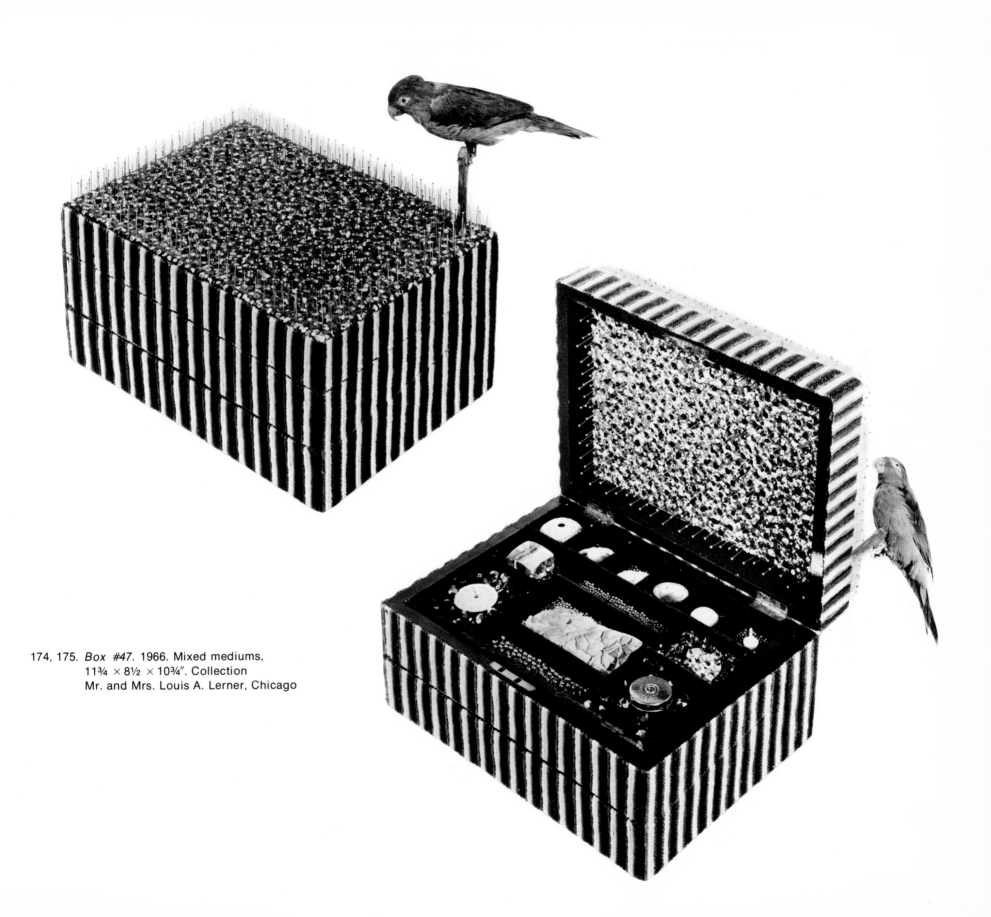

174, 175. *Box #47*. 1966. Mixed mediums,
11¾ × 8½ × 10¾″. Collection
Mr. and Mrs. Louis A. Lerner, Chicago

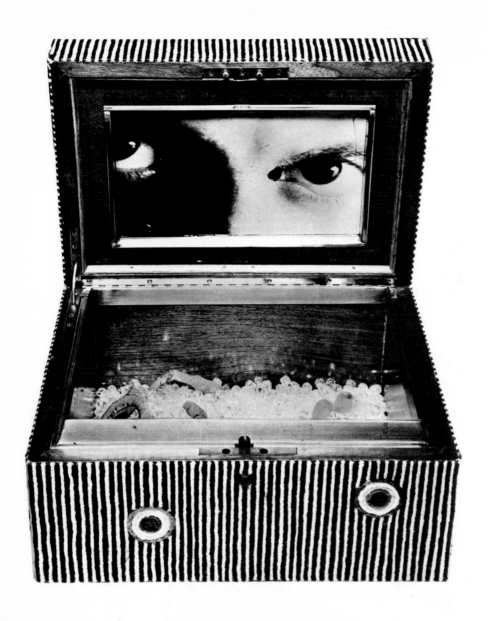

178. *Box #48*. 1966. Mixed mediums, ▶
11 × 9¼ × 14½″ (closed). Collection
Julie and Don Judd, New York

177. *Box #43*. 1966. Mixed mediums, 5½ × 8 × 11″.
Collection Robert Halff and Carl W. Johnson, Los Angeles

176. *Box #36*. 1965. Mixed mediums, 6¾ × 13¼ × 9½″ (closed).
Collection Mr. and Mrs. Richard Solomon, New York

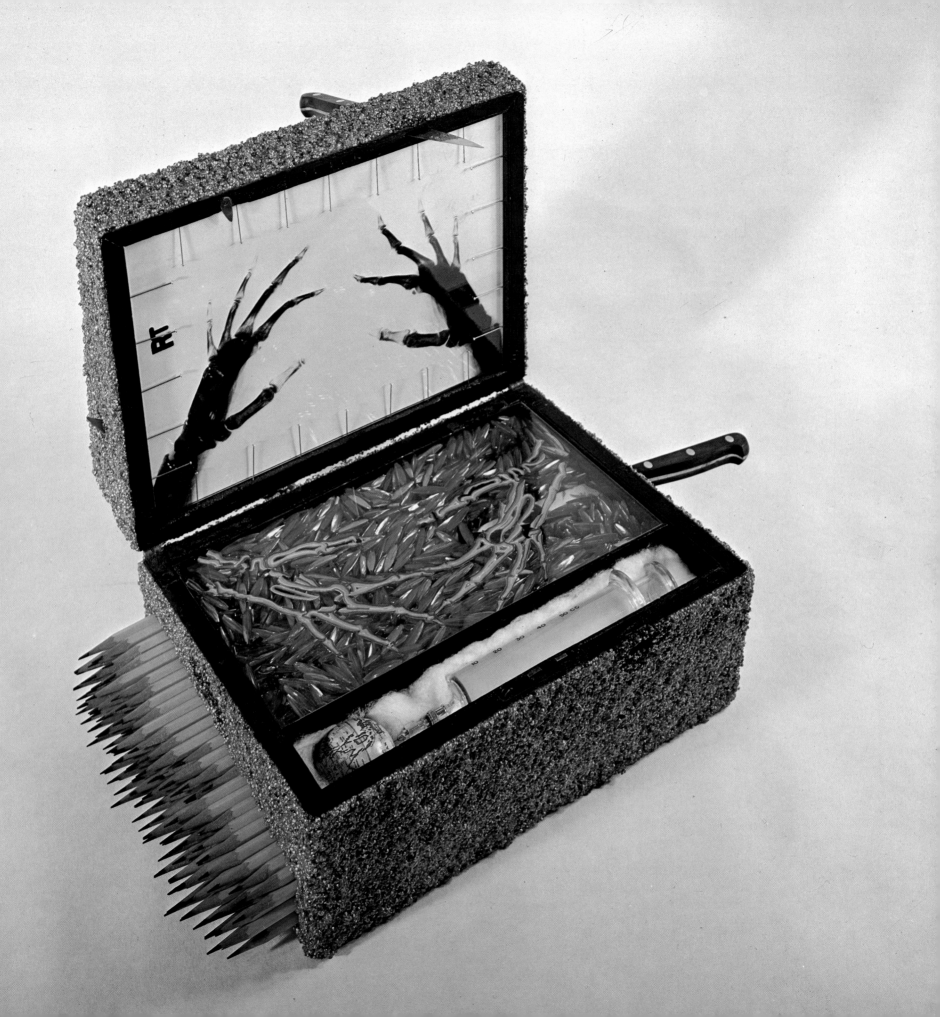

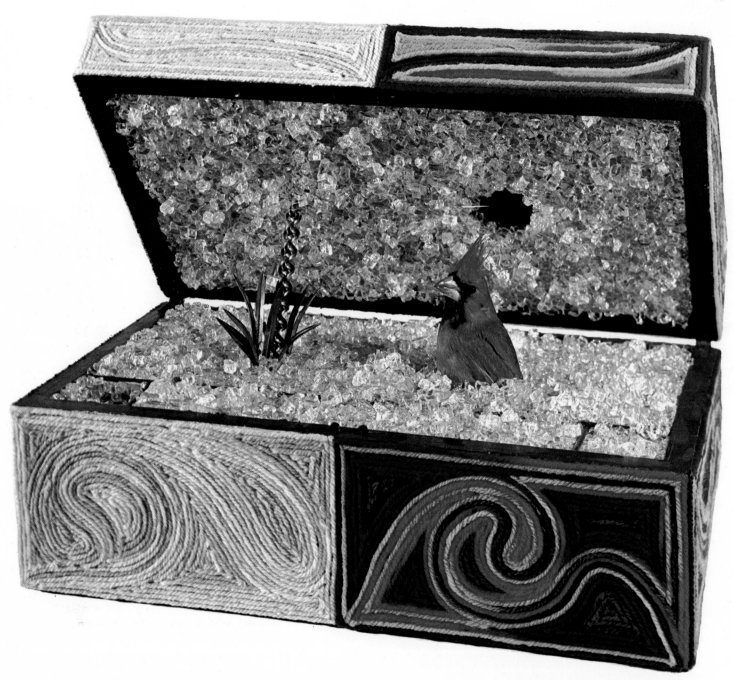

180. *Box #53.* 1966. ▶
Mixed mediums, 12 × 12 × 4″.
Collection Fred Mueller,
New York

179. *Box #55.* 1966. Mixed mediums, 12½ × 16 × 12″
Collection Mr. and Mrs. Eugene M. Schwartz, New York

181. *Box #45*. 1966.
Wood, paint, and wool, 22 × 12 × 12″.
St. Louis Art Museum. Gift of
Mr. and Mrs. George H. Schlapp

Foldout:
182. *Drawing D*. 1966.
Pencil and graphite, 17 × 14″.
Collection the artist

183. *Drawing E*. 1966.
Graphite and pencil, 16⅞ × 14″.
St. Louis Art Museum

184–88. Five drawings of boxes.
1966. Pencil,
each 11 × 8½″.
Collection the artist

182

189. *Untitled.* 1962.
Pastel, 12 × 9″.
Collection the artist

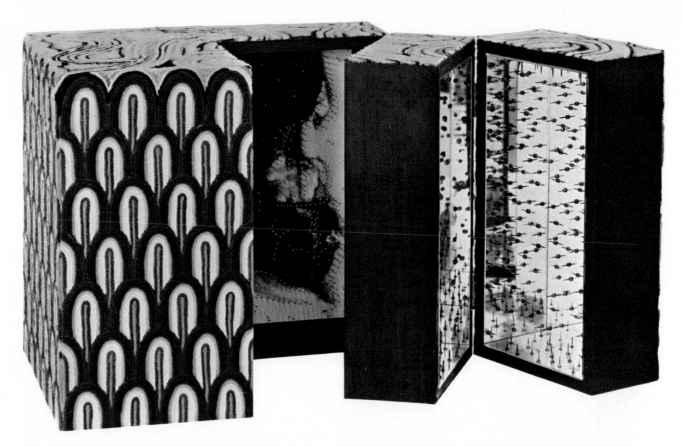

190, 191. *Box #40.* 1965. Mixed mediums,
14¼ × 12¼ × 16¼″. Collection
Mr. and Mrs. Richard H. Solomon,
New York

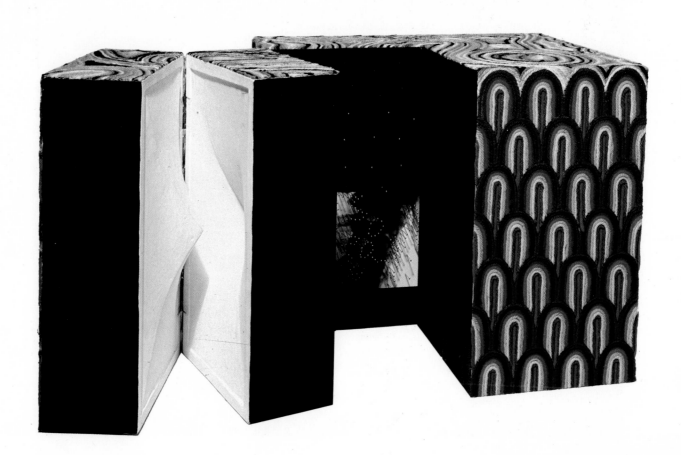

192. *Box #41.* 1965. Wood, wool, plaster, and acrylic paint, 24¾ × 17 × 10¼″. Collection Howard and Jean Lipman, New York

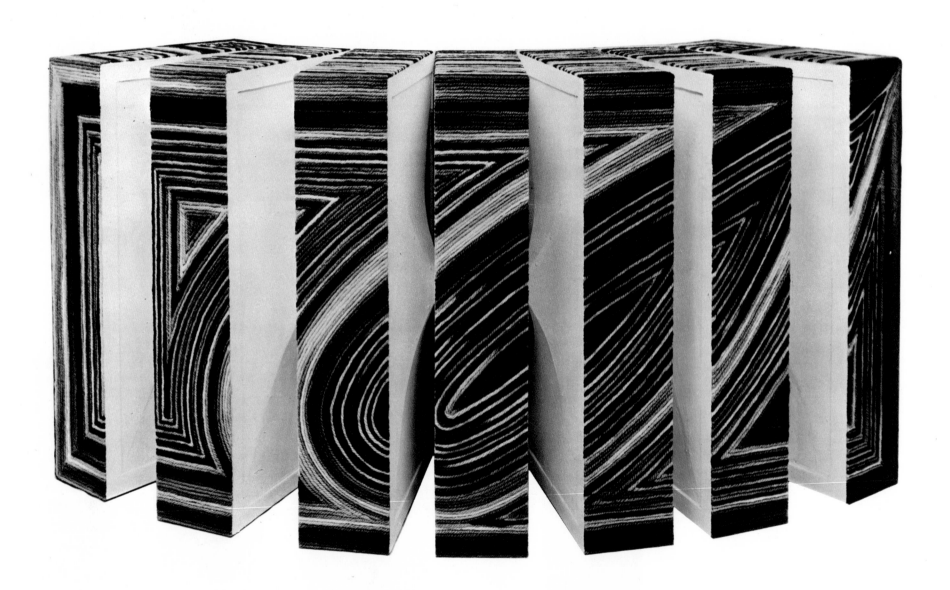

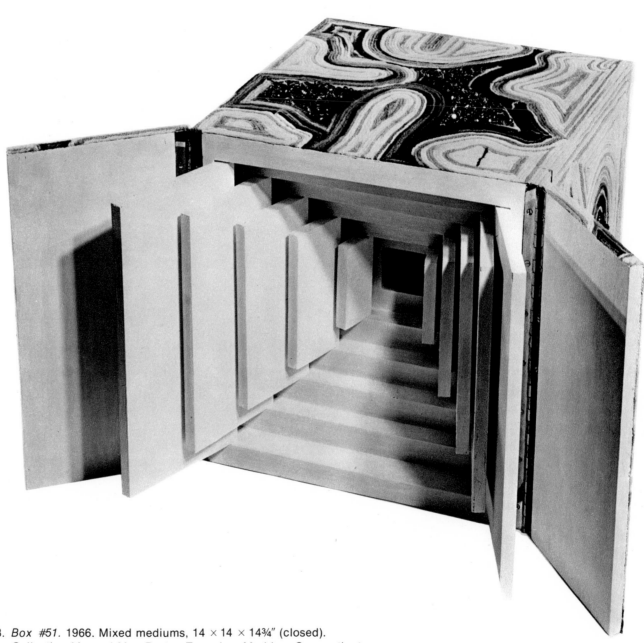

193. *Box #51*. 1966. Mixed mediums, 14 × 14 × 14¾″ (closed).
Collection Mr. and Mrs. Burton Tremaine, Meriden, Connecticut

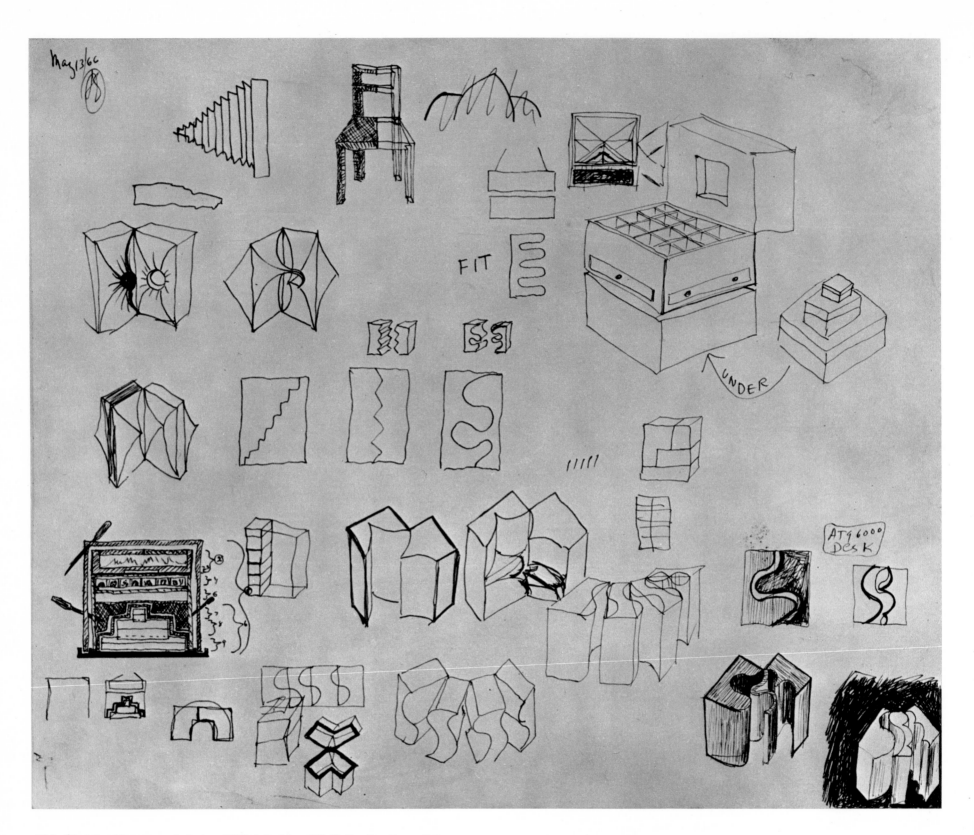

194. Sketch of boxes and chairs. 1966. Ink, 14 × 17″. Collection the artist

195. Drawing for *Box #54*. 1966. Ink, pencil,
and colored pencil, 11 × 8½″. Collection the artist

196. Drawing for *Box #50*. 1966. Ink, pencil,
and colored pencil, 11 × 8½″. Collection the artist

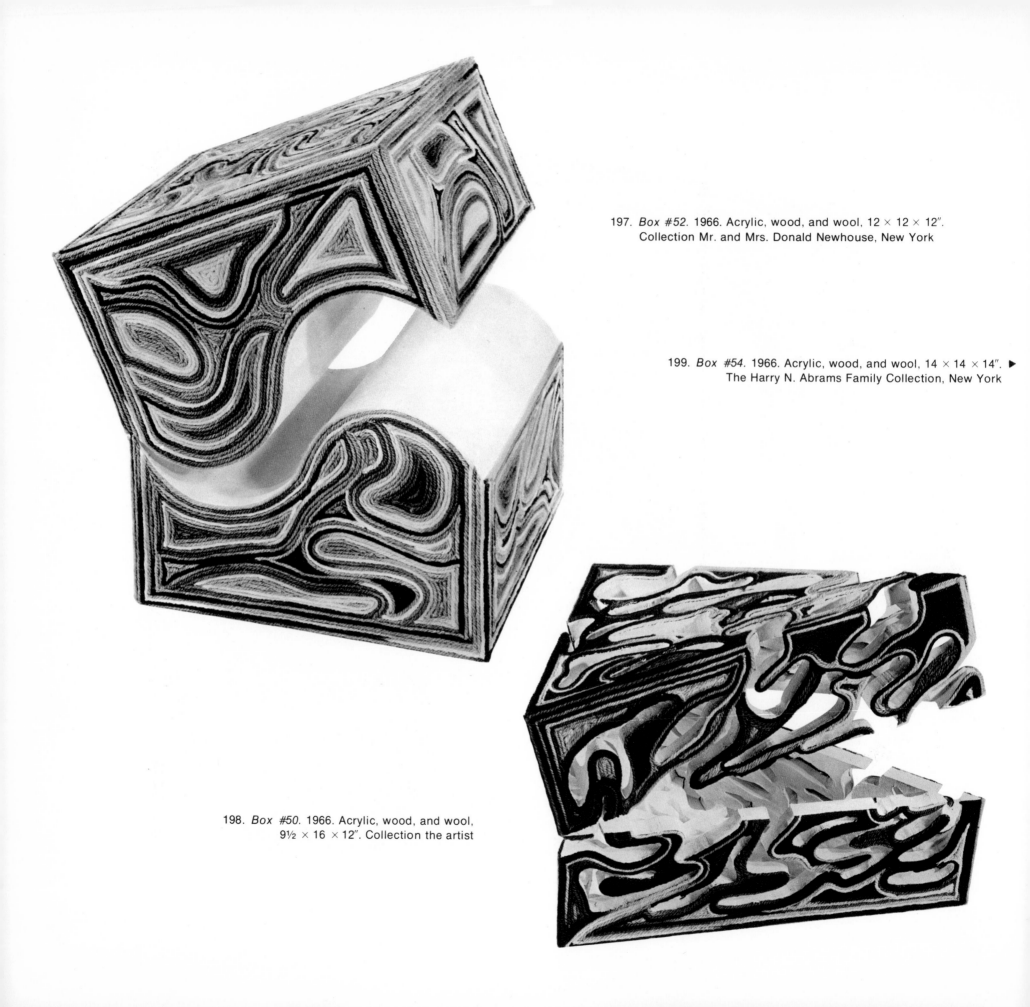

197. *Box #52*. 1966. Acrylic, wood, and wool, 12 × 12 × 12″.
Collection Mr. and Mrs. Donald Newhouse, New York

199. *Box #54*. 1966. Acrylic, wood, and wool, 14 × 14 × 14″. ▶
The Harry N. Abrams Family Collection, New York

198. *Box #50*. 1966. Acrylic, wood, and wool,
9½ × 16 × 12″. Collection the artist

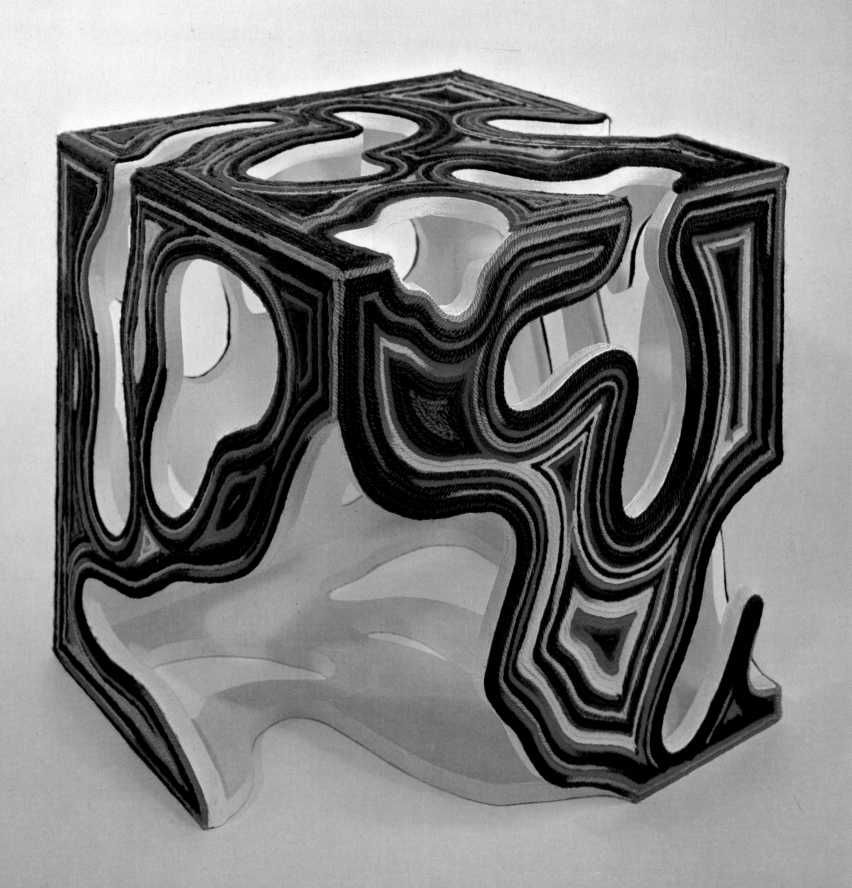

200. *Box #56*. 1966.
Mixed mediums, 12 × 12 × 12″ (closed).
Collection Howard and Jean Lipman,
New York

201–203. *Box #60*. 1967.
 Mixed mediums, 14 × 14 × 14″.
Collection Dr. and Mrs. Irving M. Forman,
Chicago

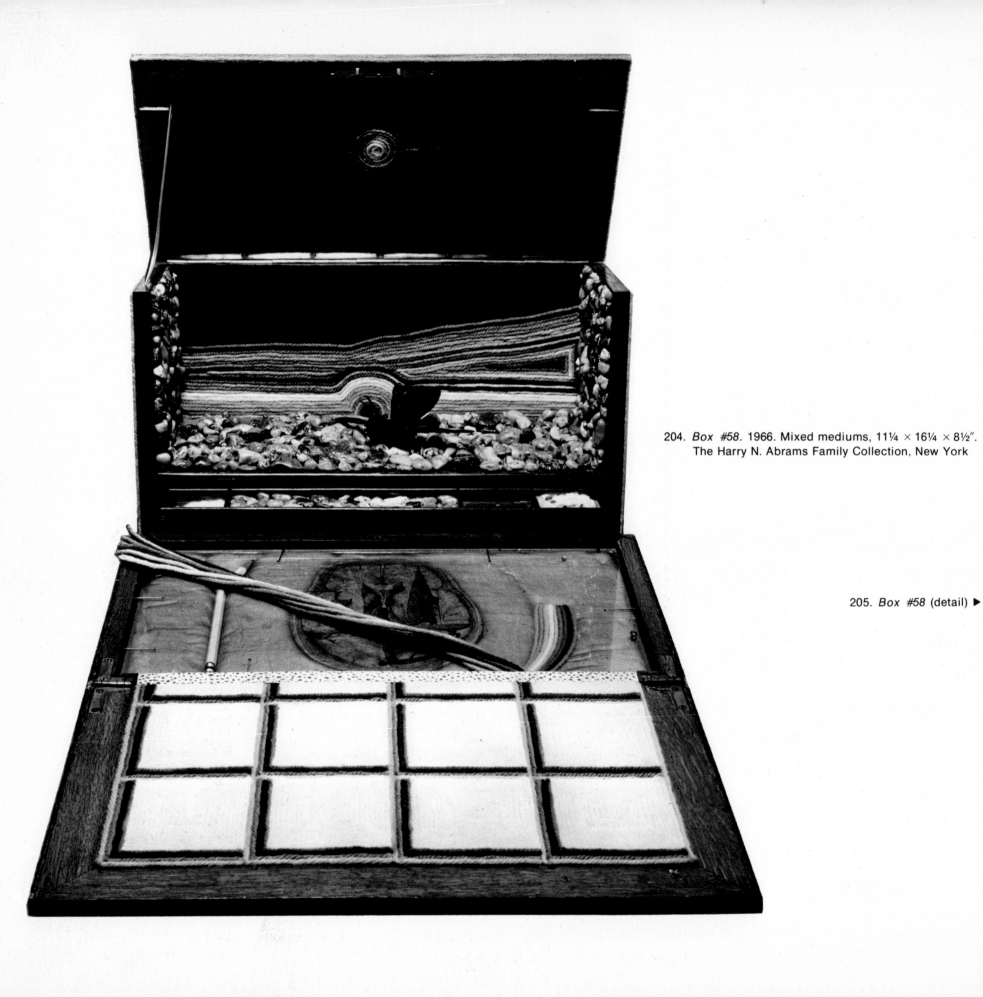

204. *Box #58*. 1966. Mixed mediums, 11¼ × 16¼ × 8½″. The Harry N. Abrams Family Collection, New York

205. *Box #58* (detail) ▶

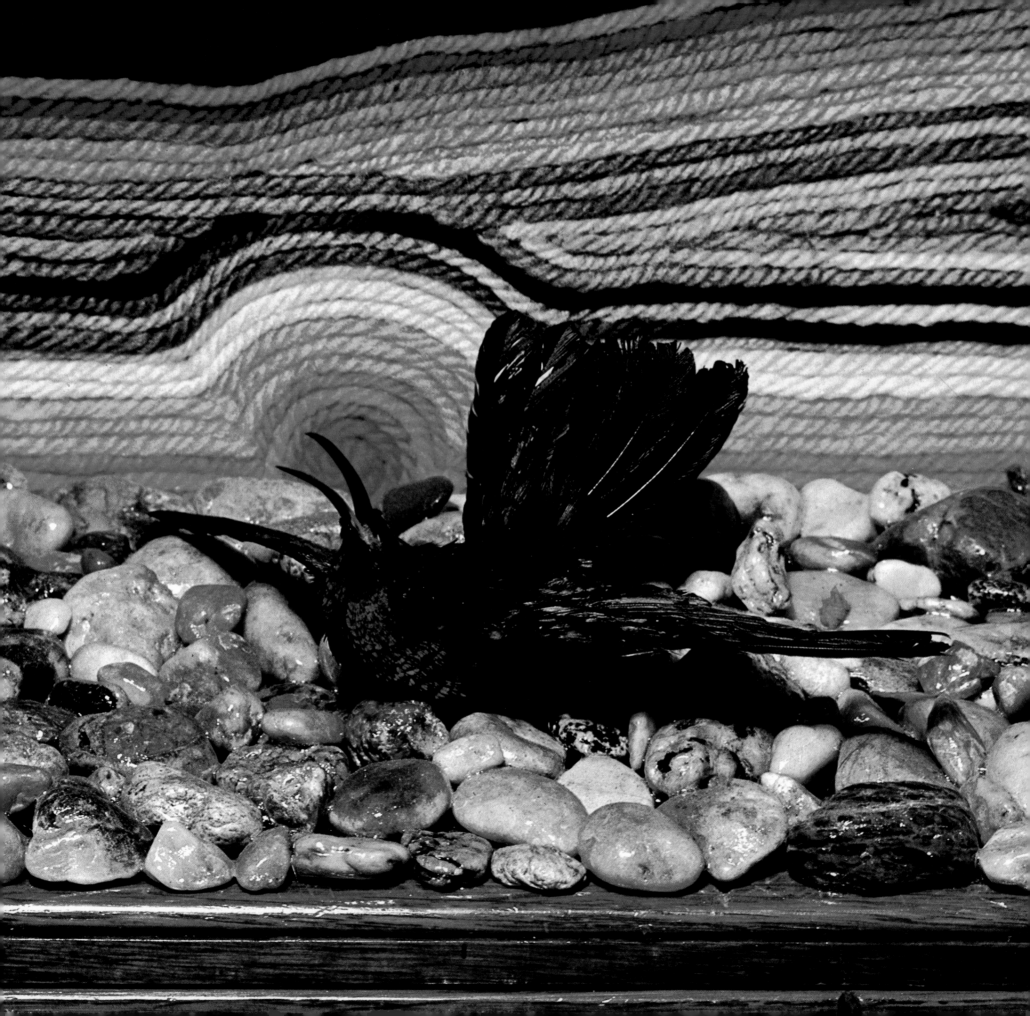

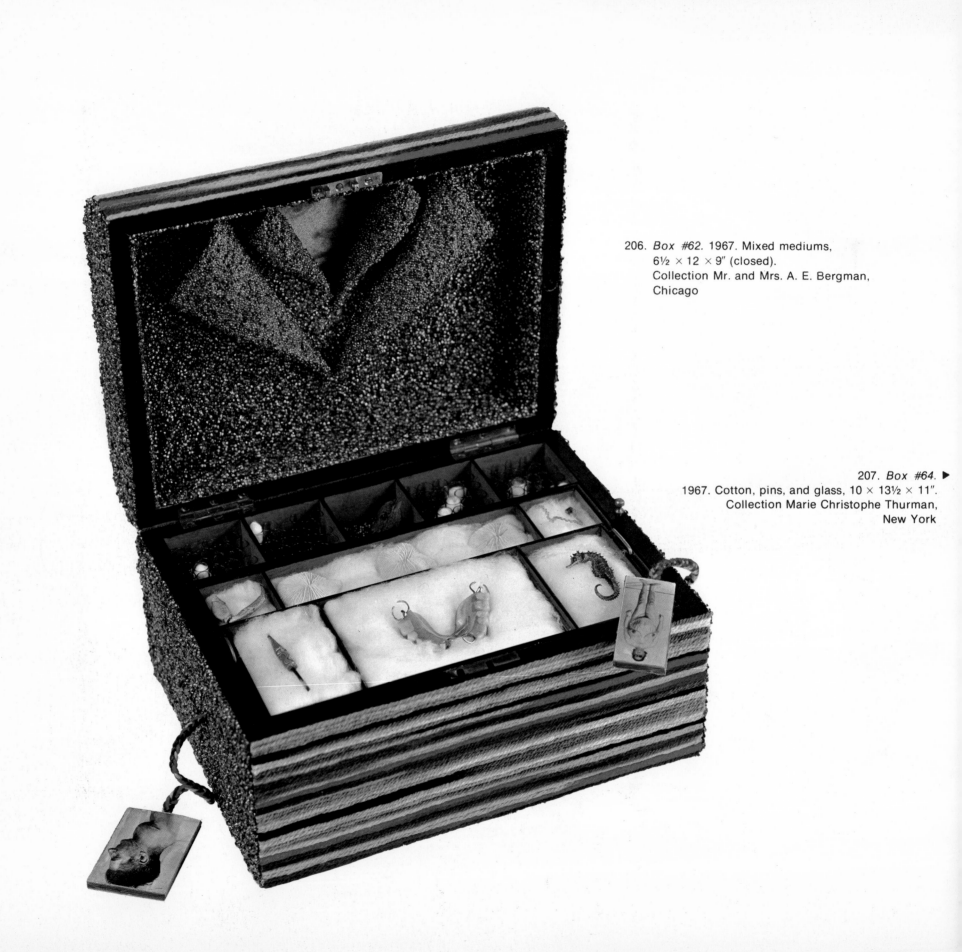

206. *Box #62.* 1967. Mixed mediums,
6½ × 12 × 9″ (closed).
Collection Mr. and Mrs. A. E. Bergman,
Chicago

207. *Box #64.* ▶
1967. Cotton, pins, and glass, 10 × 13½ × 11″.
Collection Marie Christophe Thurman,
New York

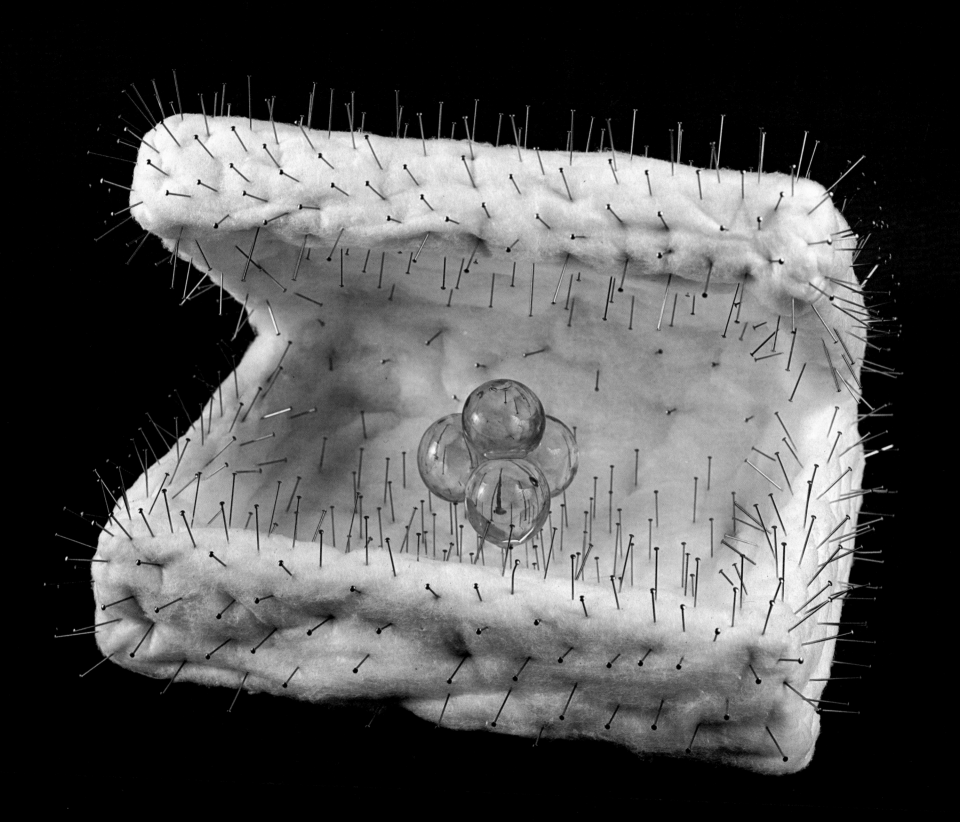

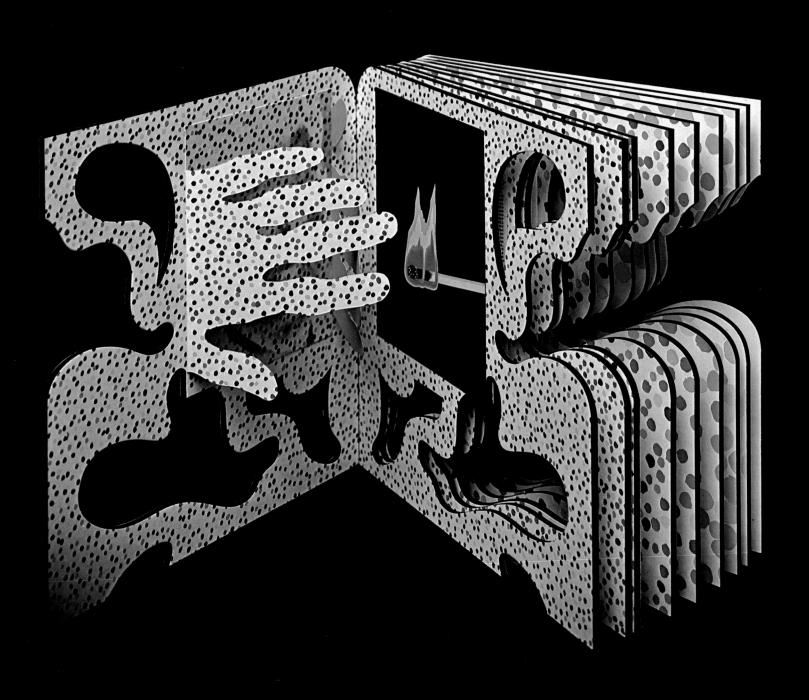

208. *Book.* 1967. Mixed mediums, 10 × 10″ (closed).
Pace Editions (1968), New York

209. *Untitled.* 1968. Acrylic, 7¾ × 7″. Collection the artist

210. *Untitled.* 1968. Acrylic, diameter 20″, depth 1½″.
Collection the artist

211. *Cut Paper Drawing #65.*
1968. Paper, 23 × 18″.
Collection the artist

212. *Cut Paper Drawing #39*. 1968. Paper, 18 × 23″. Collection the artist

213. *Untitled*. 1968.
Painted wood and Formica, 46 × 36 × 5½".
Collection Mr. and Mrs. Richard H. Solomon,
New York

214. *Box #74*. 1968. ▶
Painted wood, 15 × 21 × 6".
Collection Anne Ratner, New York

215, 216. Two drawings for boxes.
1968. Ink, 8½ × 11″.
Collection the artist

217. *Box #76*. 1968. ▶
Painted wood, 31¼ × 28½ × 6″.
The Pace Gallery, New York

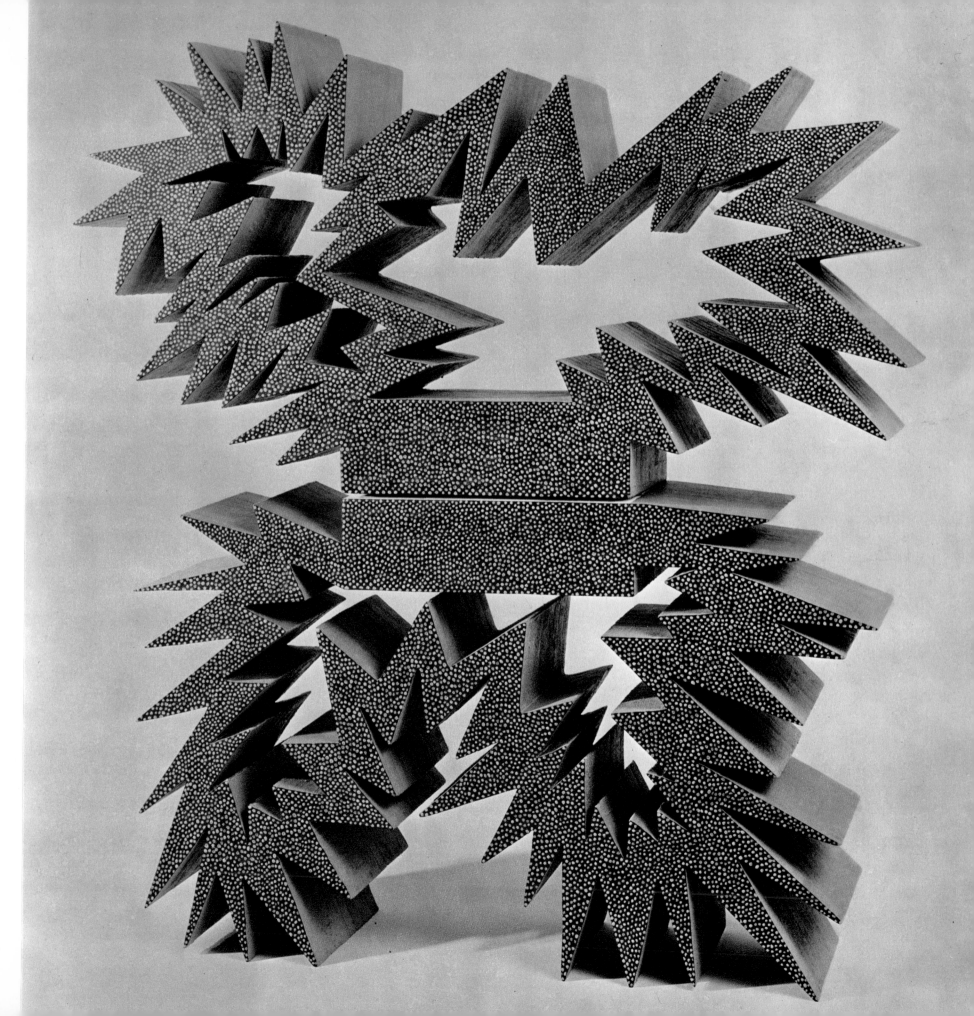

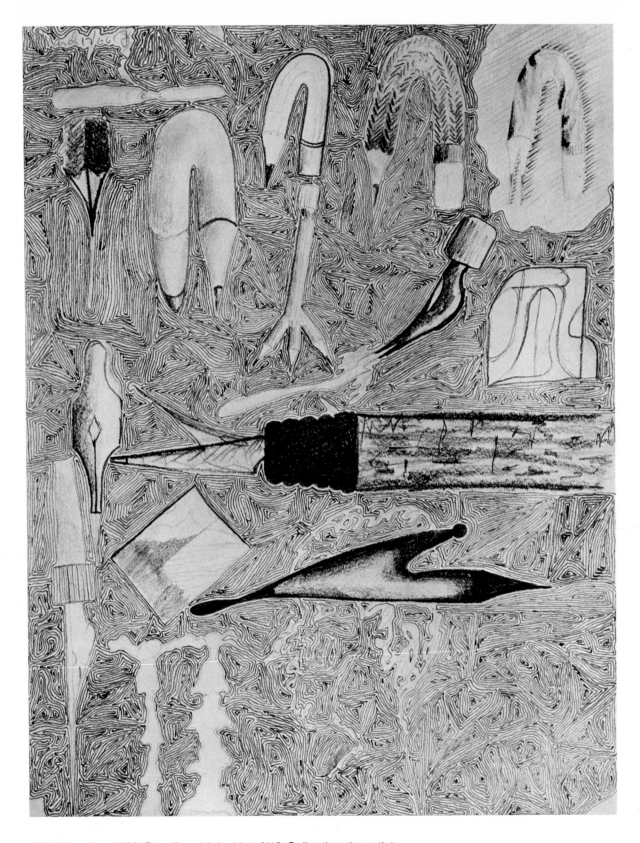

218. *Drawing*. 1966. Pencil and ink, 11 × 8½". Collection the artist

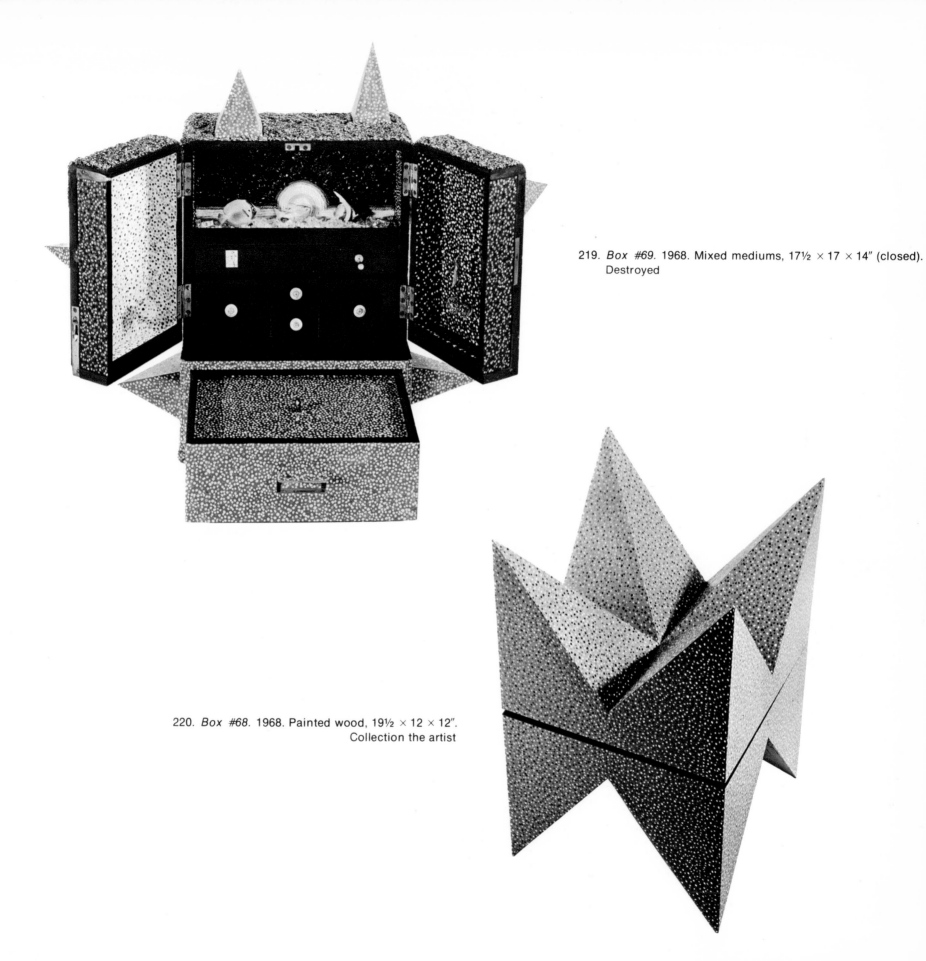

219. *Box #69.* 1968. Mixed mediums, 17½ × 17 × 14″ (closed). Destroyed

220. *Box #68.* 1968. Painted wood, 19½ × 12 × 12″. Collection the artist

221. *Box #72.* 1968. Painted wood, 14 × 26 × 8″. Collection the artist

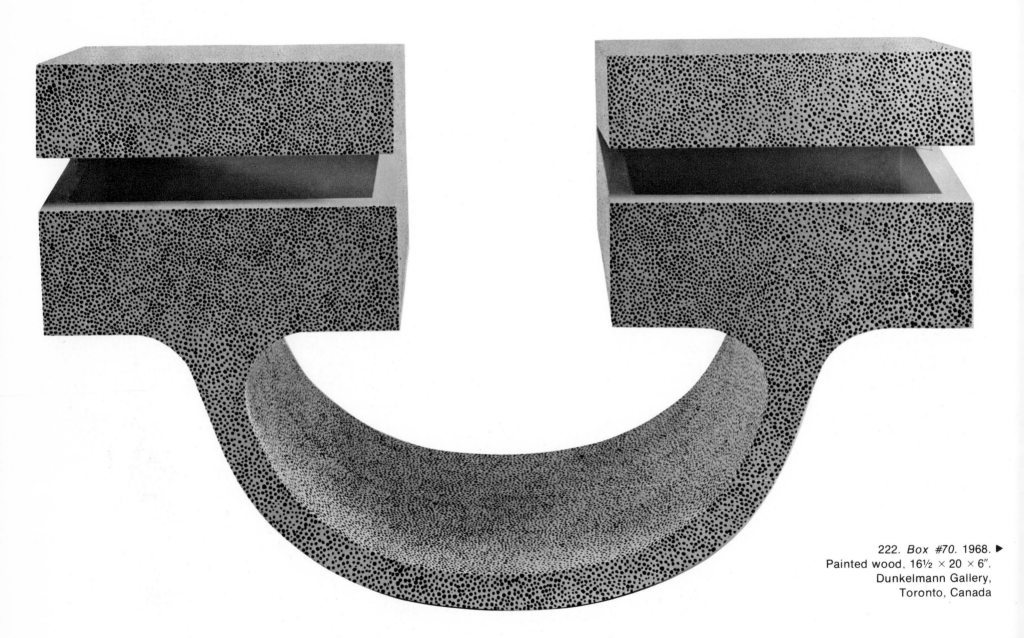

222. *Box #70.* 1968. ▶
Painted wood, 16½ × 20 × 6″.
Dunkelmann Gallery,
Toronto, Canada

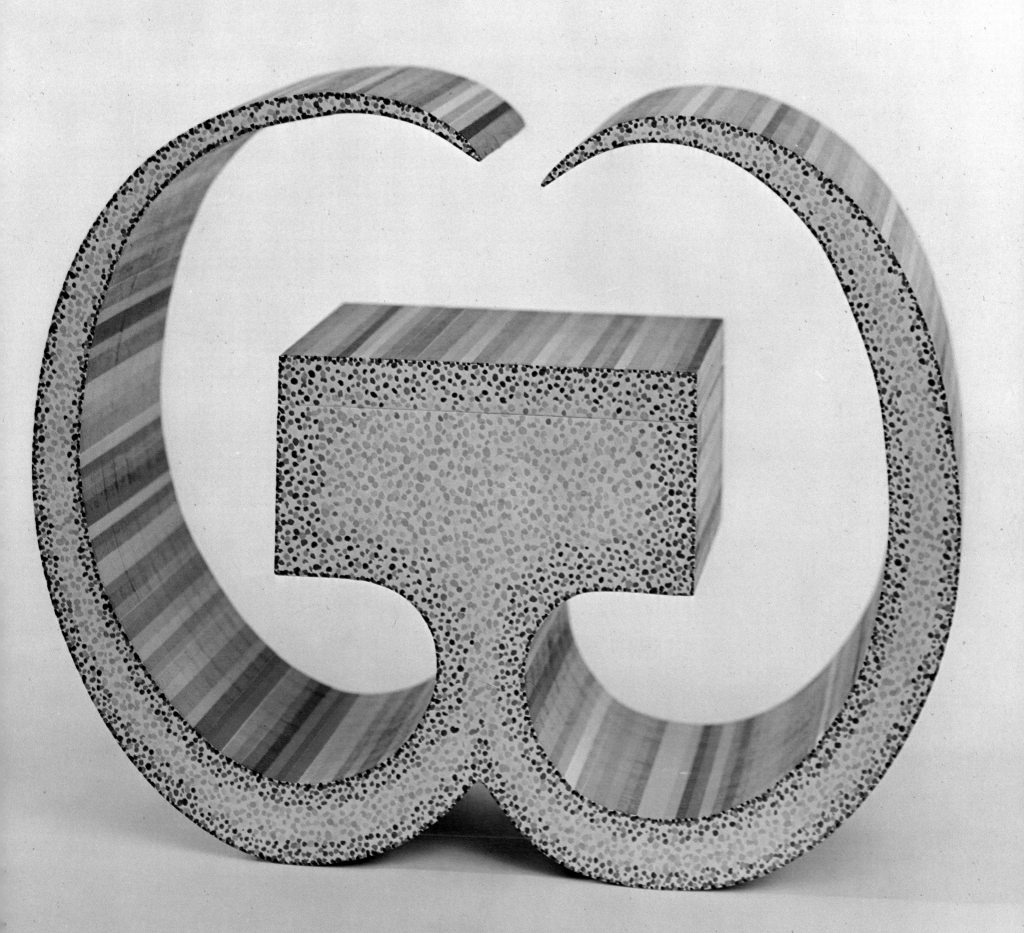

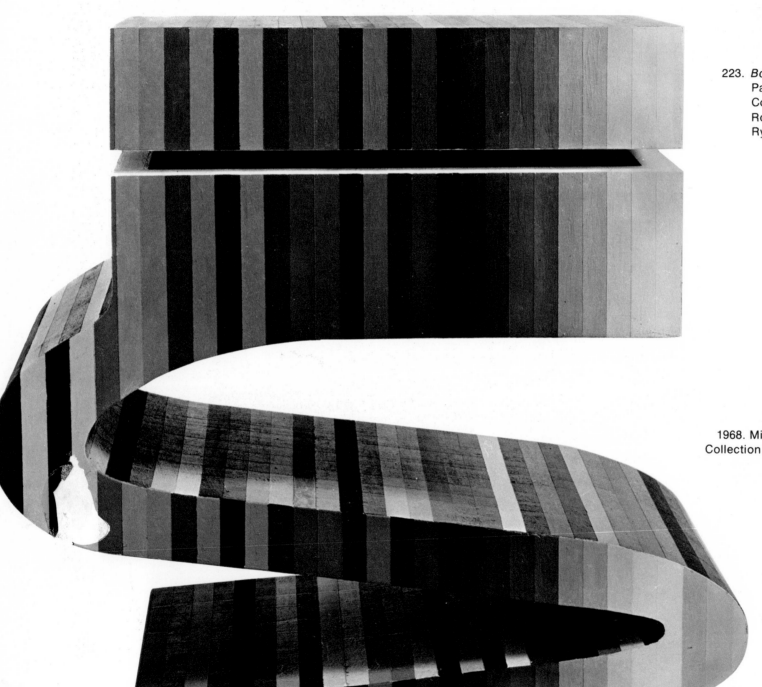

223. *Box #71.* 1968.
Painted wood, 14 × 16 × 8″.
Collection Mr. and Mrs.
Robert E. Lintin,
Rye, New York

224. *Transformation: Flowers.* ▶
1968. Mixed mediums, 53½ × 35 × 31″.
Collection Mr. and Mrs. Robert B. Mayer,
Winnetka, Illinois

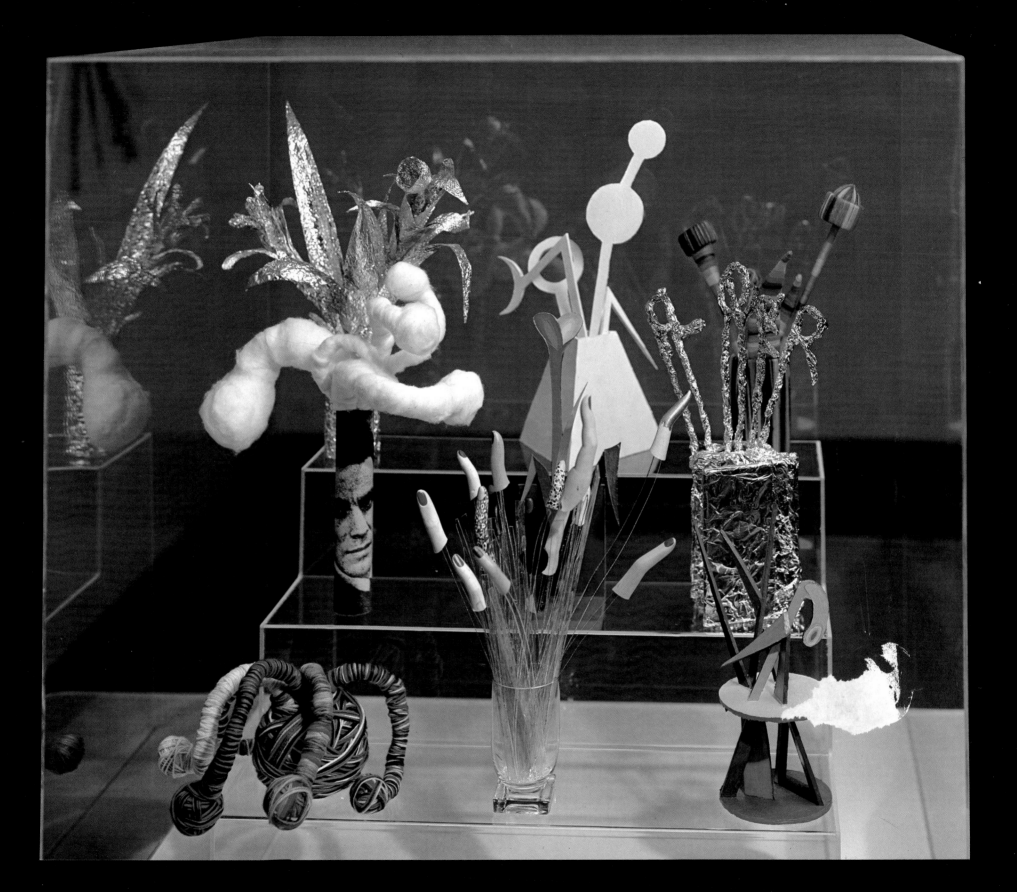

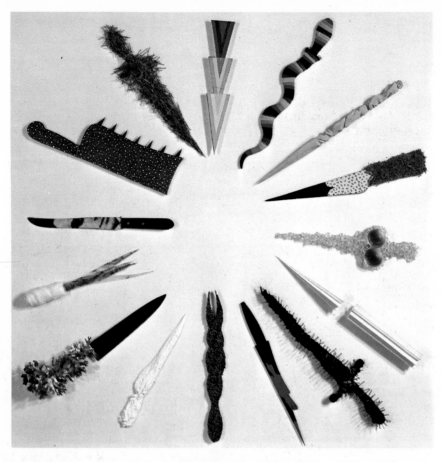

225. *Transformation: Knives.* 1968. Mixed mediums, 40¼ × 40¼ × 3½".
Collection Mr. and Mrs. A. E. Bergman, Chicago

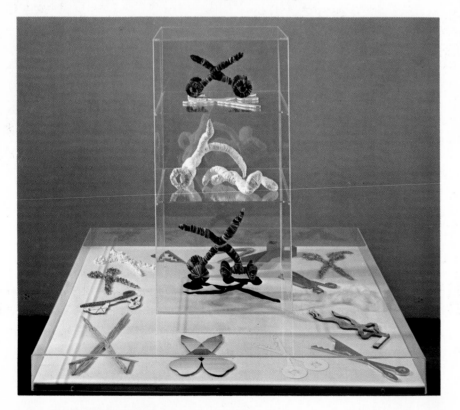

226. *Transformation: Scissors.* 1968. Mixed mediums, 51½ × 36½ × 36½".
Collection Jacques Kaplan, New York

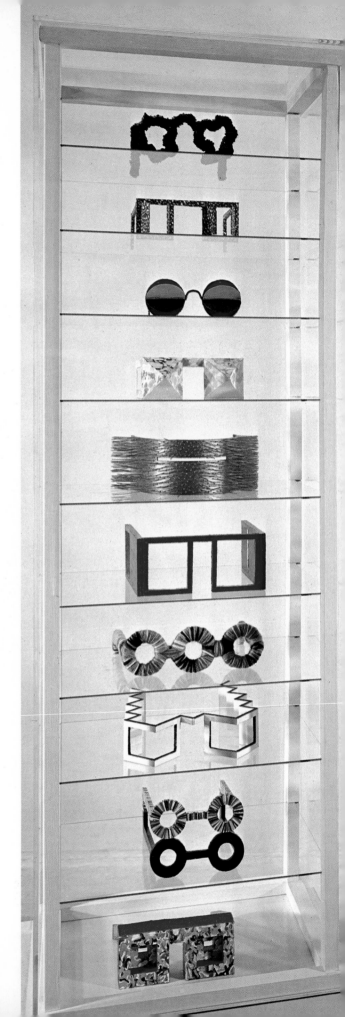

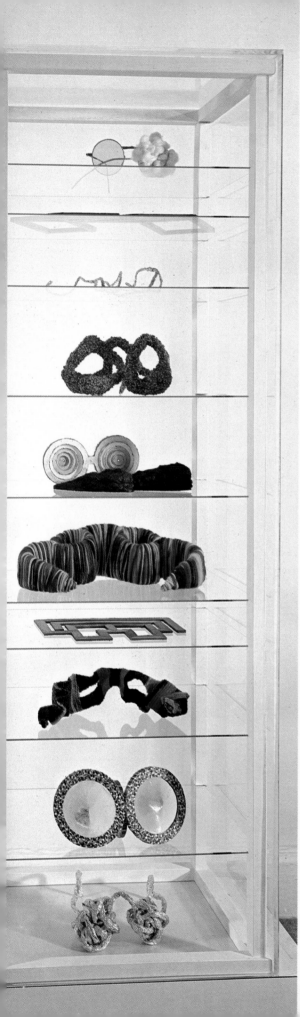

227. *Transformation: Eyeglasses.* 1966. Mixed mediums, 61 × 51 × 18".
Albert A. List Family Collection, New York

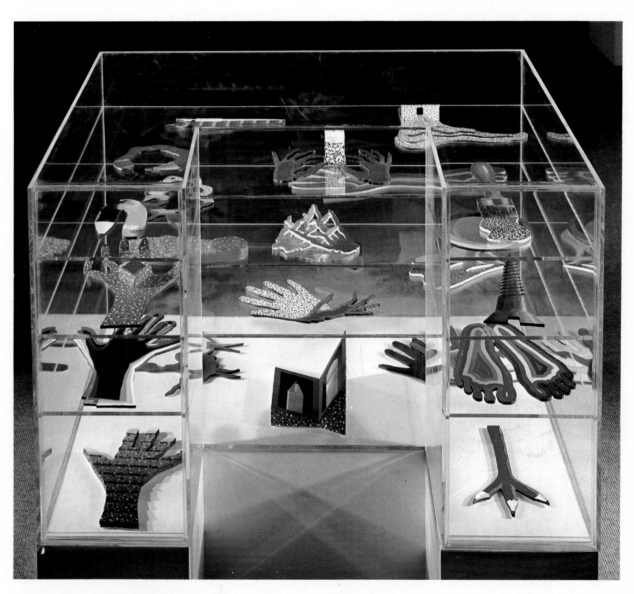

228. *Transformation: Mixed.* 1967. Painted board, 33⅛ × 36¼ × 30".
The Pace Gallery, New York

229. *Transformation: Chairs #25.*
1969–70. Plastic flowers on
wire clothes hangers,
42 × 20 × 22″. The Whitney
Museum of American Art,
New York

230. *Transformation: Chairs #16.* ▶
1969–70. Acrylic on wood,
30 × 15 × 28″. The Whitney
Museum of American Art,
New York. Gift of
Howard and Jean Lipman

231–34. Four drawings for
*Transformation: Chairs.*
1969–70. Pencil,
each 13 × 8½″.
Collection the artist

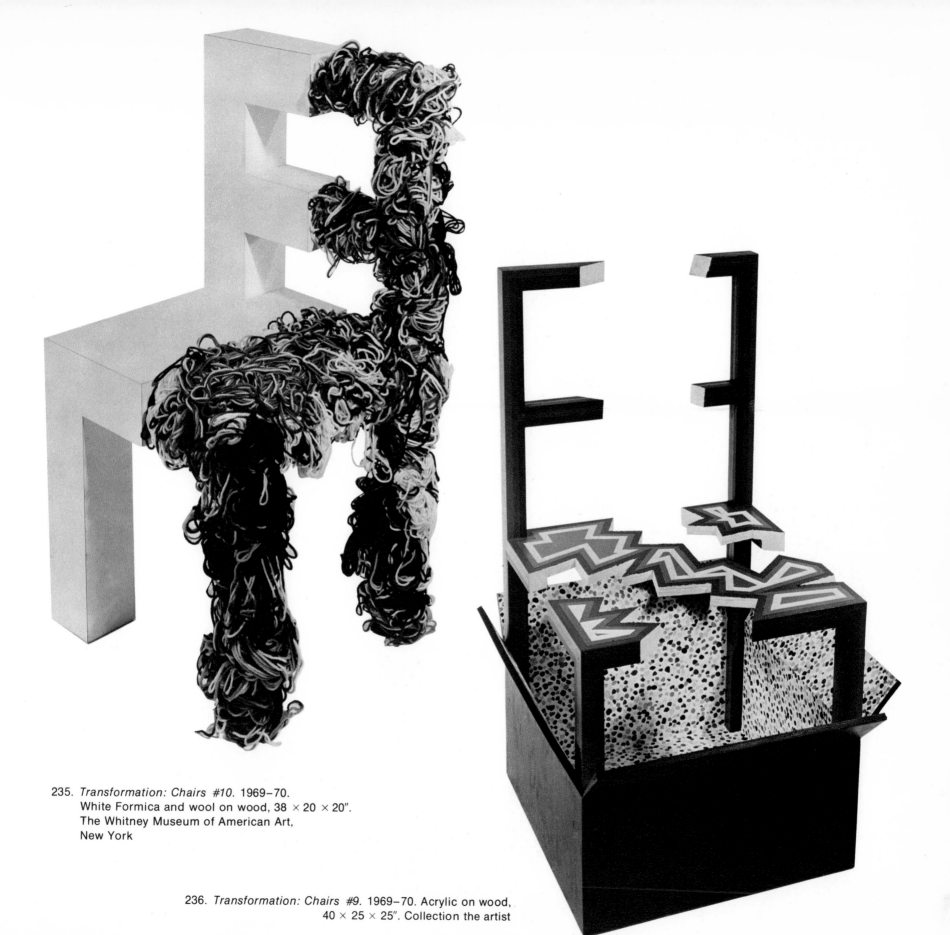

235. *Transformation: Chairs #10.* 1969–70.
White Formica and wool on wood, 38 × 20 × 20″.
The Whitney Museum of American Art,
New York

236. *Transformation: Chairs #9.* 1969–70. Acrylic on wood,
40 × 25 × 25″. Collection the artist

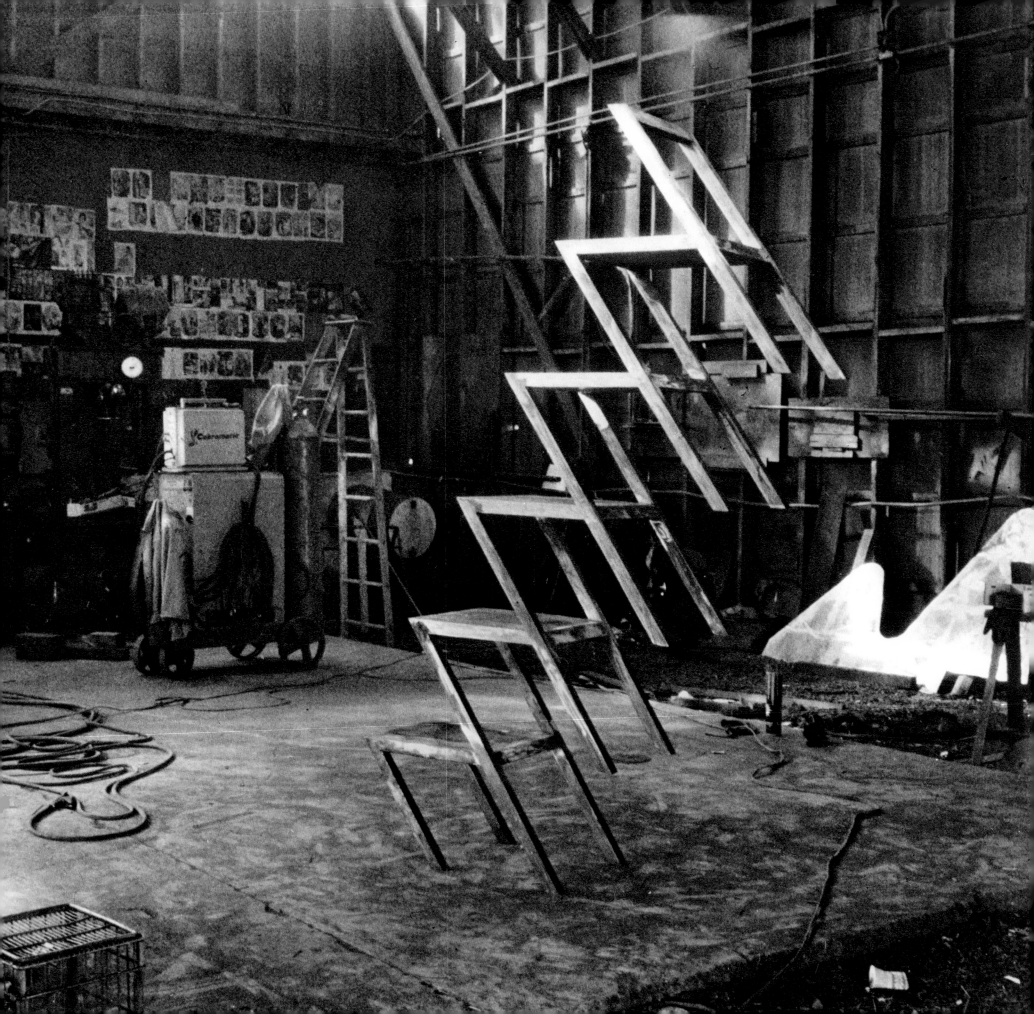

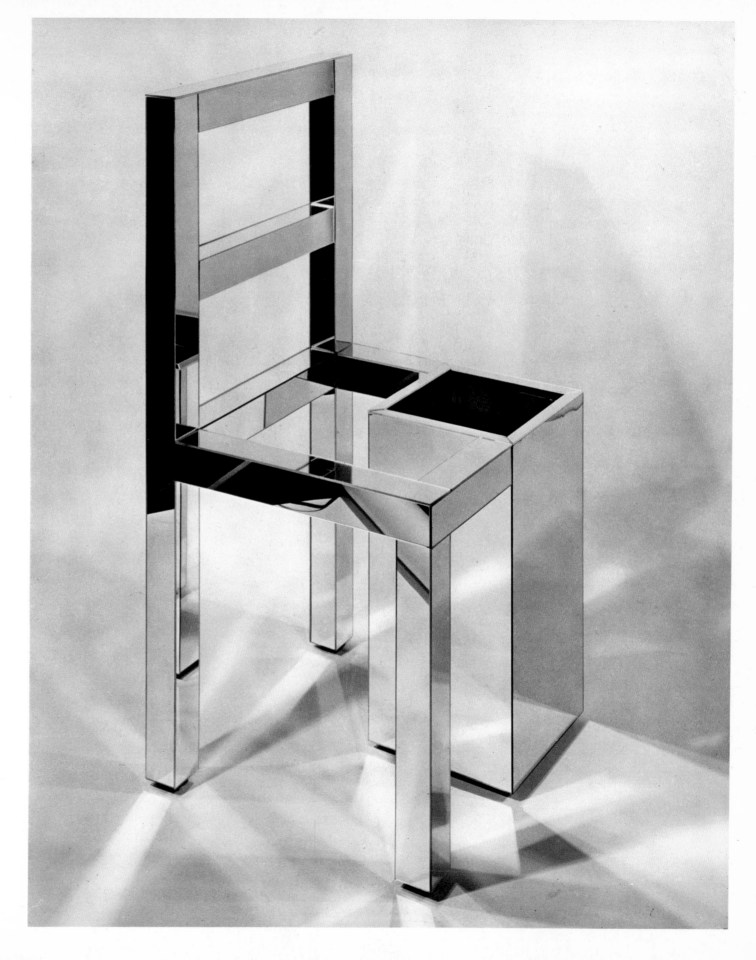

◄ 237. *Transformation: Chairs #20.*
1969–70. Cor-Ten steel,
95 × 18 × 19″.
Collection Sidney and
Phyllis Wragge, New York

238. *Transformation: Chairs #22.*
1969–70. Mirror on wood,
40 × 20 × 20″.
Collection the artist

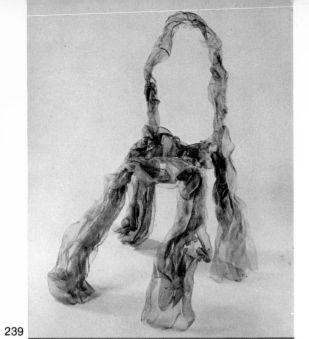

239

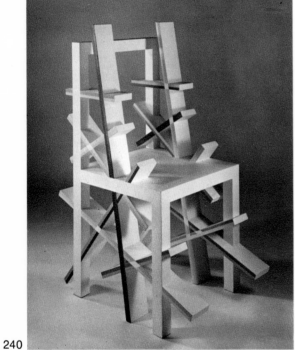

240

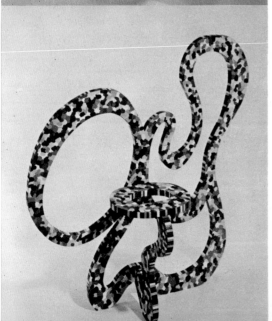

241

239. *Transformation: Chairs #5.* 1969–70. Wire mesh, 36 × 27 × 18″.
Collection the artist

240. *Transformation: Chairs #3.* 1969–70. Acrylic on wood, 43 × 20 × 30″.
Collection Mr. and Mrs. Wilfred P. Cohen, Great Neck, New York

241. *Transformation: Chairs #12.* 1969–70. Acrylic on wood, 40½ × 36 × 13″.
The Whitney Museum of American Art, New York. Gift of Howard and Jean Lipman

242. *Transformation: Chairs  #23*. 1969–70. Paper, 19 × 50 × 40″. Collection the artist

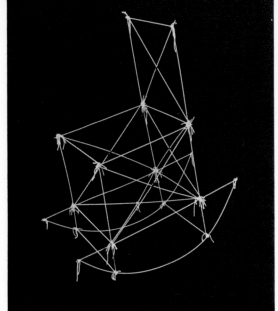

243

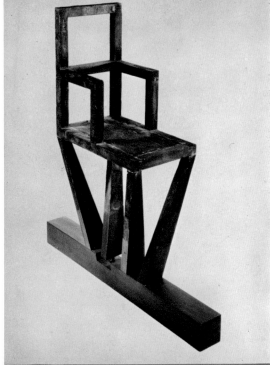

244

243. *Transformation: Chairs  #13*. 1969–70. Wood and wool, 37 × 15 × 31½″. Destroyed

244. *Transformation: Chairs #18*. 1969–70. Burned wood, 42 × 12 × 40″. Collection the artist

245. *Transformation: Chairs #17*. 1969–70. Cotton on wood, 34 × 19 × 16″. Collection the artist

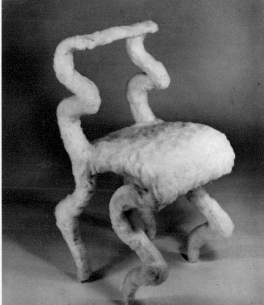

245

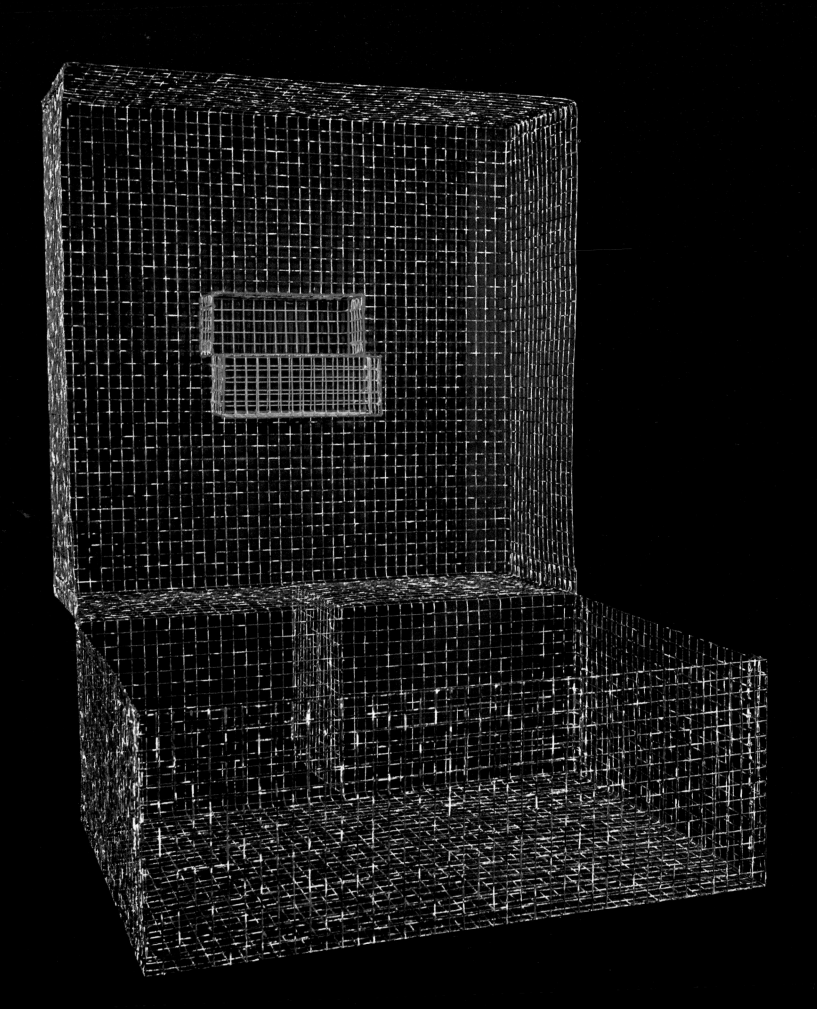

◀ 246. *Chicken Wire Box #35*. 1972. Acrylic paint on chicken wire, 27¾ × 21 × 22¾″. The Pace Gallery, New York

247–52. *Autopolaroids*. 1970–71. Copyright the artist

253–64. *Autopolaroids.* 1970–71. Copyright the artist

265. *Photo-Transformation.* 1973–74. SX 70 Polaroid, 3 × 3″. The Pace Gallery, New York

**1936** Born September 14 to Trigona Siotkas and Damianos Samaras in Kastoria, Macedonia, Greece.

**1939** Father leaves for America.

**1940** Greece enters World War II.

**1945** Civil war begins in Greece.

**1948** Lucas and mother join father in America and settle in West New York, New Jersey. Attends Public School 5.

**1951** Sister Carol is born. Lucas enters Memorial High School, where he is encouraged by his art teacher, Fabian Zaccone.

**1955–59** Admitted on scholarship to Rutgers University. Joins Rifle Club, acts in Queens Theatre performances, and becomes art editor of the University literary magazine, *The Anthologist*. Meets Allan Kaprow, George Segal, and Robert Whitman. Paints in oil and watercolor and uses pastel. Experiments with glass, tinfoil, silver paint, wax, and newsprint.

**1959** Enters Columbia University to study art history under Meyer Schapiro. Starts acting in Happenings at the Reuben Gallery, where he meets such artists as Claes Oldenburg, Jim Dine, and Red Grooms. November 6–26, one-man show of paintings and pastels at Reuben Gallery. Begins working with plaster and cloth. Completes his first food piece, a plaster hot dog. Starts work on his first story, "Pythia."

**1960** His plaster figures are included in a group show at the Reuben Gallery in January. Attends Stella Adler Theatre Studio. Makes the last of his oil paintings and begins his first boxes, using plaster, mirror, tacks, and feathers. One box is included in the show *New Forms—New Media II* at the Martha Jackson Gallery, New York.

**1961** Continues to make food pieces using kitchen utensils, china, cotton, and hardware. Spends the summer in Provincetown, Mass. Writes "Shitman" and parts of "Dickman." Completes his first floor piece, made of liquid aluminum and Sculpmetal. December 5–23, one-man show at the Green Gallery, New York. The Museum of Modern Art acquires an untitled piece made of wood and feathers which is included in the show *The Art of Assemblage*.

biographical outline

**1962** Terminates his studies at Columbia. Acts in Claes Oldenburg's and Robert Breer's film *Pat's Birthday*. Works with paper bags, tinfoil, and books; stops using pastels. Begins making pin-covered books and boxes.

**1963** Acts in Ray Saroff's film *The Real Thing*. Exhibits pin-covered pieces at the Green Gallery. Is included in the *Twenty-Eighth Biennial Exhibition* at the Corcoran Gallery of Art, Washington, D. C., and in *Mixed Media and Pop Art* at the Albright-Knox Art Gallery, Buffalo, N. Y. Begins using colored wool yarn and photographs of himself in a series of Boxes, *# 3–12*, and Dinners, *# 0–10*. Spends the summer in Provincetown. Writes "Flowerman" and "Killman."

**1964** Makes *Boxes # 13–26*, plus cubes and other shapes, using Mylar and plastic. In the summer, his parents and sister move back to Greece and he moves to New York City. September 16–October 10, *Room # 1*, a re-creation of his bedroom in West New York, is shown at the Green Gallery. November 24–January 5, 1965, one-man show at Dwan Gallery, Los Angeles. Work included in the Whitney Annual.

**1965** Makes *Boxes # 27–42*. Begins using jewels and hair in his constructions, and makes his first pin-drawings on sheets of x-ray film. Starts using pastels again. Is included in *11 from the Reuben Gallery* show at the Guggenheim Museum. The Green Gallery goes out of business during the summer, and he joins the Pace Gallery. Designs *Room # 2*, his first mirror room.

**1966** *Room # 2* is built for a show at the Pace Gallery, October 8–November 5, and is acquired by the Albright-Knox Art Gallery, Buffalo, N. Y. Makes *Boxes # 43–58*, does pencil drawings, and makes his first *Transformation* (Eyeglasses).

**1967** Writes "Waitingman" and "Stealingman." *Corridor # 1*, a mirror construction, is built and shown at the Los Angeles County Museum. Visits Greece during the summer, then moves to the Upper West Side of New York. Designs his own furniture. Creates *Book* for Pace Limited Editions. Completes *Boxes # 59–65* and begins making cut-paper drawings in December.

**1968** Continues his *Transformations*. Begins working with cardboard cutouts and using acrylics in paintings. Makes *Boxes # 66–76*, mostly out of painted wood. Writes the first chapter of his autobiography. *Room # 3*, his second mirror room, is shown at Documenta in Kassel, Germany. October 12–November 9, a mirror staircase is included in his one-man show at the Pace Gallery.

**1969** Makes a film with Kim Levin, *Self*, which is shown along with *Book* at the Museum of Modern Art. Writes the second chapter of his autobiography. Gives an advanced sculpture seminar at Yale, where, upon his arrival, he demonstrates nineteen different methods of creating fire. Begins *Transformation: Chair* series and starts working with Polaroids.

**1970** *Corridor # 2* is shown at the Philadelphia Museum of Art. October 3–31, *Transformation: Chair* is exhibited at the Pace Gallery. Writes the third chapter of his autobiography.

**1971** September 25–November 2, his *Autopolaroids* are exhibited at the Pace Gallery. October 16–November, the Cor-ten steel boxes are also exhibited there. The Museum of Contemporary Art in Chicago holds a retrospective of his boxes. Teaches at Brooklyn College 1971–72.

**1972** Makes boxes of chicken-wire mesh, which are exhibited at the end of the year at the Pace Gallery November 1972–January 1973, the Whitney Museum of American Art holds a retrospective of his work.

**1973** Makes a second series of Polaroids, *Photo-Transformations*, using the SX-70 and manipulating the emulsion.

Alloway, Lawrence. *Samaras: Selected Works 1960–1966*, The Pace Gallery, 1966.

Ashton, Dore. "A Home-Made Process for Unraveling Meanings," *Studio International*, March 1973.

Baker, Russell. "Art and the Alarming Philistine Shortage," *The New York Times* (October 8, 1964).

Benedikt, Michael. "New York Letter," *Art International* (vol. X, no. 10), pp. 67–68.

Bernstein, Richard. "Interview," *Andy Warhol's Interview*, December 1972.

Canaday, John. "Gods—With and Without Lightening," *The New York Times* (October 16, 1966).

*Current Biography*, vol. 33, no. 10, November 1972.

"Forbidden Toys," *Time* (September 20, 1968), pp. 74–75.

Friedman, Martin. "The Obsessive Images of Lucas Samaras," *Art and Artists* (November 1966), pp. 20–23.

Genauer, Emily. "Trying to Pin Down the Pin Man," *The World Journal Tribune* (October 30, 1966), p. 33.

Glueck, Grace. "Keep off the Glass," *The New York Times* (October 20, 1968).

———. *The New York Times* (October 4, 1964).

Greenfield, Lois. "Lucas Samaras: Transfigured, Mutilated, Fragmented and Abstracted . . . ," *Changes*, no. 88, June 1974.

Gruen, John. "Art in New York: Passion and Poetry," *New York* (November 4, 1968).

———. "The Art of Cruelty," *The World Journal Tribune* (October 9, 1966).

Hughes, Robert. "Menaced Skin," *Time* (November 27, 1972).

———. "Nowhere to Sit Down," *Time* (November 9, 1970), p. 62.

Johnston, Jill. "Reviews and Previews," *Art News* (December 1961), p. 14.

———. "Reviews and Previews," *Art News* (September 1964), p. 10.

Judd, Donald. "In the Galleries," *Arts* (February 1962), p. 44.

Kozloff, Max. "Art," *The Nation* (November 14, 1966), p. 525.

———. "The Uncanny Portrait: Sander, Arbus, Samaras," *Artforum* (June 1973).

Kramer, Hilton. "Inspired Transformations," *The New York Times* (November 26, 1972).

———. "Taste and Talent for the Extravagant," *The New York Times* (October 19, 1968).

Kurtz, Bruce. "Samaras Autopolaroids," *Arts* (December 1971–January 1972).

Levin, Kim. "Eros, Samaras and Recent Art," *Arts* (December 1972–January 1973).

———. "Reviews and Previews," *Art News* (December 1968), pp. 53–54.

———. "Samaras Bound," *Art News* (February 1969), pp. 35–37.

Marmer, Nancy. "Los Angeles," *Artforum* (January 1965), pp. 11–12.

Mellow, James R. "Cozy Objects Gone Berserk," *The New York Times* (October 25, 1970).

———. "New York Letter," *Art International* (December 1968).

Meyer, Arline J. "Reviews and Previews," *Art News* (November 1959), p. 65.

bibliography

Perreault, John. "Cotton Scissors," *The Village Voice* (October 24, 1968), p. 17.

————. "Going the Way of All Flash," *The Village Voice* (November 30, 1972).

Picard, Lil. *East Village Other* (October 15–November 1, 1966).

Pincus-Witten, Robert. "New York," *Artforum* (December 1968), pp. 55–59.

————. "Rosenquist and Samaras," *Artforum* (September 1972).

Raynor, Vivien. "In the Galleries," *Arts* (October 1964), pp. 64–66.

"A Reflective Artist Takes a Peculiar Slant on the World," *The Smithsonian Magazine* (February 1973).

Roberts, Collette. "Lettre de New York," *Aujourd'hui* (October 1964), p. 53.

Rose, Barbara. "New York Letter," *Art International* (November 1964), p. 54.

————. "The Other Tradition," *New York* (December 11, 1972).

Samaras, Lucas. "Autopolaroid," *Art in America* (November–December 1970), pp. 66–83.

————. *Book*. Pace Gallery, New York. 1968.

————. *Chair Transformations*. Pace Gallery, New York. 1970.

————. "Cornell Size," *Arts* (May 1967), pp. 45–47.

————. "An Exploratory Dissection of Seeing," *Artforum* (December 1967), pp. 26–27.

————. *Lucas Samaras*. Whitney Museum of American Art, New York. November 1972–January 1973.

————. "A Reconstituted Diary: Greece 1967," *Artforum* (October 1968), pp. 54–57.

————. *Samaras Album*. Whitney Museum of American Art and Pace Editions, New York. 1971.

————. "Stealingman," *Arts* (September–October 1968), pp. 46–47.

Schjeldahl, Peter. "Boxie Was a Cutie Was a Sweetie Was a Blondie Was a Pootsy," *The New York Times* (August 24, 1969).

Schwartz, Barbara. "An Interview with Lucas Samaras," *Craft Horizons* (December 1972).

Siegfried, Joan. *Lucas Samaras Boxes*. Museum of Contemporary Art, Chicago. 1971.

Solomon, Alan. "Conversation with Lucas Samaras," *"Artforum* (October 1966), pp. 39–44.

Smithson, Robert. "Quasi-Infinities and the Waning of Space," *Arts* (November 1966), p. 31.

Ventura, Anita. "In the Galleries," *Arts* (December 1959), p. 59.

Waldman, Diane. "Samaras: Reliquaries for St. Sade," *Art News* (October 1966), pp. 44–46.

Willard, Charlotte. "Eye to I," *Art in America* (March–April 1966), p. 53.